Art by Film Directors

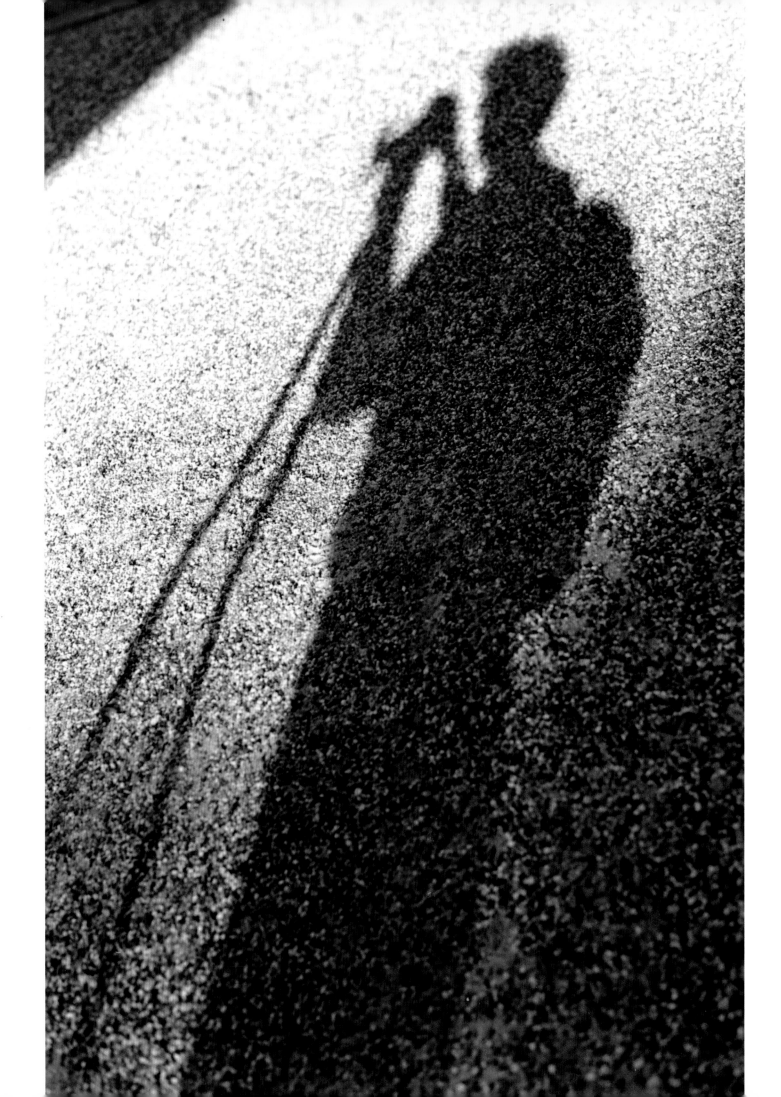

Art by Film Directors

Karl French

MITCHELL BEAZLEY

Art by Film Directors
Karl French

First published in 2004 by Mitchell Beazley,
an imprint of Octopus Publishing Group Ltd,
2–4 Heron Quays, London E14 4JP

ISBN 1 84000 770 2

A CIP catalogue copy of this book is available
from the British Library

Commissioning Editor **Mark Fletcher**
Executive Art Editor **Sarah Rock**
Managing Editor **Hannah Barnes-Murphy**
Project Editor **Emily Asquith**
Designer **Dave Crook**
Picture Research **Giulia Hetherington, Sarah Hopper, Helen Stallion**
Production Manager **Gary Hayes**
Copy Editor **Kirsty Seymour-Ure**

To order this book as a gift or an incentive contact
Mitchell Beazley on 020 7531 8481

Set in Frutiger

Printed and bound in Hong Kong by
Toppan Printing Company Limited

previous page The artist and his camera:
in a simple, neat visual joke Donata
Wenders's portrait, accompanying her
husband Wim's exhibition and book
Pictures from the Surface of the Earth
(2001), sees the photographer's shadow
cast on to the surface of the earth.

right *The Spirit of St Clerans,* 1960s.
A vivid evocation by John Huston of the
hunting and fishing trips that he enjoyed
at St Clerans, his Galway country mansion.

Contents

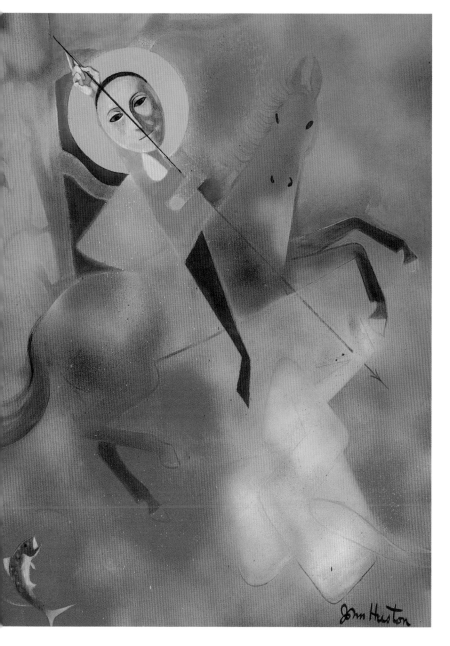

6 Introduction

12 Jean-Jacques Beineix

22 Charlie Chaplin

26 Jean Cocteau

34 Sergei Eisenstein

44 Federico Fellini

50 Mike Figgis

62 Terry Gilliam

72 Peter Greenaway

82 Alfred Hitchcock

90 Dennis Hopper

100 John Huston

104 Derek Jarman

112 Takeshi Kitano

120 Stanley Kubrick

128 Akira Kurosawa

138 Fritz Lang

144 Alan Parker

150 Gordon Parks

160 Satyajit Ray

168 Martin Scorsese

176 Josef von Sternberg

182 Jan Svankmajer

192 Wim Wenders

200 Filmography

203 Bibliography and information

205 Index

208 Acknowledgments

Introduction

This book looks at the meeting points between the cinema and other forms of visual art, and along the way highlights the surprising and illuminating connections and tensions between the different media. Born in the mid-1890s out of a marriage between technology and commerce, the cinema was and remains to a large extent a commercial, business-led medium. While other art forms may be involved with business, the impetus behind most – painting, photography, sculpture – is not inherently the need to attract as large a following as possible. Crudely put, while other visual arts are exclusive, films are inclusive. In fact cinema itself spans the range from, on the one extreme, élitist, consciously exclusive art to, at the other end, unashamed populism with little or no aspiration to art. The artist/directors featured within these pages themselves represent this full spectrum, from the aesthete Peter Greenaway, whose films are in intent and execution certainly no less works of art than his paintings, assemblages, and manipulated photographs, to the populist Alan Parker – represented here by his cartoons – who would probably take offence if anyone accused him of having made a delicate and sensitive work of art.

There have over the years been a number of routes to the director's chair, yet what all of the directors in this book have

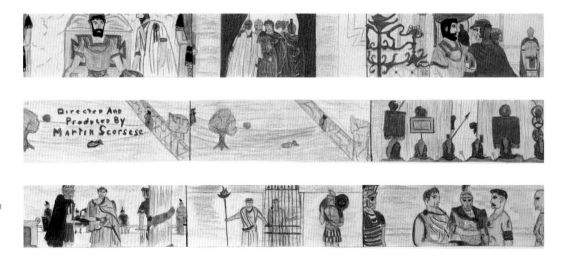

right Storyboards for an imaginary Roman epic movie created by Martin Scorsese when he was around 12 years old.

in common, with the notable exceptions of Charlie Chaplin and Martin Scorsese, is that they were trained as artists or otherwise planned for a life as a painter, photographer, cartoonist, sculptor, or ceramicist – in some cases more than one of these. While several of them – Akira Kurosawa, Satyajit Ray, Stanley Kubrick – had long harboured dreams of making moving pictures, they all entered the movies having first studied or worked, in some cases for years and with great success, in another art form.

In most cases, having established themselves as full-time directors, they continued or have continued at least to dabble in the medium in which they gained their early experience, even if only for their personal pleasure. Many of them have continued to be in demand as artists or photographers, and several, notably Jean Cocteau, Peter Greenaway, Denis Hopper, Derek Jarman, Gordon Parks, and Wim Wenders, have regularly had their work exhibited. While many had achieved at least some success in their first ventures into artistic creativity, several – including Cocteau and Terry Gilliam – were well-known artists before making their debut as movie directors, although Cocteau was more celebrated for his writing.

Art by Film Directors represents the opportunity to see some very fine, in many cases little known and rarely seen, works of art: but of course more realistically what will attract you to this book, and indeed what attracted me to the project in the first place, is the chance to explore the creative impulses of film-makers with whose work for the big screen we are very familiar, while they were working in a wholly different medium.

On a rather basic level there is a certain novelty value in seeing, say, what John Huston was like as a sketch artist, or Stanley Kubrick as a photographer. But as you will quickly see, this book is about a great deal more than novelty value. We achieve a deeper insight into the creative process, through the distinctive vision of 23 directors from around the world, many of whom would appear in most fans' and critics' lists of the greatest and most important film-makers of all time. What is striking, although perhaps not so surprising, is how consistent the vision of many of these artist/directors is. In some sense the book will serve as fuel

above Sketches of the scientist-magician, some of the many hundreds of preparatory drawings by Satyajit Ray for *The Adventures of Goopy and Bagha* (1968), the delayed adaptation of a story by his grandfather.

above *Krazy Kat Homage,* 1981.
Peter Greenaway's tribute to the early
cartoon-strip character, one whose
avowed admirers include ee cummings,
Jack Kerouac, Umberto Eco, and
Quentin Tarantino.

for those looking to revive the *auteur* theory that has long been
out of fashion (a theory popular among film critics of the 1950s
and 1960s wherein the director is regarded as the author of any
given film), and will perhaps also lead one to re-examine the
films of these directors in light of their other art works.

Even before you start to look at their work away from the
cinema, one quality shared by most if not all of the directors
featured here is the distinctive nature of their output, their
films typically being marked by certain definable, instantly
recognizable signature characteristics. The thread or threads
running through their films may be of shared themes, milieu
and genre, as with, say, Chaplin and Scorsese; or of certain
repeated themes wedded to a highly personal narrative style
and a consistent visual quality – as with Kubrick and Kurosawa;
or all of the above, as with Greenaway, Fellini, Hitchcock, *et al.*

It is somehow rather pleasing to discover that an illustration
or a photograph by, for example, Peter Greenaway bears his
distinctive mark every bit as much as one of his films. The
same can be said of the "objects" that have sprung from Jan
Svankmajer's darkly fecund imagination, and of Jarman's early
set designs or his urgent, bilious late paintings. It is no coincidence
that so many of the directors in this book have such recognizably
personal styles of film-making that adjectives have been coined
from their names, notably Cocteau, Fellini, and Hitchcock.

Another theme that emerges throughout the book, and again
it is a revealing if not a startling one, is the notion of the film
director as renaissance man, or dilettante, depending on your
appreciation of the individual concerned. When tackling Ray
and Kitano for example, both of whom came to painting very
late and in highly unusual circumstances, there is a sense that
they were dabbling, if that is not too frivolous a word, in a
number of media before alighting on the one for which their
particular talent was best suited. The same is true of Cocteau,
who regarded himself as a poet whatever the medium he was
working in. It is as if the creative impulse within them was such
that it needed a vent in whatever sphere. This notion of
something like free-form inspiration waiting to be released

and made concrete brings to mind Jan Svankmajer's oddly moving and generous-spirited insistence that there is no such thing as talent in the generally accepted sense, or rather that everyone is innately talented, it is simply that only artists have the ability to access the areas of the mind that allow this creativity to be expressed.

This book was born – the idea springing from the fertile mind of commissioning editor Mark Fletcher – out of a desire to bring together in one volume some of the more notable work in painting, cartoons, illustration, sketching, storyboarding, sculpture, photography, assemblage, collage, and various forms of design by directors whose work collectively spans all but the very earliest years of film-making. It must be said that there are antecedents for this study, although the subject has never before been tackled quite in this way or on this scale.

In March and April of 1993 at the Pace Gallery in New York the exhibition *Drawing into Film* took place, showcasing the storyboard work and preparatory sketches made by a number of the directors who feature in this book – Eisenstein, Fellini, Gilliam, Hitchcock, Huston, Kurosawa, and Scorsese. *The Director's Eye* at the Museum of Modern Art in Oxford in 1996, although itself smaller in scale, grew consciously or otherwise from *Drawing into Film*, bringing together directors' drawings that had sprung from, as well as fed into, their films.

So, although it was devised quite independently, *Art by Film Directors* is to some degree an extension and expansion of these earlier two collections. Having established that it was a viable, in fact a compelling idea for a book-length study, the next problem was to decide who should be included. Many of the directors were obvious candidates, but in the course of compiling the book there were a number of pleasant surprises, the stature of the work of Huston and Parks springing readily to mind.

There are, it must be said, a number of omissions. We would have loved to include examples of the art work of Tim Burton, Vincent Gallo, David Lynch, and Orson Welles, but for various reasons this proved impossible. We would also have liked to include more

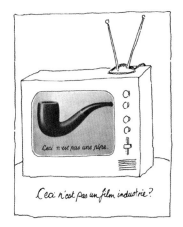

left *Ceci n'est pas un film industrie?* c1983. In a characteristically compact and bilious gag, Alan Parker makes his point about the chronic underachievement of the British film industry.

below *Roman Ipsation Machine* (from the cycle *Bilderlexicon: Technology*), 1972. Also known, more prosaically, as "Masturbation Machine", this fanciful design forms part of Jan Svankmajer's extensive *Bilderlexicon* project, and comes complete with handy user instructions.

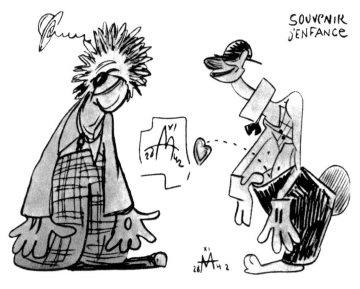

SOUVENIR D'ENFANCE

from certain directors. Some of these extra directors or this extra material could even warrant a second volume, with the inclusion perhaps of the sculptures of André de Toth, the early paintings of John Ford, and the ceramics of Jean Renoir. Then again, of the latter, Ronald Bergan has written in *Renoir* (Bloomsbury, 1992): "… it is clear that if Jean had stuck to ceramics, he would have been famous for only one thing – as the child model in his father's paintings – a mere footnote in the Auguste Renoir story. He was to come much closer to his father's vision by painting with the camera."

Some of the work included here involves – in the cases of, say, Scorsese, Hitchcock, Fellini, Gilliam, and Huston – images created explicitly in the preparation of films. While this may not fit with conventional ideas of what constitutes art, there is something fascinating about them as rough, or often not so rough, drafts for very familiar movies, showing the evolution of individual films, and characters and sequences within them. But in many cases – and Hitchcock's striking sketches for *The 39 Steps* and Fellini's witty, cartoonish preparatory drawings are obvious examples – there is an undeniable merit in the drawings themselves that allows them to stand almost independently of the works that they helped to shape.

In terms of omissions there is one glaring lack in this book and that is the fact that there is not a single female director

top *Street Front in Butte, Montana*, 2000. Wim Wenders's image is taken from his exhibition *Pictures from the Surface of the Earth*, which more than any other of his photographs shows Wenders's debt to his hero Edward Hopper.

above *George, maître de mes pensées* (left) and *Souvenir d'enfance*, both 1942. Two of the striking sketches that Sergei Eisenstein seemed to pluck from his subconscious while he was planning the epic *Ivan the Terrible* trilogy.

featured. This was not for want of trying, and while it is clearly regrettable it proved all but unavoidable. It turned out to be impossible to unearth art work created by an established female director. For example Kathryn Bigelow was for some time a promising candidate – she attended art college and was connected to the New York art scene in the early 1970s – but, sadly, on looking back on her own files Bigelow herself was able to find no examples of her work from this period, so all we have are the tantalizing descriptions of her elaborate art installations.

There are other images that one would like to have included but that have been destroyed or are otherwise unavailable – for example, the paintings that Jean-Luc Godard made when he was a teenager in Switzerland, and similarly Robert Bresson's paintings. Equally tantalizing are missing works from directors, other examples of whose art does appear here. There are unfortunately no extant pieces from the time during Hitchcock's young adulthood when he studied art, worked as a draftsman for an advertising company, and created the intertitles for silent movies. And there must be dotted across America former GIs who passed through Rome during the closing days of the Second World War unaware that the amusing caricature that has been hanging on their wall for the past six decades was scribbled by none other than Fellini himself. Then there are the supposedly expansive works created by the aspirant artist Fritz Lang in the years before the First World War.

What the book does include is a mass of material in different media, from the primitive to the elaborate, from Hopper's strikingly simple and expertly framed – thanks to some early advice from James Dean – photographs of the actors and artists who were his friends and peers, to Wenders's extraordinary, expansive wide-screen photographs which display the same love of landscape as *Paris, Texas*. From Eisenstein's playful sketches to Kurosawa's loving pastiches of his idol Van Gogh. Some of the images will be familiar, most will not, but seen individually and collectively they shed considerable light on the evolution of the artist/directors and on the relationship between cinema and other visual arts.

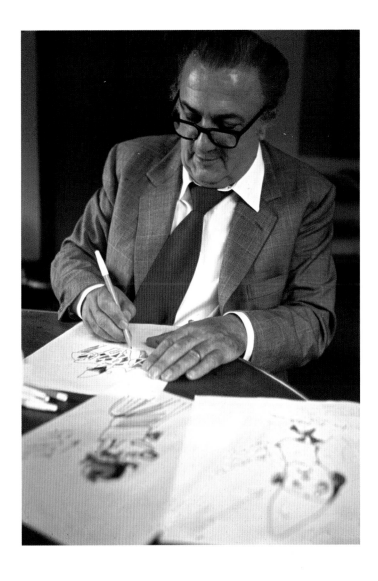

below Federico Fellini, who was often to be seen scribbling some caricature on a napkin in a restaurant or sketching in one of his notebooks, is captured here in 1971, possibly creating preparatory sketches for *Fellini's Roma*, released the following year.

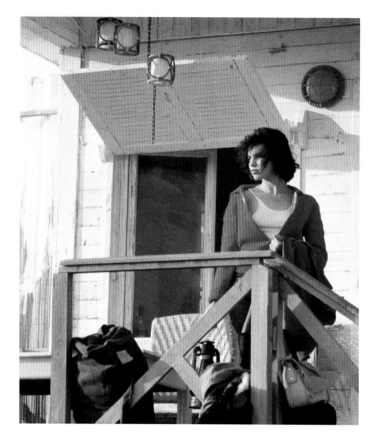

Jean-Jacques Beineix

b. Paris, France, 1946

Jean-Jacques Beineix is one of the great stylists of modern popular cinema, responsible, along with Léo Carax and Luc Besson, for creating a cool, flashy, glossy, visually inventive New Wave of French cinema in the 1980s, which came to be known as the Cinéma du Look. Beineix, born in Paris in 1946, entered medical school in the mid-1960s, but movies had always been his primary passion, and while at college he increasingly spent his days hanging around film sets.

In time he found work as an assistant director to the likes of René Clément, Claude Berri, and most significantly and most often, Claude Zidi, the director best known outside France for *La Totale*, remade as the Cameron/Schwarzenegger vehicle *True Lies*. In these early years Beineix also worked as assistant director for Jerry

above Betty (Béatrice Dalle) on the balcony of the beach house whose immolation forces her and boyfriend Zorg on the road to glory and doom in the picaresque romantic tragedy *Betty Blue*.

opposite *Humilité 3,* 1996. Beineix in reflective mood the year before returning from semi-retirement with the thoughtful TV movie *Locked-in Syndrome*.

Lewis, the object of adoration for French cinephiles, on *The Day the Clown Cried*, the (thankfully) rarely seen concentration camp movie that sees Lewis as a clown amusing Jewish children on their way to the gas chambers.

Beineix made an immediate splash with his feature debut as director, *Diva* (1980), a dazzling, slick neo-*noir* thriller-cum-art-house movie. The story centres on the adventures of a delivery boy with a passion for opera whose illicit recording of his favourite singer in concert brings him into conflict with a gang of Taiwanese gangsters, a situation resolved with the aid of Richard Bohringer's Zen master, Gorodish. Beineix arrived on the film-making scene as a ready-made *auteur*, his signature style instantly established, the film a startling blend of intellectual seriousness bordering on the pretentious and an almost obsessive interest in the look of every shot. *Diva* displays an almost fetishistic use of complex camera angles and reflective surfaces in everything from Gorodish's polished Rolls-Royce to the shades always sported by the assassin Le Curé (Dominique Pinon).

Diva was a breakout commercial success, but failed to win the hearts of the critics, particularly in France, where Beineix has been consistently, if unfairly, reviled; indeed the director now regularly jokes that each successive film release represents the opening of "Beineix season" among the French critical establishment. The greatest savagery was reserved for the director's second outing as feature director, an exquisitely designed, if somewhat portentous adaptation of the cult novel *The Moon in the Gutter* (1983), starring Nastassja Kinski and Gérard Depardieu, the latter memorably and bloodily depicted munching his way through a block of ice.

right *Bananes,* 1996. In the catalogue for his 1996 exhibition *Miroirs Brisés* Beineix remarks that painting is "an adult game which I play with the seriousness of a child".

After the commercial and critical disappointment of *The Moon in the Gutter*, the director enjoyed the greatest success of his career thus far with the erotically-charged, tragicomic love story/road-movie *Betty Blue* (1985), which made an instant star of Béatrice Dalle as the doomed heroine who falls for the house-painter and wannabe novelist Zorg (Jean-Hugues Anglade). With his talent and fascination for the composition of each shot, Beineix could be seen as the Gallic equivalent of Ridley Scott, although Beineix has made the opposite journey to Scott's, moving increasingly into advertising from feature directing through the 1980s.

above *L'origine d'Edmonde*, 2000. The title pun is lost in translation, being a play on *"L'origine du monde"* (the beginning of the world), in contrast to the picture opposite.

below *La fin du monde*, 2000. The
end of the world, envisaged by Beineix
as a kind of abstract, garish, neon-lit
celestial terminus.

right *Miroirs Brisés,* 1994. This is the painting that, rather gauchely translated as "Shiver Mirrors", lent its name to Beineix's 1996 exhibition.

The director's experience on two separate advertising
commissions fed into his next film, the disappointing but still
beautiful *Roselyne and the Lions* (1989), while his fifth film,
bearing the somewhat Felliniesque title *IP5* (1992), was a
quirky, lush love story, this time involving a graffiti artist and
his friend going on the run. The film carries a certain weight
of poignancy for containing the last performance of the dying
Yves Montand.

Beineix then took a professional detour into the world of
documentary film-making, his most notable achievement being
Locked-in Syndrome, a TV film based on the experiences of the
journalist Jean-Dominique Bauby, as documented in the
extraordinary memoir *The Diving Bell and the Butterfly*. Beineix
returned to feature film directing with *Mortel Transfert* (2001),
starring Anglade as a possibly murderous psychoanalyst, and
proved that he had lost none of his stylistic panache nor his
ability to infuriate French movie critics.

Considering his talent for elegantly designed compositions and
other visual flourishes it is no surprise that Beineix has turned
his hand to paintings and sketches nor that his work has been
exhibited. The surprise is that he took it up so late, and that his
first exhibition only took place in the 1990s. The exhibition
from which most of the images here are reproduced was entitled
Miroirs Brisés, translated as *Shiver Mirrors*, which could have
served as the subtitle to *Diva*. In the introduction to the
catalogue, Marie Binet writes: "He paints in order to halt the
passage of time. His eye is a highly developed camera, with
the shutter, his iris, the visible aperture, his pupil, the film, his
retina, on which pure visual impressions are projected, just like
the solid colours he applies in order to enhance the play of light
on the surface."

Beineix's images, while owing an expressed debt to Francis Bacon,
Miró, Naum Gabo, and others, are distinctive, but when asked in
an interview with Stephanie Rosset (www.filmfestivals.com) if he
would ever contemplate making the permanent shift from the
moving to the still image, Beineix insists modestly: "I'm already an
average director, I'm not sure I'd pass mediocrity in painting."

above Jean-Jacques Beineix beside
one of his paintings. In the *Miroirs Brisés*
catalogue he comments: "I need to
paint, that's all there is to it. I don't
try to explain it."

right *Ventre (Belly)*, 1994. Miró meets
Francis Bacon in the nightmare cartoon
"Belly" which is rich in symbolism ranging
from the transparent to the impenetrable.

Charlie Chaplin

b. London, England, 1892
d. Vevey, Switzerland, 1977

above Chaplin's tender portrait of his young wife Oona O'Neill, the mother of eight of his ten children and, like his three other wives, a teenager at the time of their wedding.

right A poster announcing a putative Chaplin production to be called *Shoulder Arms*, that was, according to Chaplin's biographer David Robinson "probably sketched by Chaplin in April–May 1918".

opposite Chaplin turns the tables with this caricature of Ralph Barton, a friend and one of the leading caricaturists of the 1920s and 1930s, who also worked as a stills photographer on Chaplin's 1931 masterpiece *City Lights*.

Born in England but living in the United States from around 1913, Charlie Chaplin was for some years in the 1920s probably the most famous person on the planet – perhaps the most widely recognized person that had ever lived. Yet what would become his iconic image of the little, everyman tramp was apparently hastily thrown together one day with what came to hand in a prop room. The bowler hat, tattered suit, cane, and outsized shoes would be his signature through the scores of short films and handful of features that propelled him to an unprecedented level of international fame, and vast wealth. The creation of this character from these few elements and the films in which the Little Tramp appeared themselves constitute some of the key achievements in 20th-century visual art. The character of the Little Tramp, created as it was almost haphazardly for the short docu-comedy *Kid Auto Races at Venice* (1914), would survive almost unchanged through countless shorts and feature films, most notably Chaplin's four masterpieces *The Gold Rush* (1925), *Modern Times* (1936), *City Lights* (1931), and *The Great Dictator* (1940).

Like Alfred Hitchcock, Chaplin recognized his image as his trademark and learned to incorporate a sketchy self-portrait into

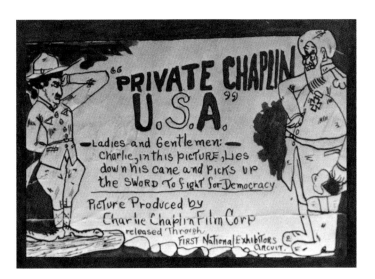

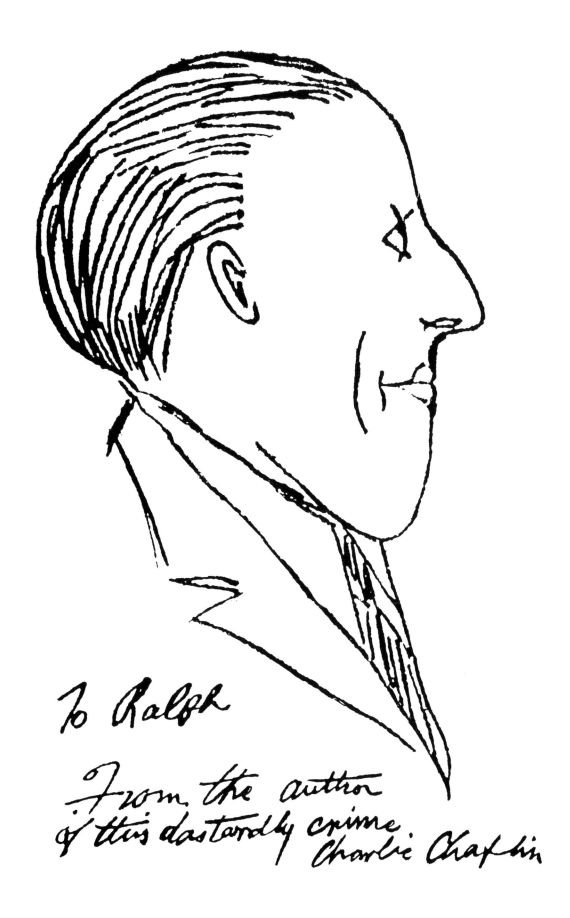

To Ralph

From the author
of this dastardly crime.
Charlie Chaplin

below The artist at the easel – Chaplin
is pictured in the film *The Face on the
Bar-Room Floor*, one of 35 films featuring
the young clown that were made in 1914,
more than 20 of which were directed
by Chaplin himself.

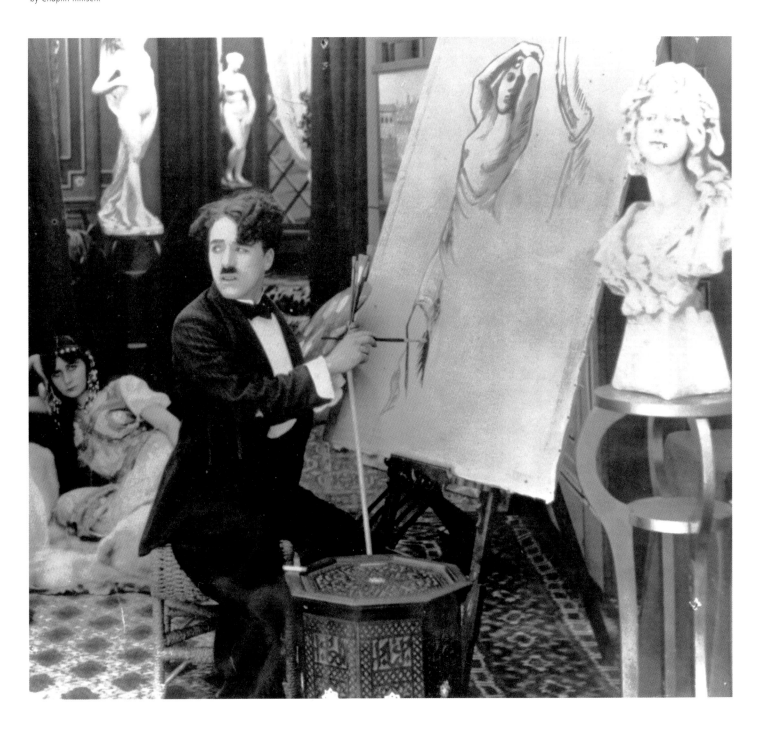

left In a publicity still taken in the early 1920s Chaplin fosters his reputation as the obsessive, perfectionist artisan/artist.

below Chaplin's hastily assembled uniform – partially borrowed, according to legend, from the wardrobes of comics Fatty Arbuckle and Chester Conklin – that literally became Chaplin's signature and established him as one of the cultural icons of the 20th century.

his signature. "Painters are a bore because most of them would have you believe they are philosophers more than painters," Chaplin said in his autobiography; yet he became friendly or at least acquainted with many artists, Picasso and Jean Cocteau among them. Whether or not they were friends, Cocteau was an avowed Chaplin fan, considering *The Gold Rush* one of only four great films of the early years of cinema. But in his writings Chaplin makes no reference to his own art aside from the captions to the sketches that appear in his autobiography and which are reproduced here. So all that we know for sure is that he had no formal training in painting; indeed he had almost no schooling of any kind.

Since his family and representatives of the Chaplin Institute in Paris are aware of no extant works by him other than those reproduced here, we are in the position of being able to present what appear to be the complete art works of Charlie Chaplin.

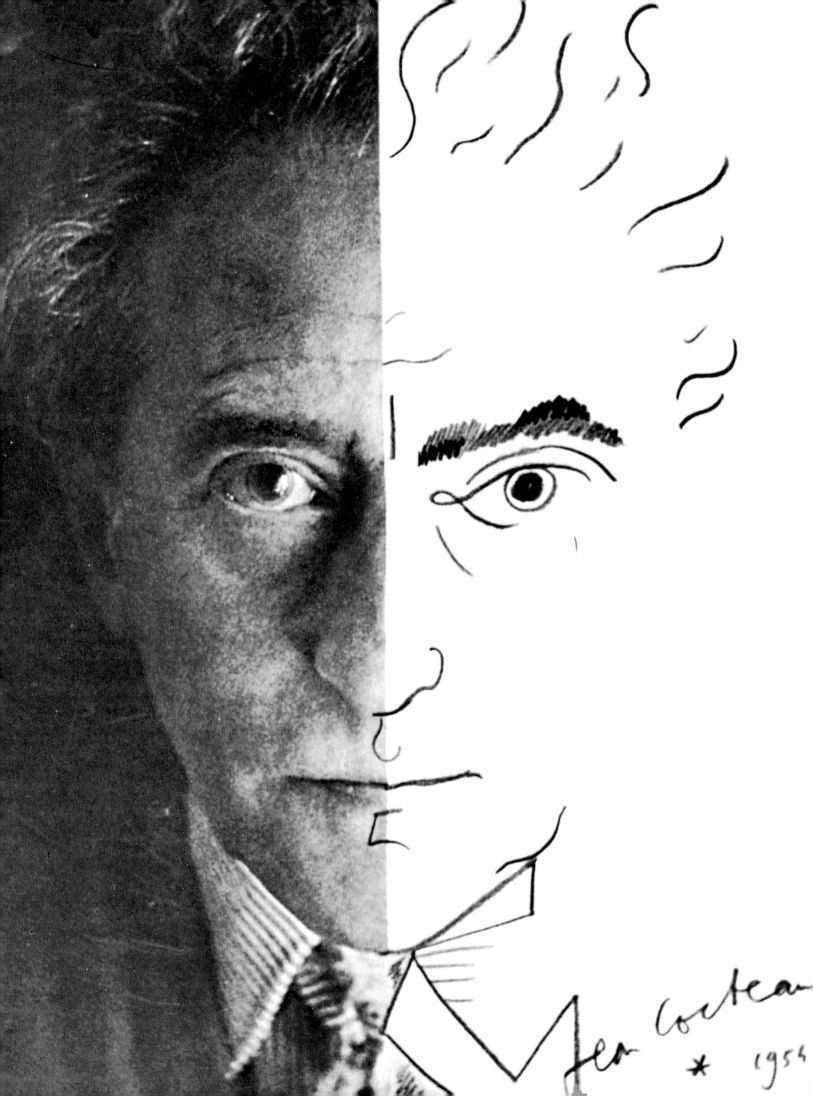

Jean Cocteau
* 1955

Jean Cocteau

b. Yvelins, France, 1889
d. Essone, France, 1963

Even by the standards of the other artist/directors featured in this book, Jean Cocteau was exceptionally versatile. He was a poet, film-maker (he always preferred the term cinematographer to director) master conversationalist, theatrical adaptor, playwright, novelist, publisher, journalist, librettist, choreographer, drummer, essayist, cultural critic – not least film critic – opium fiend, poster designer, muralist, ceramicist, and painter. Francis Steegmuller's biography recalls Edith Wharton's remark, on having first met the young Cocteau, "I have known no other young man who so recalled Wordsworth's 'O Bliss was it in that dawn to be alive'". Cocteau seems to have been a friend of, or at least acquainted with, virtually every cultural icon who went near Paris during the first half of the 20th century. Cocteau's extraordinary roll-call of celebrity pals including Rodin, Matisse, Man Ray, Dufy, Isadora Duncan, Apollinaire, Rilke, Charlie Chaplin, Diaghilev, Stravinsky, Picasso, Braque, Satie, Modigliani, Proust, Gertrude Stein, Gide, Colette, Edith Piaf, and T.S. Eliot.

Already a known aesthete, socialite, and poet, Cocteau first emerged as a draftsman when in 1911 he was commissioned to create a poster of Nijinsky, Diaghilev's famous protégé and the dancer for whom Cocteau harboured a not-so-secret passion. Throughout the First World War, while working as an ambulance man, and in between other artistic endeavours (chiefly a collaboration with Satie, Picasso, and choreographer Léonide Massine on the ballet *Parade*), Cocteau turned out a series of illustrations, mostly for his own publication *Le Mot*.

A passionate romance with the precociously gifted young novelist Raymond Radiguet ended in 1923 with Radiguet's death aged 20.

opposite Jean Cocteau's 1954 self-portrait which appeared on the cover of the collection of poetry *Clair-Obscur*.

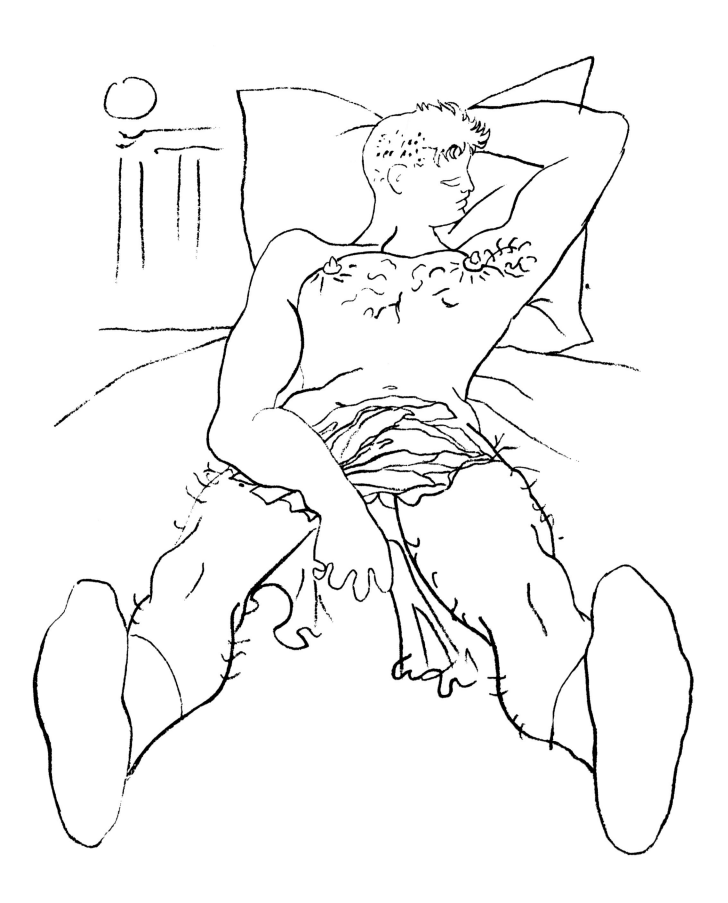

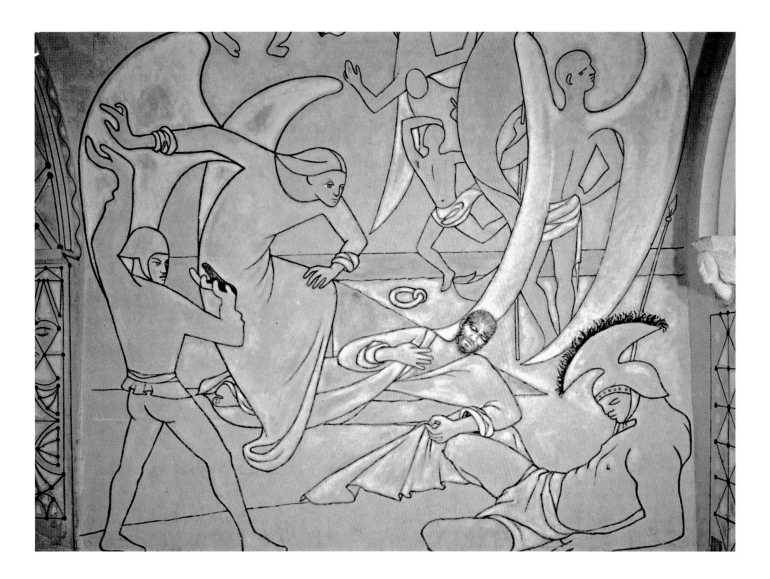

Cocteau descended into a profound crisis of depression and opium addiction, emerging from this experience as a suddenly prolific novelist (*Orphée*, 1926; *Les Enfants terribles*, 1929) and poet, as well as making his debut as director. Drifting between periods of relative inertia – invariably as a result of his continual descent back into opium use – and creative activity, Cocteau would over the next 20 years write notable plays (including *La Machine infernale*, 1934) and screenplays (*Les Enfants terribles*), and write and direct at least two cinematic masterpieces (*La Belle et la bête*, 1946, and *Orphée*, 1949). Both these films starred Cocteau's close friend Jean Marais, who played a key role in reinvigorating Cocteau as a creative force. At heart Cocteau was always a poet, and from his striking debut as film director,

above A detail from Cocteau's 1956 mural at the Chapelle Saint-Pierre de Villefranche-sur-Mer, depicting St Peter being freed from King Herod by an angel.

opposite One of a series of homo-erotic line-drawings that Cocteau produced in 1947 for his friend Jean Genet's novel *Querelle de Brest*.

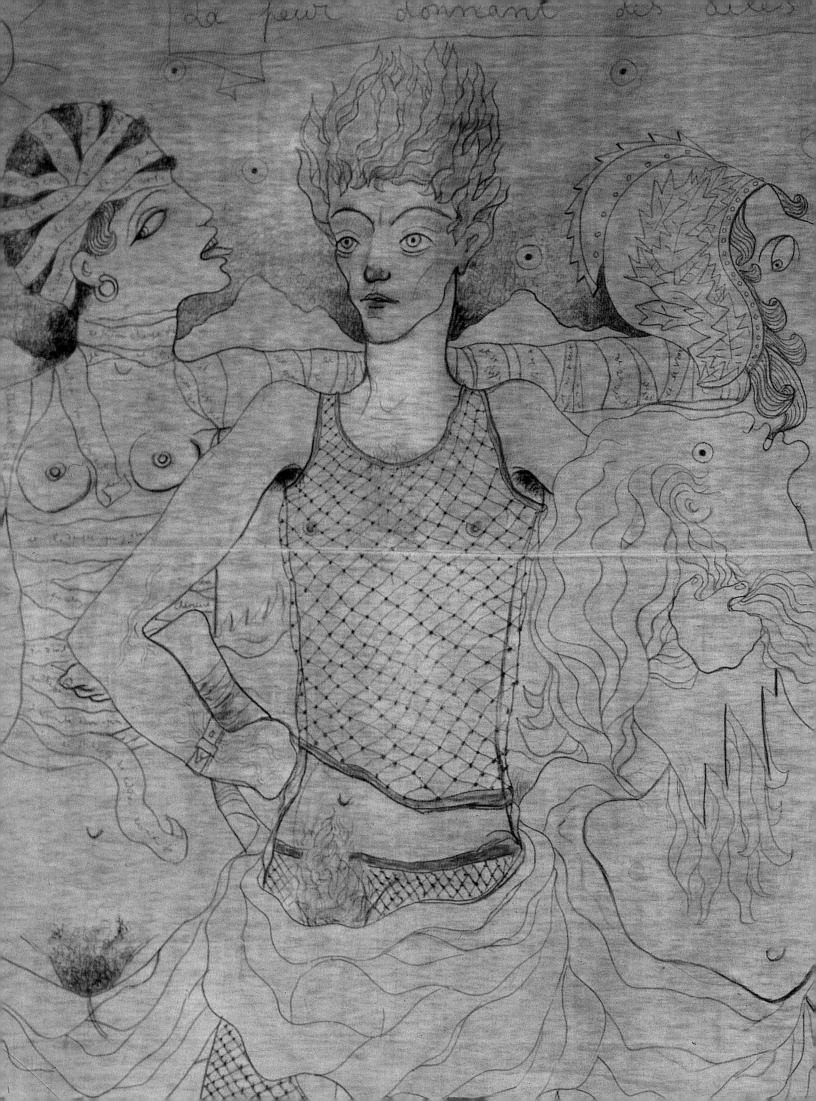

la peur donnant des ailes

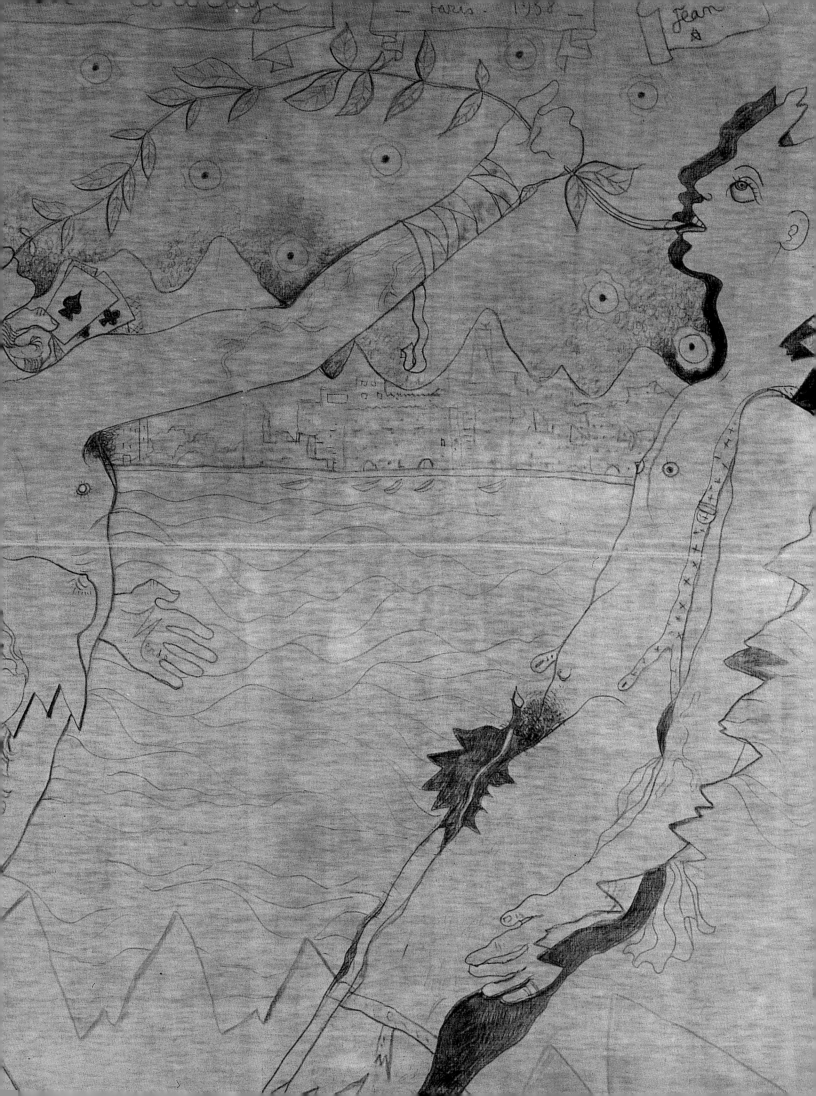

Paris 1938 — Jean

Le Sang d'un poète (1931), to his disappointing swan song Le Testament d'Orphée (1959), he could truly be characterized as a poet of the cinema, one constantly seeking to explore and expose the magic and mystery of the creative process.

In 1924 Cocteau published a limited edition of Dessins (more than 100 of his stark and striking line-drawing portraits). The following year there appeared under the title Le Mystère de Jean l'Oiselier, Monologues a facsimile edition of 30 annotated self-portraits created in a haze of grief and opium consumption. The Surrealist sketches inspired by, indeed made during, his stay in a sanatorium to cure his addiction, were published under the title Maison de santé (1926). He also illustrated editions of his own work (Thomas l'imposteur, originally published 1923, illustrated version 1924). His golden age as an illustrator was as a young man and he would never again achieve paintings as powerful as the simple line drawings in Dessins.

previous page La peur donnant des ailes au courage, 1938. One of a number of illustrations, this one on a bed-sheet, and entitled "Fear giving courage wings" drawn by Cocteau in January of 1938, using at various times, charcoal, crayon, and blood.

above Diaghilev, Misia Sert, Nijinsky à la première du Spectre de la Rose, 1923. The illustration depicts an exhausted Nijinsky backstage, whom Cocteau, in recollections, contrasted starkly with the vibrant, onstage Nijinsky who had just received 50 curtain calls.

opposite Jean Marais, the eponymous hero of Orphée (1949), caressing his own image in the portal to the underworld. Steegmuller's biography recalls how Cocteau said of his masterpiece: "It is much less a film than it is myself."

However, having entered semi-retirement from certain forms of creative endeavour, in the last decade of his life Cocteau enjoyed a return to other forms of artistic creation. He began to produce a number of what he termed "poem objects", small trinkets and other sculptures generally made in bronze, and became a prolific ceramicist, creating pots decorated with his distinctive designs. As he declared with characteristic breathlessness in a 1958 interview in *L'artisan d'art*: "Pottery has saved my life! It stops me from using ink, which has become too dangerous, since everything we write is systematically deformed by our readers."

More significantly, and very much more publicly, Cocteau returned to painting when he painted murals on the walls of the Villa Santo Sospir, the St Jean Cap Ferrat residence of his patron Mme Alec Weisweiler, where he was based for much of the time during his last years. These informal illustrations, which owed a great deal to the sketches of his sometime friend and collaborator Picasso (the two were reconciled toward the end of Cocteau's life after a protracted falling out that had kept them apart for nearly three decades) led to a series of commissions to undertake similar works. While these frescoes scarcely bear comparison to Cocteau's other creative achievements, they are marked by a certain style, by thematic and mythical concerns, and by a homoerotic content – more freely and more directly expressed here than elsewhere – that run through his career. It was a career that, taken as a whole, can be seen as an extended response to Diaghilev's famous command to the young Cocteau: "Astound me!"

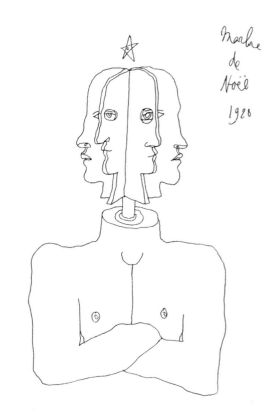

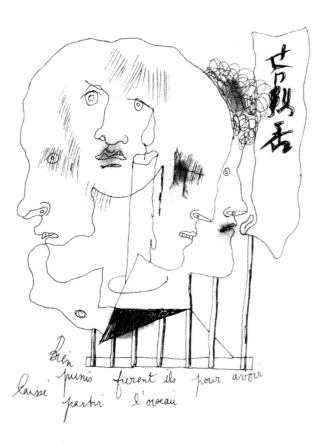

opposite *Les Eugènes de la guerre,* 1913–14. One of the cubist-inflected illustrations gathered together in *Le Potomak* (1919), Cocteau's poetic anthology-cum-fantasy memoir, Eugène being one of his own middle names.

right *Marbre de Noel,* 1928 (above) and *Bien punis furent-ils pour avoir laissé partir l'oiseau,* 1928. Two line-drawings, unpublished in book form, from the drug-influenced series that was used for Cocteau's *Opium* (1930).

"BLACK MAJESTY"
Scene with the lustre

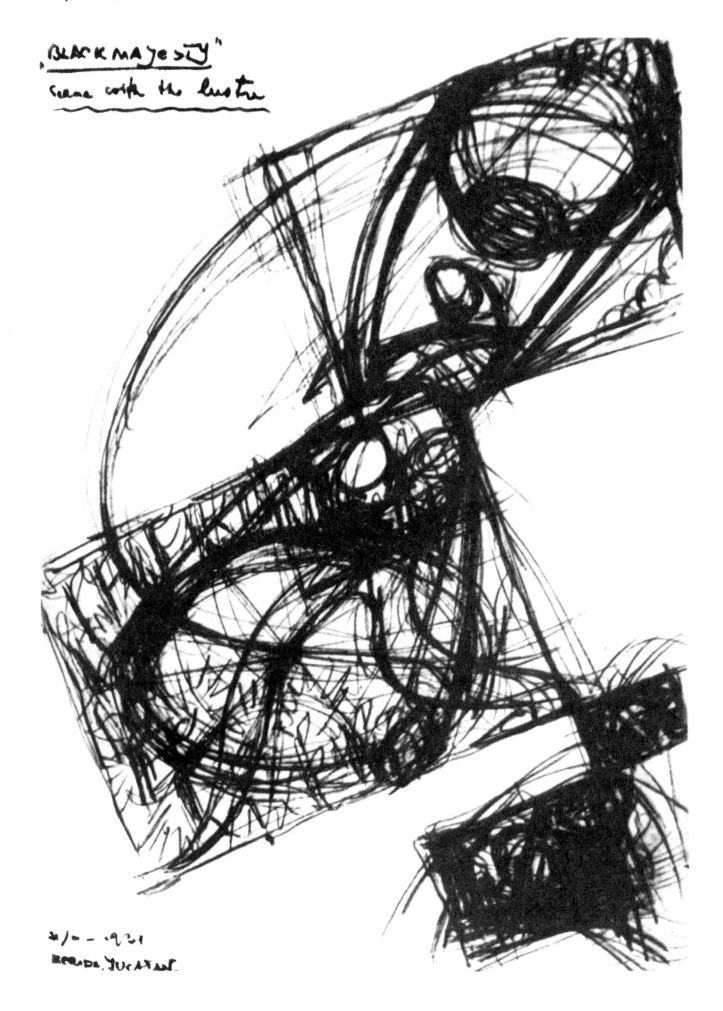

2/11 - 1931
MERIDA, YUCATAN.

left A sketchy self-caricature, one that points to the sly, sometimes bawdy humour of this most serious-minded of cinematic artists.

opposite Eisenstein's sketch for a proposed film based on the Haitian slave revolution and set to star Paul Robeson. It was to be called either *Black Majesty*, the title of the John W. Vandercook story that inspired him, or *The Black Consul*, a 1932 novel on the same subject written by Anatoli Vinogradov and inspired by Eisenstein's putative project.

Sergei Eisenstein

b. Riga, Russian Empire
(now Latvia), 1898
d. Moscow, Soviet Union
(now Russia), 1948

Herbert Marshall, translator of Eisenstein's autobiography in 1985, wrote of his subject: "It was difficult to know what he was fundamentally. He never expressed it verbally. Still, there was one medium through which he expressed his innermost feelings – his drawings and caricatures." It seems at first remarkable that one of the great figures of world cinema, the man who is widely acknowledged as having helped establish, with his first few groundbreaking films, the very grammar of film-making, should reveal himself not through these same films, but through the often playful sketches and doodles that he turned out through-out his life. But when you see these sketches, these often wild,

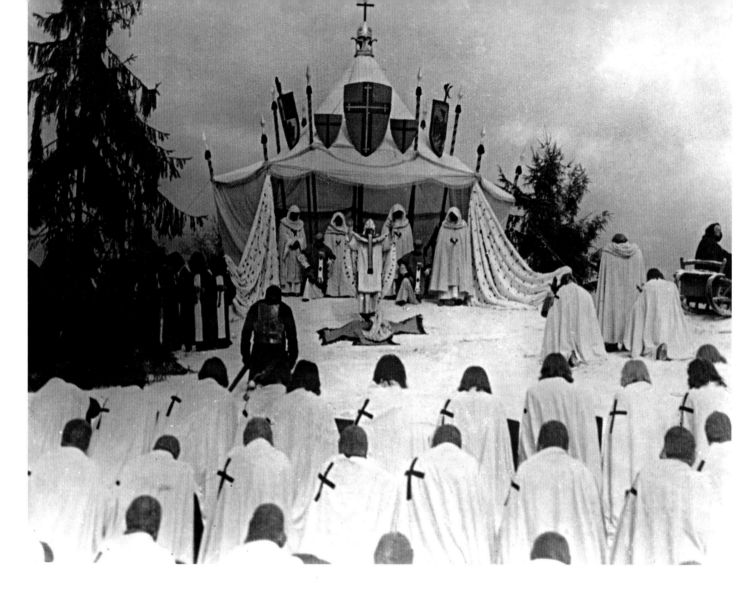

erotically charged expressions of his conscious and subconscious mind, beside his astonishing but austere, profoundly serious, politically committed masterpieces, this appraisal makes sense.

Sergei Mikhailovich Eisenstein was born in Riga, Latvia, in 1898 into a middle-class family – his father was a trained architect – and was educated in Riga and St Petersburg. In his autobiography, *Immoral Memories*, he describes his epiphanic introduction to the joys of painting, when a friend of his parents made for him, with white chalk on a blue card-table, line drawings of animals. Watching, the young Sergei was enchanted, and it was particularly the *movement* of the line that engaged and struck him: "Here, before the very eyes of the delighted onlooker, the line of contour springs up and moves. Moving, it traced the invisible outline of the object, and magically made it appear on the dark blue cloth. … And no doubt, in the years to come, I shall remember that sharp sense of line as dynamic movement; line as a process; line as a route. Many years later it impelled me to write in my heart the wise saying of Wang Pi, of the 3rd century BC: 'What is a line? It speaks of movement.'"

Eisenstein studied architecture and engineering at the Petrograd Institute of Civil Engineering, but while there he developed a passion for the theatre. His education was interrupted and his political sense sharpened by the 1917 revolution, in the aftermath of which he became a prolific satirical cartoonist, his sketches appearing in the *St Petersburg Gazette*. He also signed up in the Red Army. While still in the army – throughout which period he continued to sketch, doodle, and churn out political cartoons – Eisenstein moved into theatrical work, initially as a painter and designer.

Political and artistic expression were always intertwined as Eisenstein progressed swiftly through his theatrical career. He exchanged his role as a stage designer for training as a director, and then moved from theatre to cinema via a job as assistant to the editor charged with the job of reshaping Fritz Lang's *Dr Mabuse, der Spieler* for a Soviet audience. Eisenstein was still only in his twenties when he produced the quartet of films on which his reputation was made, and with which he established his philosophy of film-making. In *Strike* (1924), *The Battleship*

above Eisenstein's design for *Ivan the Terrible*, the final masterpiece in three parts, that was left incomplete at the time of the director's tragically early death.

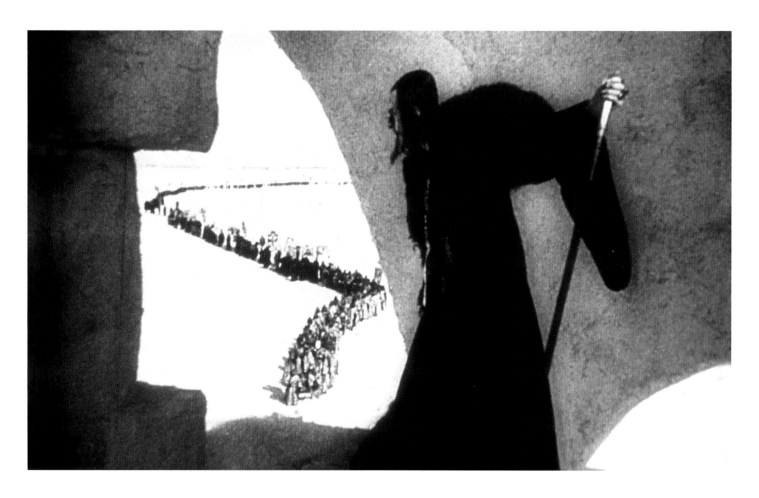

Potemkin (1925), *October* (1927), and *The General Line* (1929), while working within the strictures of Party-approved guidelines and sometimes under the direct scrutiny of Stalin himself, Eisenstein brought to fruition his notions of cinematic storytelling via montage and the central role in film-making of cutting and dramatic juxtaposition. These ideas would be further developed in his academic lectures.

An unhappy sojourn in Hollywood led to an aborted attempt to make his dream project *¡Que Viva Mexico!* The footage he shot was used in other films, and the ideas he had for the film are outlined in his book *Mexican Drawings*. Returning to the Soviet Union in the early 1930s, Eisenstein alternated his academic work with his increasingly frustrated attempts at film-making. However, the signal success of *Alexander Nevsky* (1938) restored his fortunes, and he died having completed the first two parts of the proposed *Ivan the Terrible* trilogy (1942 and 1946).

Anyone who is at all interested in the cinema has to see the films of Sergei Eisenstein, and anyone at all interested in Eisenstein must see his sketches and doodles.

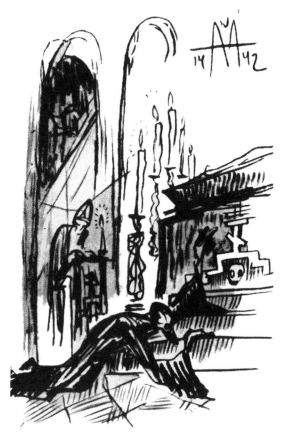

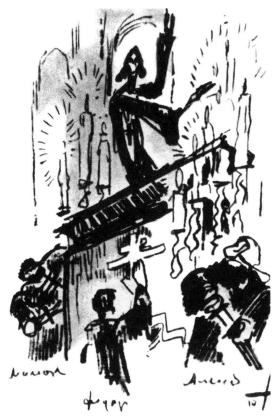

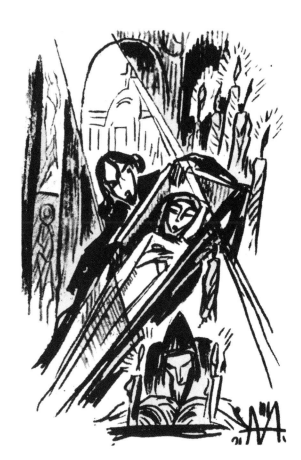

left More of the hundreds of sketches that Eisenstein made in the lengthy and elaborate preparations for *Ivan the Terrible*, his last and most ambitious work.

opposite The Tsar looks out to see the approach of the snaking procession that is coming to take him back to Moscow in *Ivan the Terrible Part I* (1945).

right Apollo, one of a quartet of sketches
of mythological figures created by
Eisenstein on 25 January 1941, the day
before he began his preparatory drawings
for *Ivan the Terrible*.

opposite More sketches from unrealized
projects: top right, a bullfight, possibly for
Que Viva Mexico!; bottom right, Lady
Macbeth (a subject Eisenstein had tackled
on stage); the remainder drawn in 1937
for *The False Nero*, a proposed play.

20 II 37
4

vaRpds Daughter

Claudia Acte

FRonto

Varro

Federico Fellini

b. Rimini, Italy, 1920
d. Rome, Italy, 1993

Ten years after his death, Fellini's stature in the pantheon of great international directors is perhaps more contentious than ever, with almost as many critics and film historians dismissing him as overrated as declaring him a great and unique genius. What Fellini unquestionably brought to his work was an individuality, which, especially from *La Dolce Vita* (1960) and *8½* (1963) onward, marked his films to the extent that the adjective "Felliniesque" entered the language. This word encapsulated the sense of a cinematic world as a kind of near-direct expression of the director's inner urges, with memories, dreams, and both conscious and subconscious desires projected onto the screen, often with little or no concern for linear narrative. Fellini himself became a legendary figure and he more than anyone helped to nurture his own status.

In *I, Fellini*, Charlotte Chandler's distillation of a series of interviews with the director conducted over the last 14 years of his life, Fellini said, "If I hadn't been a film director I'd have wanted to be a comic-strip artist". In fact he almost stumbled into film-making in his mid-twenties, having made a good living for more than a decade via his writing – often of comic material – and his illustration. Fellini had a lifelong passion for drawing, and his sketches played a vital role in the translation of ideas from his imagination to the screen. His output as an illustrator can be divided into four distinct sections: caricatures; cartoons and comic strips; preparatory sketches for his films; and illustrations for his extensive, seemingly comprehensive dream diaries.

Fellini became fixated on cartoons when as a young boy aged five or six he first encountered the comic-strip character Little Nemo. He was the central figure in a series of wildly imaginative dream world adventures, significantly featuring clowns in improbably prominent roles, which appealed to the young Fellini and clearly played some role in shaping his own singular vision. His artistic talents had been nurtured by his mother from the outset – he was, reputedly, encouraged by her to daub the walls and

opposite Fellini captured on set during the production of *La Dolce Vita* (1960).

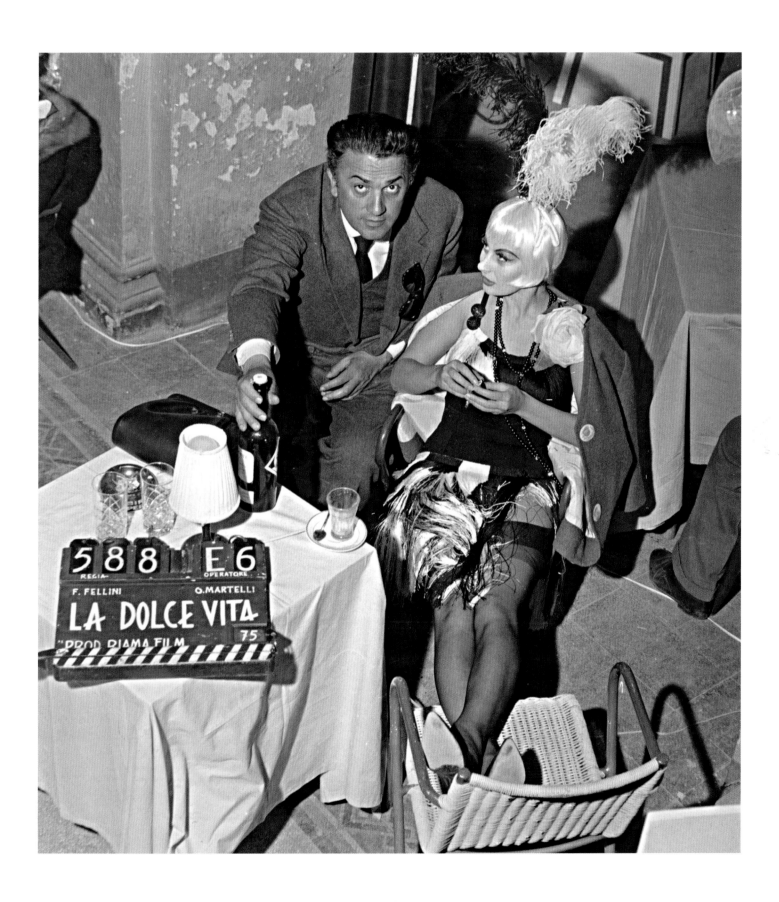

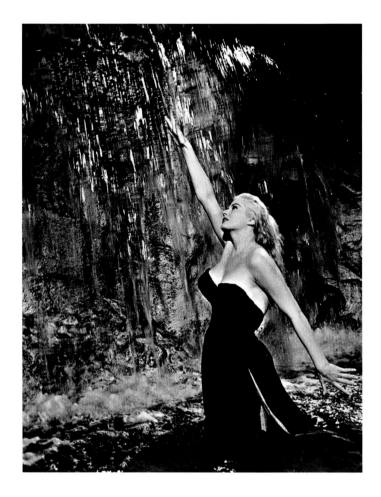

above The iconic image from *La Dolce Vita* of Sylvia in Rome's Trevi Fountain. Of Anita Ekberg, the director recalled in *I, Fellini*: "She thought everyone wanted to go to bed with her, just because every man *did* want to go to bed with her."

opposite *Sylvia come Via Lattea*. One of Fellini's preparatory sketches for *La Dolce Vita* of "Sylvia as the Milky Way" which suggests why he saw Ekberg as perfectly cast for Sylvia.

furniture of his home with his crayon jottings – and he was, from an early age, impelled to attempt to copy the Little Nemo comic strips. He also fell in love with Popeye and Flash Gordon, and one, still contested, story has him working in Florence as a 17-year-old, attempting to revive the defunct Flash Gordon cartoon strip.

What is clear is that by the time he arrived in Florence from his home in Rimini to work for the magazine *420*, he was already a seasoned cartoonist. By 1943 he was based in Rome and churning out prodigious quantities of written material and illustrations for the satirical magazine *Marc'Aurelio*. By the summer of 1944 he and some friends had opened the shop Funny Face, outside which he would routinely sit, creating caricatures of the GIs who were, in his recollection, the sole patrons of this establishment. By this stage Fellini had already gained a reputation for his written work, and it was to Funny Face that the director Roberto Rossellini came one day to seek him out for the commission that would transform his life – to collaborate on the script for *Open City* (1945), the film that also effectively launched the Italian neo-realist movement.

Fellini, who also worked with Rossellini on *Paisà* (1946), gradually assumed more control of his work, moving into direction almost by stealth *The White Sheik* (1952), before embarking on a series of films, alternately autobiographical or created expressly for his wife, the actress Giulietta Masina, that would establish his international reputation. Every time he planned his next project he set about drawing preparatory sketches for the work and it would be with these drawings that he would more fully realize what was in store. Fellini spoke of how he came to create *The Road* (1954) when he first sketched the character who would become Gelsomina, to be played by Masina. This sketch began with Fellini drawing Gelsomina's round head, and from that film onward, Masina would experience a shudder of excitement whenever her husband would trace this distinctive shape on his sketchpad, knowing that he was in the process of creating her next character (see p.49).

I, Fellini contains a story that crystallizes the process and usefulness of creating these sketches. Fellini remembered his

per Gherardi

1) Desiderio Tivoli
2) Trucco Anita
3) Diadema in
 testa (?)

per
ANITA

ab.to lungo blu
notte con una spirale
vertiginosa di stelline
come la via lattea

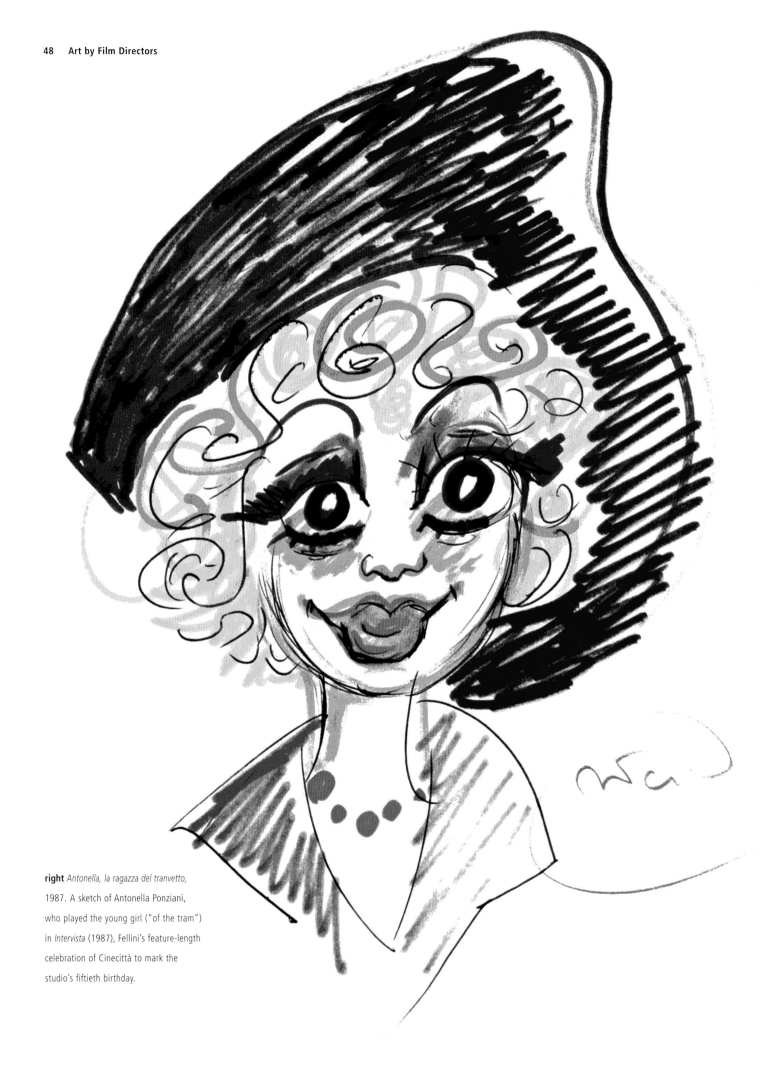

right *Antonella, la ragazza del tranvetto,* 1987. A sketch of Antonella Ponziani, who played the young girl ("of the tram") in *Intervista* (1987), Fellini's feature-length celebration of Cinecittà to mark the studio's fiftieth birthday.

unusual pitch to Marcello Mastroianni for the role of Marcello in *La Dolce Vita*: "I gave him a thick manuscript, every page blank except the first. On it was a picture I had drawn showing his character as I saw him. He was alone in a little boat in the middle of the ocean with a prick that reached all the way down to the bottom of the ocean, and there were beautiful lady sea sirens swimming all around it. Marcello looked at the picture and said, 'It's an interesting part. I'll do it.'"

Dreams were central to Fellini's work and, during the preparation for *8½*, he was introduced to a Jungian analyst, Dr Ernst Bernhard, who encouraged the director to keep a record of his dreams. This he studiously proceeded to do, filling many volumes with illustrations created moments after waking from his, generally it seems, anxiety- and sex-fuelled dreams. His biographer Charlotte Chandler writes in *I, Fellini* of the alarming experience of being introduced to these visions by an eager Fellini who delighted in exposing his inner self to her while, in mock coyness, protecting her from those images that he decided were excessively obscene.

Fellini's sketches, doodles, cartoons, and dream pictures are of a piece with and complementary to his films. In *I, Fellini*, in a disarming moment of modesty from the great self-mythologizer, having been asked to assess his reputation and what it was that had propelled him along the path to cinematic stardom, Fellini said: "Fame. How? For what? My drawings weren't good enough."

above right *Otto e mezzo: la soubrette,* 1962. One of hundreds of Fellini's sketches of impossibly curvaceous, pneumatic women, this one for *8½.*

right Fellini's favourite subject, his wife Giulietta Masina, here in a preparatory sketch for her eponymous role in the 1957 film *Nights of Cabiria.*

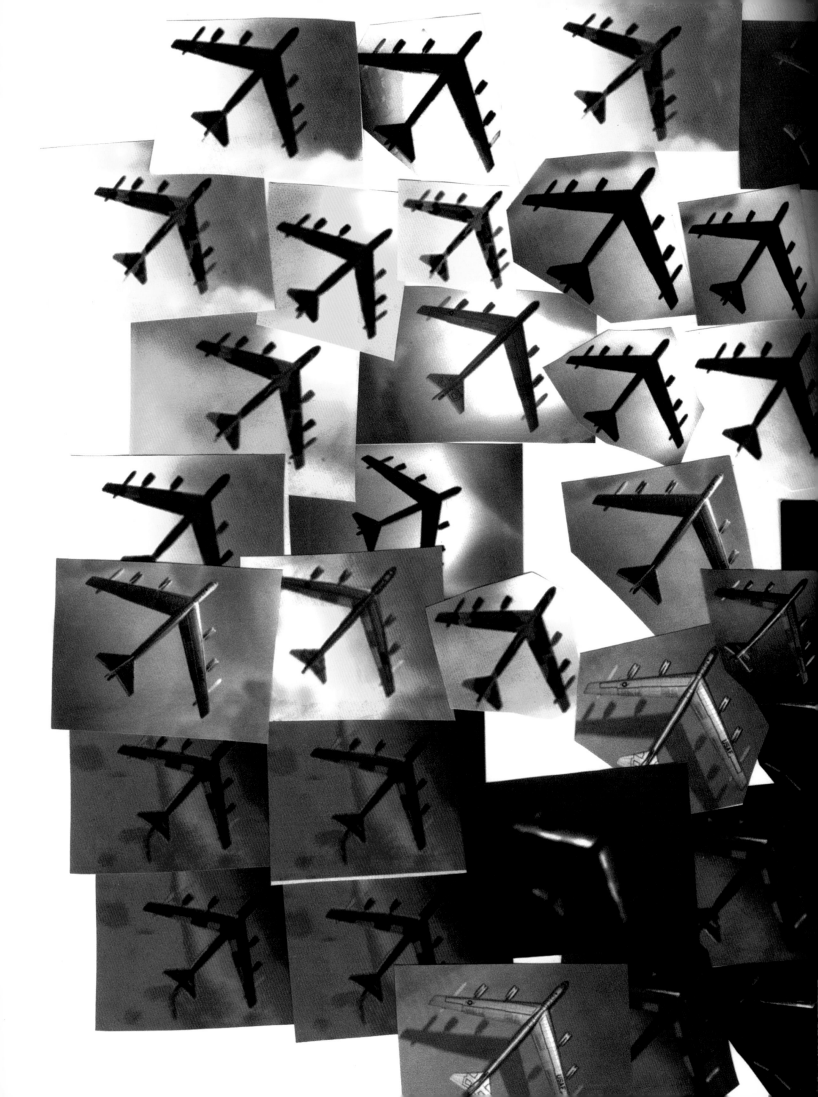

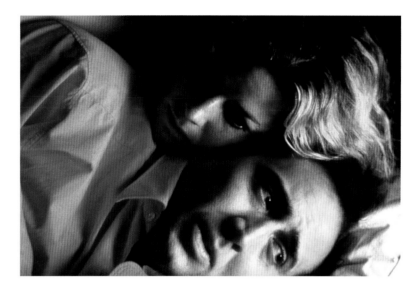

Mike Figgis

b. Carlisle, England, 1949

Mike Figgis spent much of his early childhood in Kenya, returning to north-east England at the age of 10. The upper-class accent he had picked up in colonial Africa set him apart from his peers and he sought refuge in, among other things, photography, which he took to with a passion that has never deserted him. Around the same time he fell in love with music – jazz, blues, and rock 'n' roll – and began to play trumpet and guitar. Rejected by the National Film School, Figgis moved down to London where he joined the People Show, an avant-garde musical theatre group with which he stayed for more than a decade and where he was able to give rein to his wide-ranging creativity: writing, directing, acting, composing, and performing. Also during this time, the 1970s, he played with a number of jazz bands. In 1980 he formed the Mike Figgis Group, and staged various theatrical shows relying heavily on music that he composed and film footage that he directed.

Having attracted the attention of Channel 4 television, for which he made the feature-length *The House* (1984), Figgis made his real debut in 1988 with *Stormy Monday*, a stylish, Newcastle-set neo-*noir* in which he showed a sureness of touch both in the film's visual style and in his ability to handle a star cast. His next film, and his first in Hollywood, *Internal Affairs* (1990), was a

above Nicolas Cage and Elizabeth Shue in *Leaving Las Vegas* (1997), the outstanding masterpiece of Figgis's career thus far.

opposite *Weapons of mass destruction,* 2003. This photo-montage was made for an installation at the 2003 Valencia Bienal. The model plane was photographed in Figgis's bath in Los Angeles.

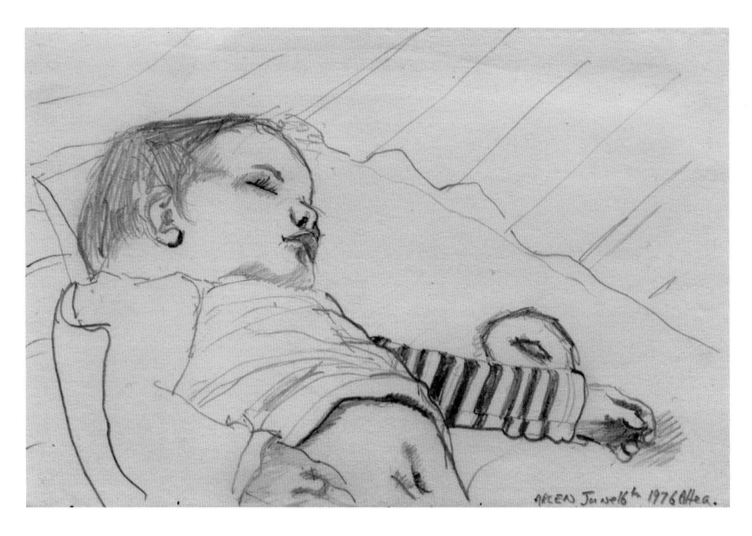

great leap from his debut, and again he proved his talent for
handling actors and discovering in them previously unexplored,
often very dark talents, drawing from Richard Gere possibly his
finest and certainly his most unsettling performance.

His next three films suggested that Figgis was still struggling to
fit his talent for erotically charged examinations of the workings
of the human psyche and the extremes of human relationships
into the Hollywood style of movie-making. *Liebestraum* (1991)
was a low-key thriller, *Mr Jones* (1993) a disappointing reunion
with Gere, *The Browning Version* (1994) a rather straightforward
Rattigan adaptation. For his next film, Figgis stripped the budget
to its bare minimum and shot on 16mm, and the result was
Leaving Las Vegas (1995), the masterpiece of his career thus far,
with astonishing performances from Nicolas Cage as the doomed

above *Arlen, Devon,* 1976. Figgis's
touching line-drawing of his infant son.

opposite *LA Cops,* 1995. A kinetic image
of LAPD (Los Angeles Police Department)
officers in mid-bust reminiscent, in its
sinister neo-*noir* mood, of Figgis's first
American feature *Internal Affairs* (1990).

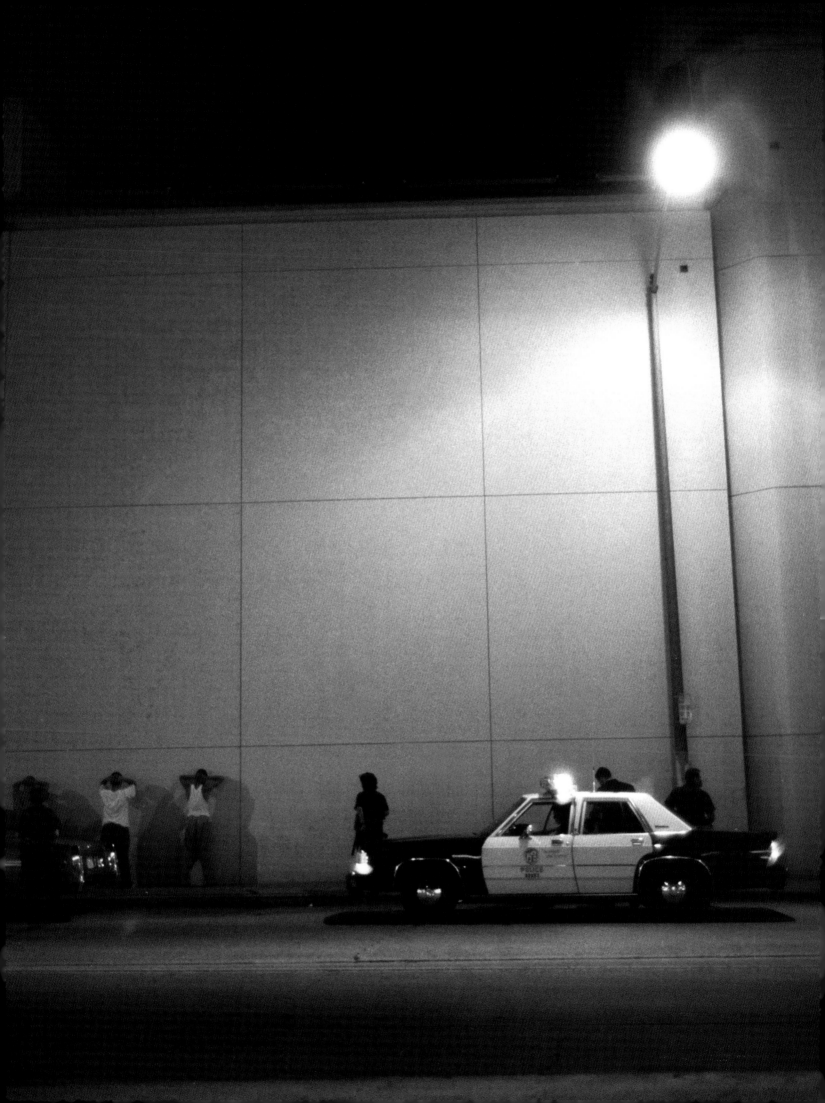

Alexandra, 2004. An ambiguous, dynamic, impressionistic shot of an androgynous nude.

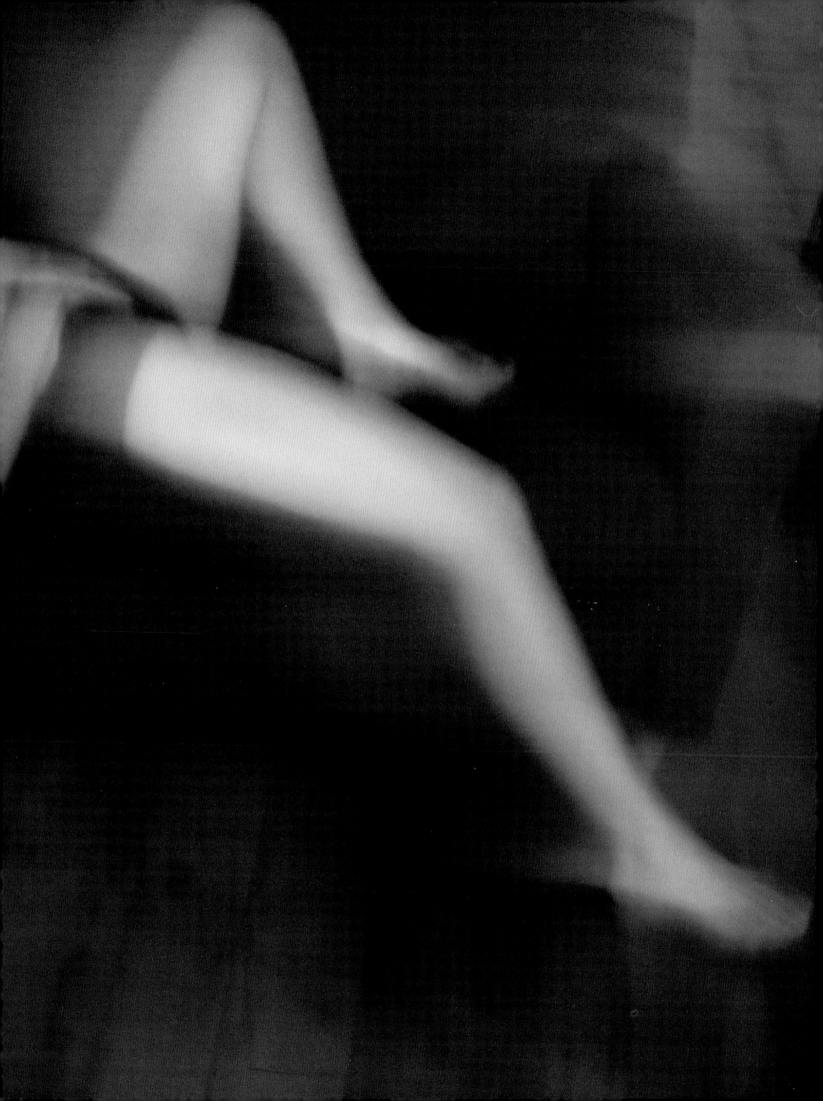

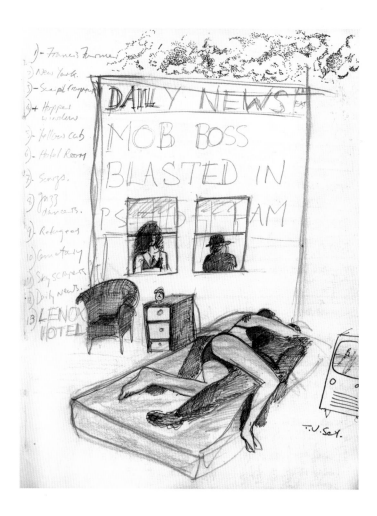

hero and Elizabeth Shue as his hapless lover. With his next
film Figgis again showed what could be achieved within the
mainstream, taking on an original script from Joe Eszterhas and
creating from it the intense, undervalued *One Night Stand* (1997).

From there Figgis became ever more experimental, first in the
episodic, myth-rich *The Loss of Sexual Innocence* (1999), next in
the dazzling split-screen experiment of *Timecode* (2000), and
then in *Hotel* (2001), a murky, opaque, multi-layered story which,
like the previous film, exploits the potential of digital video
technology. The disappointing, conventional *Cold Creek Manor*
(2003) is surely just a blip in one of the most fascinating of
contemporary film careers.

Figgis has been taking photographs for more than four decades,
his passion enhanced by the possibilities afforded by digital

above *Koy Wren,* 1986. A sketch for a
performance-art piece called *Animals of the
City*, the title *Koy Wren* being an anagram
of "New York".

opposite *John Coltrane,* 1970. Figgis,
a dedicated jazz aficionado – as well as
composer and performer – captures jazz's
great mystical genius.

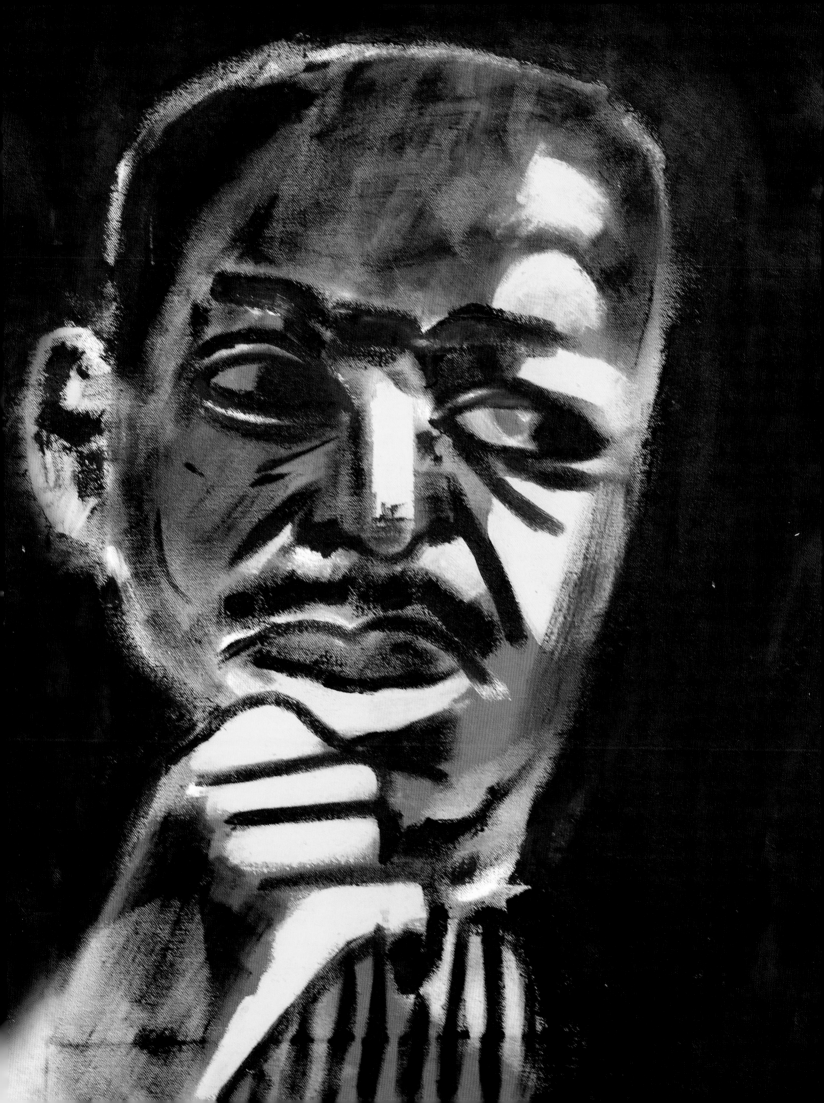

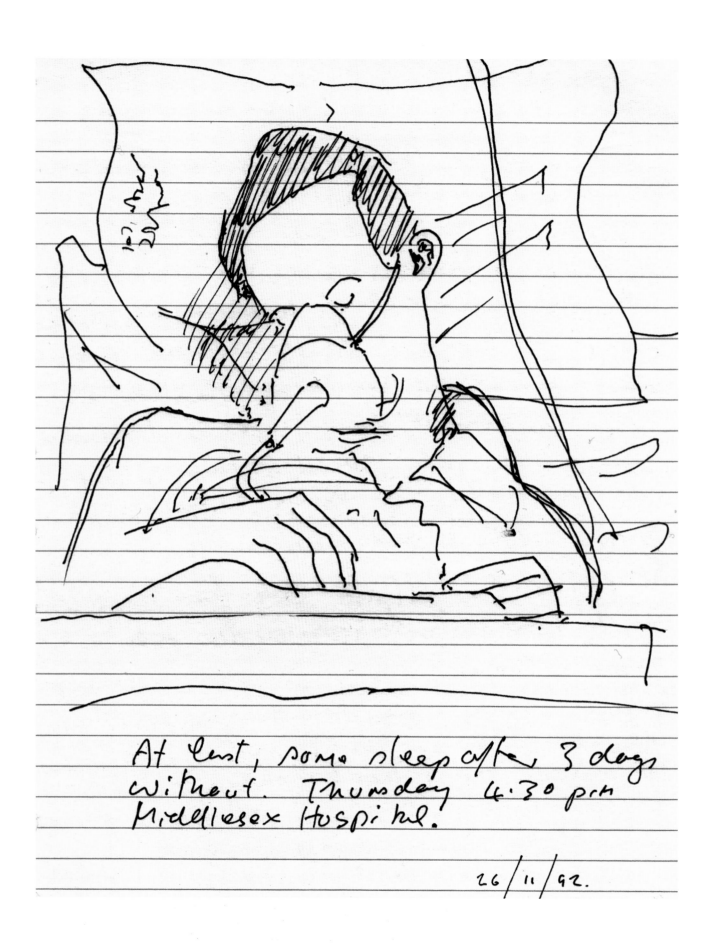

left and opposite *Mum, dad's funeral,* 1976**.** *Steven, Middlesex Hospital,* 1992. Figgis displays the gift of the far from dispassionate observer with (left) this simple but very moving pen sketch of his mother and (opposite) a sketch of a close friend dying of Aids.

overleaf left *Paris,* 2003. Figgis is an exceptionally gifted photographer of the female nude, and here captures his friend, Paris Hilton, who was keen not to be photographed naked.

overleaf right *May,* 2003. Another of Figgis's kinetic action shots, here suggesting that the photographer was moving past or circling his subject.

photography. As well as being an almost obsessive note-taker and filer of his notebooks, sketches, and other art works, Figgis takes his camera with him everywhere he goes. The result, aside from serving as an alternative diary recounting his work and travels, is an exceptional body of art. Although his subjects are wide-ranging – striking streetscapes, close-ups of rusty metal, satirical, political work, and some interesting pieces using electronic manipulation – his approach is generally straightforward and his favourite subject is the female nude. Figgis's vast collection of portraits is dotted with exquisitely composed images, many of women he has befriended or worked with. He was asked, alongside other contemporary film-makers, to contribute a spread to the fiftieth anniversary issue of *Playboy* magazine. Asked in an interview with *Camden New Journal* what keeps drawing him back to the nude, he has said simply: "To me there's nothing more beautiful than a naked woman."

Terry Gilliam

b. Minneapolis, Minnesota,
USA 1940

Even if he had never directed a single film, Terry Gilliam's fame
as an artist gifted with a wholly distinctive style would be assured
by his contributions to the *Monty Python* television shows
(1969–74) and spin-off movies. By the time he joined the Python
gang he had already established a small reputation for himself
with his work on similar comedy programmes in the late 1960s,
such as the children's show *Do Not Adjust Your Set*, but it was
with *Monty Python* that the Gilliam visual style of trippy,
absurdist visual cut-and-paste came to international fame.

Terry Gilliam was born in Minnesota in 1940. Asked by Ian
Christie in *Gilliam on Gilliam* how his parents, neither of whom
was Minnesotan by birth, came to be there at that time, Gilliam
responded: "These are things I should know, but I only remember
things that are important to me, and that's not important – they
were there, so it doesn't matter how they got there." This is

left "Frank Capra meets Franz Kafka"
(*Gilliam on Gilliam*) with overtones of
George Orwell and *Blade Runner*, in
Gilliam's dark fantasy *Brazil* as Sam
(Jonathan Pryce) struggles to escape
from the nightmare that is his reality.

opposite A hyper-pneumatic nude, one
of Gilliam's stock characters, descends
from the heavens in this detail of an
illustration from *Animations of Mortality*,
his notebook-cum-visual memoir.

overleaf Gilliam's contribution to the
bfi/Hayward Gallery's 1996 exhibition
Spellbound, featuring a projection of the
then soon-to-be-released *Twelve Monkeys*,
which echoed the bureaucratic nightmare
world of *Brazil*.

characteristic of Gilliam and also points to one of the key, and also one of the most contentious, elements of his work. A clear line can be drawn from his earliest days as an artist through his experimental work on television, via his move from visual stylist to director, up to his current status as genius cult *auteur*. Throughout, he has remained concerned not with a coherent narrative thread (a lack of interest in plotting is a persistent criticism of his work) so much as in the single moment, the set-up, the crystalline idea, either a philosophical or more often a visual one. In a sense it does not matter to Gilliam how his characters get to be where they are: what matters is what that place looks like and what they do once there.

The first films Gilliam recalls seeing were, significantly, large-scale retellings of myths: *Snow White and the Seven Dwarfs* (1937) – although *Pinocchio* (1940) would later become his favourite animated film – and Alexander Korda's *The Thief of Baghdad* (1940). He talks of never remembering a time when he did not draw. By the time he arrived at Occidental College, in Eagle Rock, California, his visual imagination had been further fuelled by exposure to *Mad* magazine, and he helped launch the college magazine *Fang*. This publication drew him to the attention of Harvey Kurtzman, who had left *Mad* to launch a new title, *Help!* After graduation in 1962 Gilliam moved to New York, where he hooked up with Kurtzman and landed the job of assistant editor on the magazine. There, rubbing shoulders with the likes of the great Robert Crumb, the cartoonist whose weird art work helped shape the visual style of late 1960s American counter-culture, Gilliam refined his technique as an illustrator, at the same time picking up some rudimentary lessons in film-making by working unpaid at a small film studio. Perhaps most significantly, it was at this time that he encountered the English comic John Cleese, who was touring New York as part of the *Cambridge Circus* revue.

Partly to further his career and partly to avoid the Vietnam draft, Gilliam headed for London, where he joined forces with Cleese and producer Humphrey Barclay. Barclay, himself an animator, hired Gilliam to turn out sketches of contributors to his television show *We Have Ways of Making You Laugh* live on air, and then agreed to let him provide a cartoon accompaniment to a gag-filled audio tape of Jimmy Young for the same show. In this

LIBERAL LESSONS No. 23
LEARNING TO SEE THE WORLD THROUGH SOMEONE ELSE'S EYES....

HOW ANGELS LEARN TO FLY...

opposite top *Liberal Lessons No. 23.* Even when dealing with political material, Gilliam is always a visual artist, ready to resort to bathos and a neat, (j)ocular pun.

opposite bottom *How Angels Learn to Fly.* As a teenager, Gilliam in all seriousness considered a life as a Presbyterian missionary, before being struck by an anti-revelation: "I couldn't stand the fact that nobody felt able to laugh at God." (*Gilliam on Gilliam*)

above Salvador Dalí meets Todd *Freaks* Browning in a horrific/comic hybrid image typical of the Gilliam style at the height of the *Python* years.

commission was born the final ingredient in Gilliam's signature
art work – the cut-and-paste of existing images, generally taken
from classical paintings or erotic Victorian photographs, jerkily
moving in the foreground, against a colourful, airbrushed, often
phantasmagorical background. (Like Federico Fellini, Gilliam
produced wild cartoon images, often featuring absurdly
pneumatic women, which seemed to owe something to narcotics,
although, again like Fellini, he barely ever touched drugs.)

Gilliam moved seamlessly on to *Monty Python's Flying Circus*,
his *outré* visuals making up for what he may have lacked in
talent as a performer. Indeed these stream-of-consciousness,
hallucinatory cartoons would supply the glue for the disparate
items of the show, creating surreal links from one skit to the next
and crucially freeing the other members from the tyranny of the
punchline. Gilliam was allowed the freedom to express his
strange ideas, fusing wildly disparate elements with lashings of
sex and violence. Speaking to Bob McCabe in *Dark Knights and
Holy Fools: The Art and Films of Terry Gilliam*, he summed up his
approach: "It comes from drawing a moustache on the Mona
Lisa. That's what it's all about, and to me it's always two things
because I really love the stuff but I also find it funny. If you take
it out of its pompous context there's a nice combination of
reactions and emotions, so I worked like that. Because you're
dealing with old paintings, you have kings and queens and
beautiful Italian masters and you start f***ing around with them."

Despite his relative lack of experience, his shift into direction
was just another stage in his smooth progression, when he
co-directed with Terry Jones the team's second feature film,
Monty Python and the Holy Grail (1975). This again was filled
with the elements that would mark his later works as director,
chief among them the absurd juxtaposition – of old and new, of
hi- and lo-tec – and the bathos of the silly gag elaborately set up.

All his later films, from the emetic medievalism of *Jabberwocky*
(1977) to the Orwellian/Kafkaesque dystopian future of *Brazil*
(1985), are graced with an instantly recognizable visual style. The
process of sketching and storyboarding is of course central in the
preparation of the film's eventual look, as he points out in *Dark
Knights and Holy Fools*: "One of the things that happens with me

is that when we're writing it, I start drawing. The storyboard to me is like writing. I start drawing it and I'm telling the story in a different way because the picture is telling me the story. In the act of drawing it, I'm changing my ideas of what I'm doing. And it's really magical when I get going."

above The iconic image of *Monty Python* — simple, subversive, sublime, and silly. The foot is Cupid's, lifted from Bronzino's *Allegory with Venus and Cupid*, c1540–50.

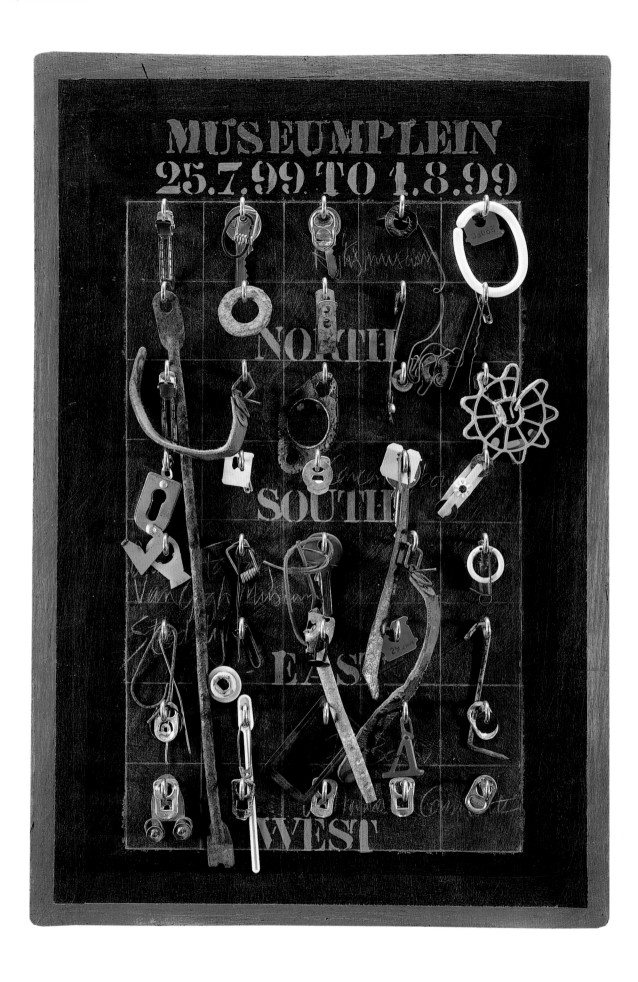

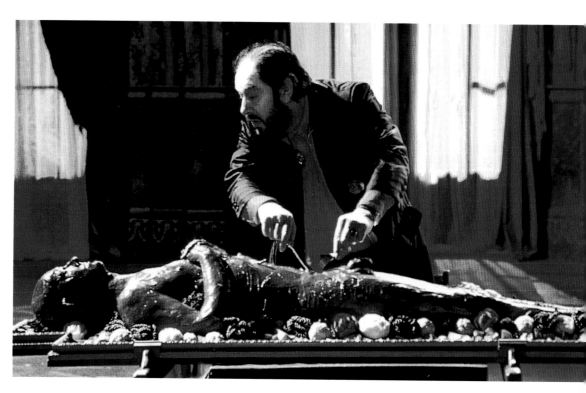

Peter Greenaway

b. Newport, Wales, 1942

Born in Wales, and brought up in Wanstead, East London, Peter Greenaway attended Walthamstow Art School. Having completed his secondary education at a stuffy minor public school, Greenaway found: "Going to art school was a breath of fresh air – the novelty value lasted for years, and there I tried to make some sense of an accidental discovery – Bergman's *The Seventh Seal* (1957). That film changed everything. [My career in cinema] is almost all down to that film" (interviewed by Jonathan Hacker and David Price in *Take 10: Contemporary British Film Directors*). The other seminal film in the development of Greenaway the director was Alan Resnais's terminally bewildering *Last Year at Marienbad* (1961), and if Greenaway fits into any tradition it is that of the 1960s European art-house *auteurs* – Ingmar Bergman, Resnais, Jean-Luc Godard – through whose work Greenaway gained his education in cinema.

This education continued through the 1960s, when he found work at the British Film Institute (bfi) and then at the Central Office of Information, where he eventually picked up experience in film-editing. For years Greenaway made small, self-financed, experimental films, gradually gaining funds from the bfi and the

above Albert (Michael Gambon) is forced to tuck into Michael (Alan Howard) who has been lovingly prepared by Richard (Richard Bohringer) in Greenaway's colour-coded masterpiece *The Cook, the Thief, His Wife and Her Lover*.

opposite *Museumplein one week 25.7.99 to 1.8.99*, 1999. Greenaway is a curator as well as an artist and this plan for a show is wholly characteristic of his work – structurally meticulous, self-contained, and apparently self-explanatory, while at the same time teasing and playful.

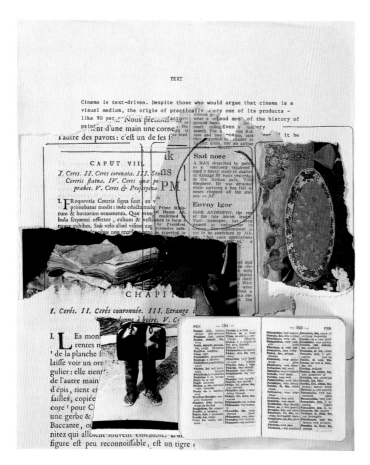

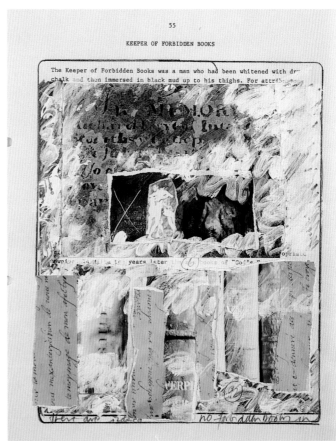

Arts Council to create *Dear Phone*, and *A Walk through H*, a film inspired by the death of his father, and *Vertical Features Remake*, featuring Greenaway's alter ego Tulse Luper, who would return in 2003 in Greenaway's *Tulse Luper Suitcases: The Moab Story*.

In 1980 Greenaway completed his first feature-length film, *The Falls*, the critical success of which led to his breakthrough *The Draughtman's Contract* (1982), the film that most obviously owes a debt to Resnais. With this, the template for Greenaway's work was established and he continued to turn out playful, obscure, erudite, and somehow always controversial films at the rate of roughly one every two years, invariably enjoying greater critical and commercial success on the Continent than in Britain – indeed for years his chief source of financing for his films has been a Dutch production company.

Interviewed by Spencer H. Abbott, Greenaway outlined his argument that film be treated as an autonomous form freed from its reliance on text as a source. Countering the notion that film is a window on the world, he insists: "It is an artificial construct which is contained within its own conventions and

above left *The Keeper of Forbidden Books*, 1988. The book as artefact, text as art, the layering of image and writing – themes familiar from *The Cook, the Thief...*, *Prospero's Books*, and *The Pillow Book*.

above right *In the Dark*, 1996. Motifs recur in Greenaway's work whatever the art form. Here he explores one of his favourite notions, the text-bound nature of film: "Cinema is text-driven..."

above *Flying Over Water,* 1996. Icarus, a figure of endless fascination for Greenaway, was a key figure in the 1997 *Flying Over Water* series and exhibition in which Greenaway explored the history and mythology of human flight.

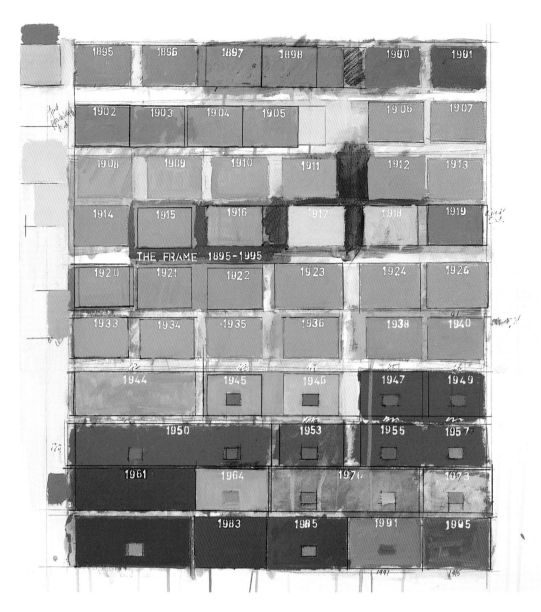

THE FRAME 1895-1995

previous page *In the Dark*. Greenaway's
contribution to the bfi/Hayward Gallery's
1996 exhibition *Spellbound* was an
installation called (like the picture on p.74
and related to it) *In the Dark*. Here, not for
the first time, Greenaway broke down
cinema into its constituent parts – actors,
props, music, and seats for the audience.

above *Short Frame Resumé*, 1981.
Suggestive of the numerical structure
of *Drowning by Numbers*, this work is
also an implicit pun on the notion of
the time-frame. As Greenaway himself
has commented in an interview on his
website: "I believe in every case
that my art works show a wish to order,
or a wish to contemplate order."

devices, and I think we should acknowledge that in a very
self-conscious way." Like all his works in whatever medium,
Greenaway's films are nothing if not self-consciously constructed.

Greenaway has said: "I still consider myself a painter, but one
who happens to be working in cinema" (*Paris New Music Review*,
November 1994). There is a thematic consistency between his
output for the screen and the art work that he has continued
to produce between film assignments or in the service of (or
simply complementing) his films. The exquisite sketches for *The
Draughtsman's Contract* and *A Walk through H*, the elaborate
imaginary maps created for his children's book *Hannah and
the Companions of Boom*, and the stark, often repellent mixed-
media nudes in *100 Allegories* (published in 1998), share certain

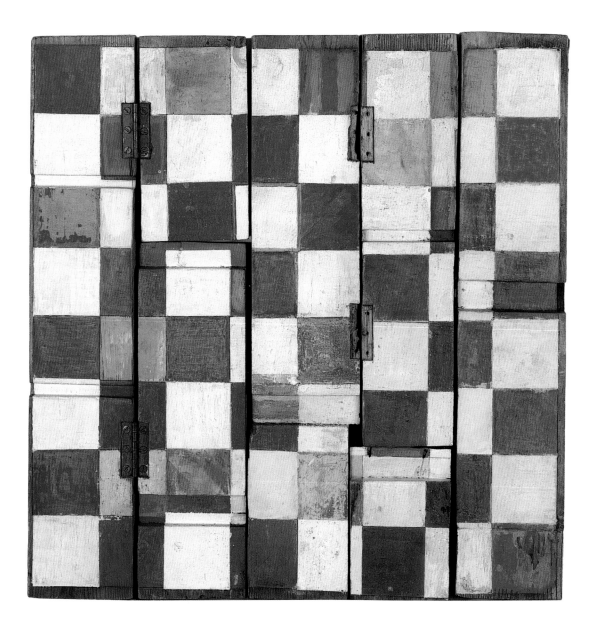

distinctive qualities with his films. The latter, for instance, with their myth-rich, multilayered construction, are very clearly the product of the same imagination from which sprang *Prospero's Books* (1991), Greenaway's visually arresting, intellectually complex take on Shakespeare's *The Tempest*.

As a young boy Greenaway resisted his father's attempts to introduce him to the joys of ornithology, and yet, in what seems like a typically arch Greenaway joke, he chose to devote himself to entomology, collecting insects. So while the father was gathering the hunters, the son was collecting and ordering their prey. Greenaway acknowledges that, by osmosis rather than example, he inherited his father's love of landscape – one of the trademarks of his films and other art works – and the collection

above *Gaming Board,* 1968. An early and simple metaphor for the films to follow: simultaneously symmetrical and skewed, a playful piece, explicitly a game with the invitation to explore whatever is secreted beneath the surface.

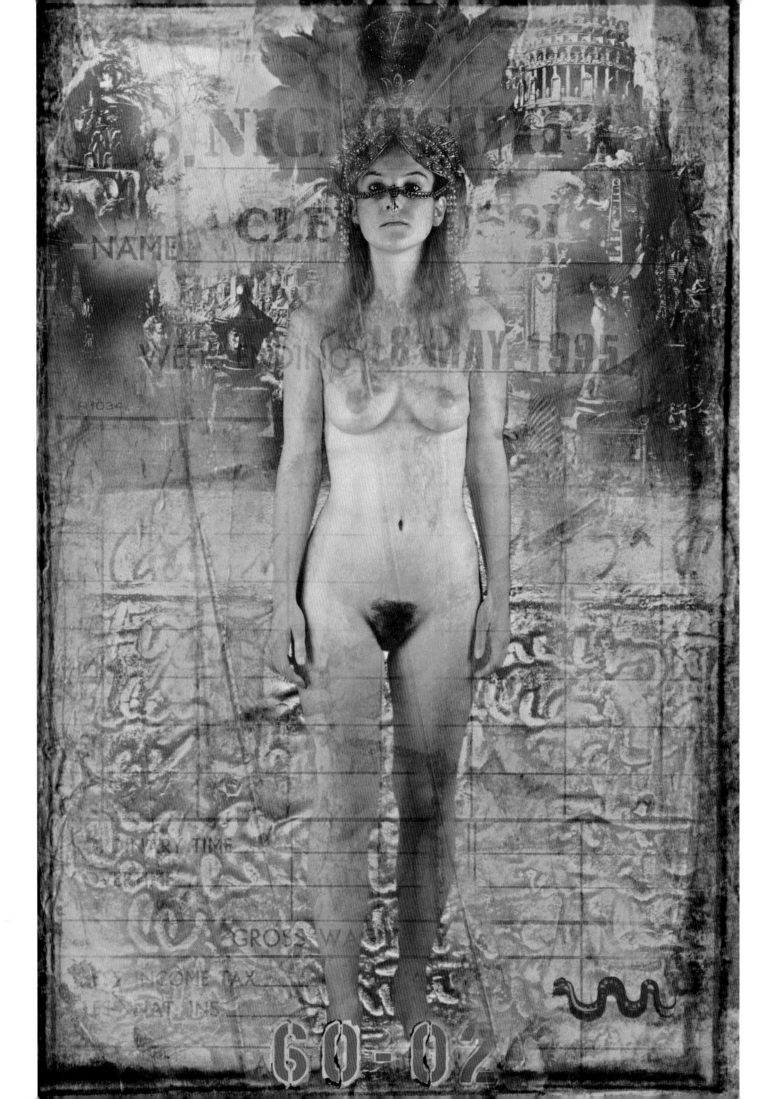

and ordering of birds and insects satisfied or inspired his obsessive regard for order in all its forms. Several of his most striking works are 3-D assemblages that are explicitly taxonomical in nature.

The central tension in his films is between the human capacity for, and attraction toward, chaos, ugliness, and violence, and the ability or desire to impose order on the world through elaborate taxonomy or game-playing. The films themselves are filled with generally arcane jokes and references, and are often broken down into discrete segments – sometimes numbered, as with the dark, ludic, and stylish *Drowning by Numbers* (1988), or colour-coded, as in the case of the gross-out masterpiece *The Cook, the Thief, His Wife and Her Lover* (1989). His films touch on or are awash with sex, death, decay, violence, and characters who are either ciphers or loathsome and sometimes both. Yet this is all set within a meticulously realized structure containing a sense of order and attention to detail that is equally crucial to his paintings, sketches, and 3-D assemblages. The actor Tim Roth summed up the artist-director's obsessiveness when he said, only half-jokingly, that during the production of *The Cook, the Thief, His Wife and Her Lover*, the only significant direction he received from Greenaway was to move a couple of inches this way or that to restore the essential symmetry of the composition.

above *Water in the House,* 1999. A simple image detailing a central theme in Greenaway's work: the tension between the human desire to impose order and the irrational, uncontrollable, and destructive forces of nature.

opposite *Dido from 100 Allegories to Represent the World,* 1998. This image is part of a project started in 1993 in which Greenaway used computerized manipulations of photographs to re-examine mythological figures. Here it is Dido, the exemplar of the exotic Eastern woman exploited by a man of the West.

Alfred Hitchcock

b. London, England, 1899

d. Los Angeles, California, USA, 1980

Discounting Charlie Chaplin, Orson Welles, and Woody Allen, for the obvious reason that they were, or are, also film stars, Alfred Hitchcock was and remains the most instantly recognizable film director of all time. In fact, Hitchcock's distinctive rotund profile was so characteristic that he was able to make his final cameo appearance in *Family Plot* (1976) simply as a silhouette in an interior door's smoked-glass window.

His films were every bit as distinctive. Inspired initially by German Expressionist cinema, HItchcock developed a signature style of film-making, working almost exclusively within the suspense genre that he made his own. He returned over and over again to the same themes – fear of authority figures; overbearing mothers; false accusation, with innocent men drawn into desperate situations by malign fate; elaborately staged set-pieces and extended takes; his often cheeky cameo appearances in his own films. All of these characteristics would come to be bracketed together under the adjective "Hitchcockian".

Yet this consummate artist of the unashamedly popular cinema, for all his willingness to discuss at great length his technique and philosophy of the craft of movie direction, like some populist Eisenstein, professed (as would Allen decades later) a distaste for the actual process of film-making. Allen attributed this feeling to a discomfort in dealing with actors and a continual disappointment in the results compared to the image he had of the films in his head. However Hitchcock felt, or claimed to feel, that rendering the action on celluloid was almost redundant, as he had already created the films in the elaborate storyboarding sessions that preceded each production. Although he would generally employ a professional, specialist storyboard artist for the work, for when he contributed his own sketches they tended to be hastily prepared and very rough, Hitchcock himself was a gifted draftsman, and as his preparatory sketches for *The 39 Steps* (1935) prove, was capable of producing atmospheric work of high quality.

opposite The master of suspense poses in characteristically deadpan style for a publicity shot on the set of his 1960 proto-slasher masterpiece *Psycho*.

"PSYCHO" 9401
DIR. MR. HITCHCOCK
CAM. J. RUSSELL
1-29-60 DAY

TR 8 | 6

below Hitchcock's storyboard sketches for the climactic Mt Rushmore chase sequence in *North by Northwest*, a film that was originally called by Hitchcock and co-screenwiter Ernest Lehman *The Man in Lincoln's Nose*.

Leaving school in his early teens, Hitchcock went to work for the Henley Telegraph Company. He also attended night classes at the University of London, where he was tutored in life drawing and received a rudimentary education in the history of black-and-white illustration. The latter instilled in Hitchcock an enduring fondness for illustrators of the 19th and early 20th centuries, chief among them Thomas Rowlandson, whose works he would later collect, with other favourites such as Paul Klee and Walter Sickert. When this training came to the attention of his employers he was shifted to the telegraph company's advertising department, where he would churn out images over the next few years.

In 1920 Famous Players-Lasky opened a studio in North London, where Hitchcock went to work, initially unpaid, supplying the title cards for silent films. As he remembered when discussing his career with François Truffaut in the book-length interview *Hitchcock by Truffaut*: "At that time those titles were illustrated. On each card you had the narrative title, the dialogue, and a small drawing. The most famous of these narrative titles was 'Came the dawn'. You also had 'The next morning …' For instance, if the line read: 'George was leading a very fast life by this time', I would draw a candle, with a flame at each end, just below the sentence. Very naïve."

above and opposite top Hitchcock's scratchy preparatory sketches for another of his trademark climactic face-offs at iconic, instantly familiar landmarks. Here the sequence of the fateful encounter between Kane (Robert Cummings) and Fry (Norman Lloyd) at the top of the Statue of Liberty in *Saboteur* (1942) is recognizable virtually shot by shot.

these pages Rare surviving testimony of Hitchcock's skill as a draftsman in his elegant, beautifully composed preparatory drawings for his seminal innocent-man-on-the-run thriller *The 39 Steps* (1935).

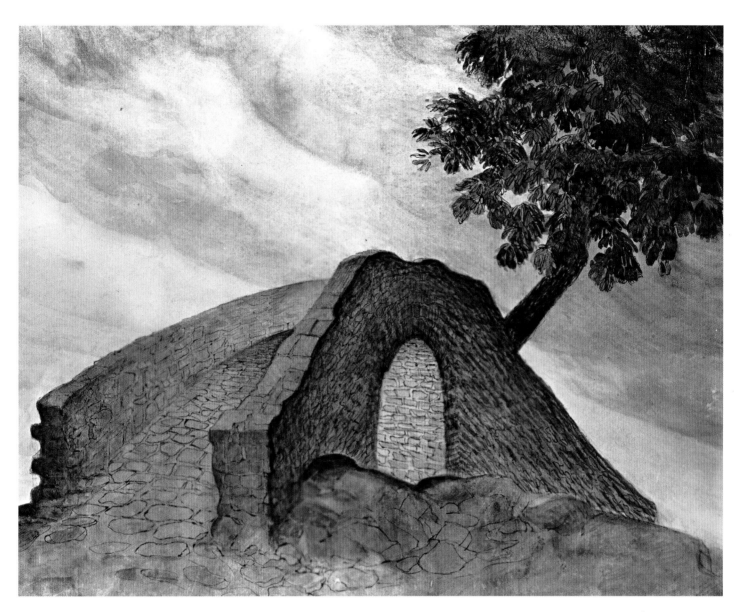

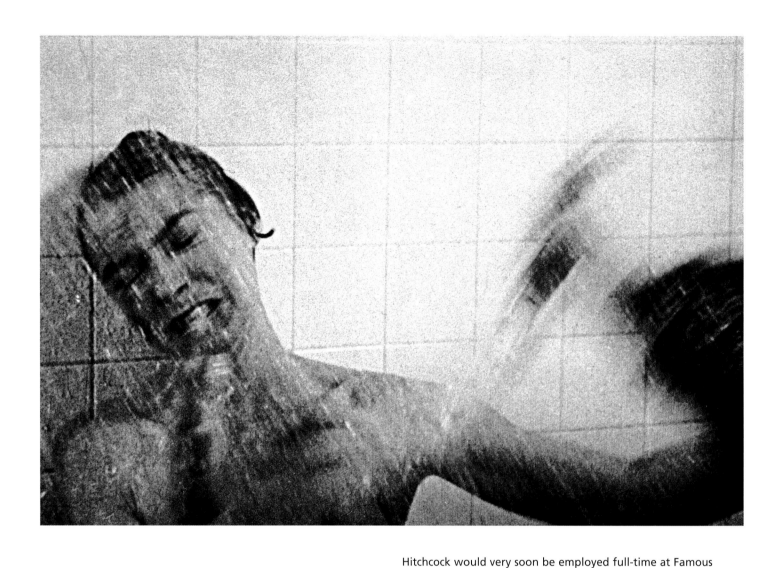

above In the much-imitated shower
sequence from *Psycho* (1960), Hitchcock
confirmed that he was a master of
cinematic shock as well as suspense.

Hitchcock would very soon be employed full-time at Famous
Players-Lasky and in time was made head of titles. In 1925, when
he was himself 25, he would make his solo feature directorial
debut with *The Pleasure Garden* (he had by that stage already
collaborated on a feature and worked alone on an incomplete
short film), before emerging as a gifted, richly imaginative film-
maker with his third release, *The Lodger* (1926). There followed,
some early hiccups aside, an extraordinary run of 50 features
over the next 50 years – including such masterpieces of suspense
as *The 39 Steps* (1935), *Notorious* (1946), *Strangers on a Train*
(1951), *Rear Window* (1954), *Vertigo* (1958), *North by Northwest*
(1959), and *Psycho* (1960) – as well as a shift into television
production in the 1950s. In the course of this unparalleled career
he would establish himself as the master of suspense,
later simply the Master.

Hitchcock has inspired countless film directors, some more
obviously than others, notably Brian De Palma, and also a number

of artists. Most recently, artist Douglas Gordon has made the remarkable *24 Hour Psycho* (1993), in which Hitchcock's seminal slasher movie is projected frame by frame. Of his own early illustrations, sadly none of his advertising work survives, nor any of the title cards from his Famous Players days. We do have a handful of his storyboards, rudimentary and otherwise, but also one of the iconic images of 20th-century cinema and television (right). The first known appearance of this sketch was in December 1927, when to mark Christmas as well as the first anniversary of his marriage to Alma Reville, who would contribute to all his films as script associate, Hitchcock sent to a chosen few friends and colleagues an intriguing wooden jigsaw puzzle wrapped in a linen bag. When assembled, these pieces formed the soon-to-be famous Hitchcock profile, a self-portrait that Hitch would refine to a simplified, nine-line sketch.

ABSOLUT HITCHCOCK.

above and left Hitchcock, the most immediately recognizable of all directors in the plentiful flesh, refined his signature self-portrait to just a few pen-strokes. This image itself acquired an iconic status through its appearance in the credits of his television shows, to the extent that advertisers could pay economical homage in just two lines.

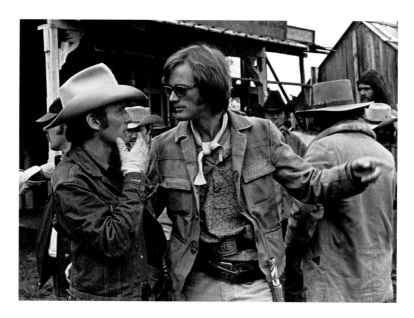

Dennis Hopper

b. Dodge City, Kansas, USA, 1936

Dennis Hopper is, and has been for nearly five decades, not merely a star, actor, producer, director, painter, and assemblage artist, but also a great art collector. He has amassed several collections over the years, his earlier ones being lost to a catastrophic fire and to almost equally costly divorces. His current collection, including paintings by Julian Schnabel, Jean-Michel Basquiat, and Andy Warhol, is housed in his home in the insalubrious neighbourhood of Venice Beach, Los Angeles.

When Hopper moved to Hollywood in his late teens, he was already a keen painter, a talent nurtured by his friendship with James Dean, who was himself a painter. Perhaps more significant still was Dean's encouraging Hopper to explore his artistic talents via a still camera, another of his own passions. The exhibition catalogue for *A Keen Eye* notes how Hopper recalled his friend telling him: "You gotta get out and take photographs. Learn about art, learn about literature, even if you want to be an actor." Dean was insistent that in his photographs Hopper use the whole frame, arguing: "Cropping is not a luxury a director would have." Hopper was shattered by the death of his friend and mentor in 1955, and his career nosedived when he fell out with director

above Dennis Hopper (left) and his collaborator/friend/nemesis Peter Fonda on the set of the sprawling, doomed, visionary folly or masterpiece *The Last Movie* (1971).

right *Untitled (paintbrush),* 1982. The series of paintings and assemblages created during Hopper's prolific period of 1982–83 share a sense of urgency, even incompleteness.

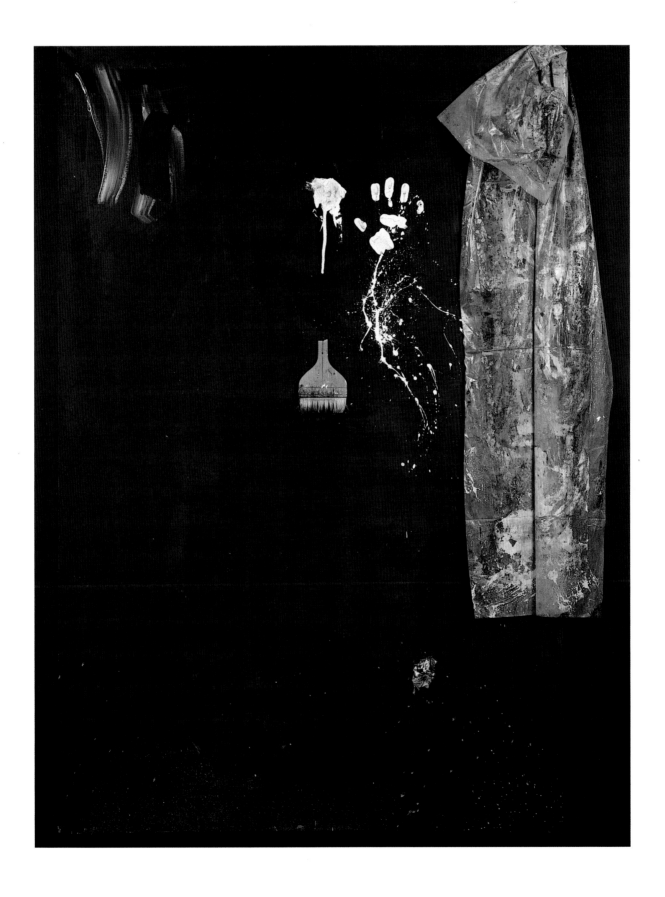

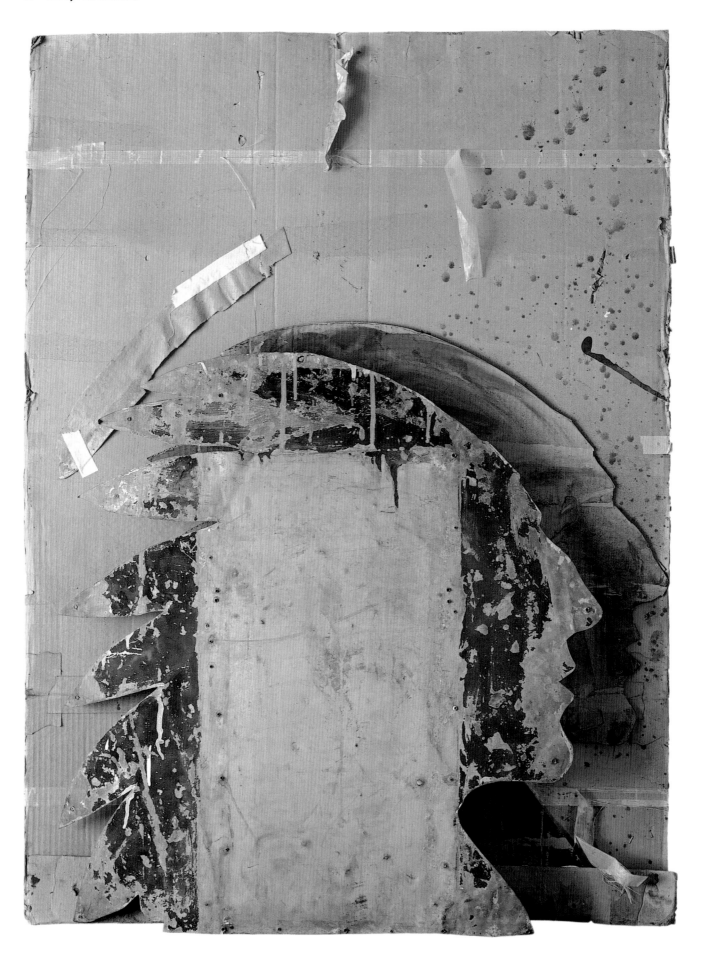

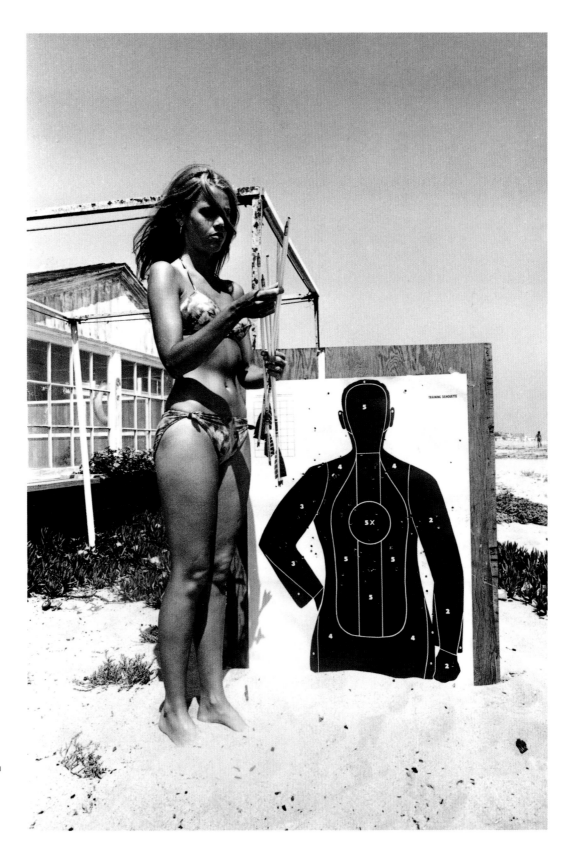

opposite *Untitled (cardboard, tin Indian),* 1982. Having all but abandoned his artwork following *Easy Rider* (1969), Hopper returned to the sphere of rough-hewn assemblages in which he had experimented throughout the 1960s.

right *Jane Fonda,* 1964. Hopper was both observer and participant, taking part in the Hollywood lifestyle of the 1950s and 1960s and chronicling it from within.

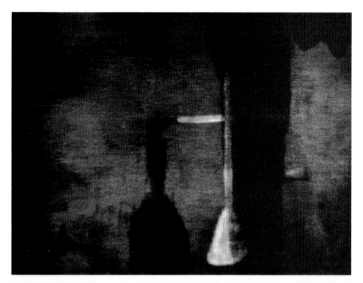

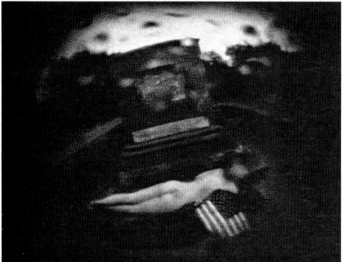

Henry Hathaway during the production of *From Hell to Texas* in 1958. There would be a rapprochement some years later, with Hopper taking small but telling roles in two further Hathaway westerns, *The Sons of Katie Elder* (1965) and *True Grit* (1969), but in the late 1950s, having barely started out in Hollywood, Hopper was effectively blackballed.

However, his removal from film-making allowed him to immerse himself in the art world on both coasts of the United States, first in Los Angeles, where he befriended and was profoundly influenced by the assemblage artists Wallace Berman, Ed Kienholz, and Bruce Connor, and then in New York with Andy Warhol, Roy Lichtenstein, and Claes Oldenburg. Works by these artists as well as by David Hockney and Peter Blake would be destroyed in the disastrous fire at his studio in 1961: more than 300 paintings in all, including many of his own pictures, were lost.

For a few brief years from the mid-1960s, Hopper would enjoy a richly fertile creative period. During this time he was acting regularly in mainstream Hollywood films as well as becoming part of the informal Roger Corman repertory company. At the same time he continued to experiment as a visual artist, painting and more often working on his assemblages, and all the while documenting with his still camera the life he was leading on both sides of the United States, hanging out with movie people, artists, and musicians.

This intensely busy and creative period reached a climax and a burnout with Hopper's respectively celebrated and reviled first two outings as a director. *Easy Rider* (1969) would turn into an era-defining, zeitgeist-surfing smash hit, one that has been credited with reshaping Hollywood and ushering in a new generation of film-makers and moguls. However influential it was, and however much money and kudos it earned for its co-writer-director-star, the production saw Hopper edging close to a breakdown, falling out with his friend and co-star Peter Fonda and many others involved in the project. His ego perhaps inflated by the success of *Easy Rider*, Hopper moved on to the ill-fated *The Last Movie* (1971), the overblown vanity project that would see his reputation damaged and his mental health further ravaged.

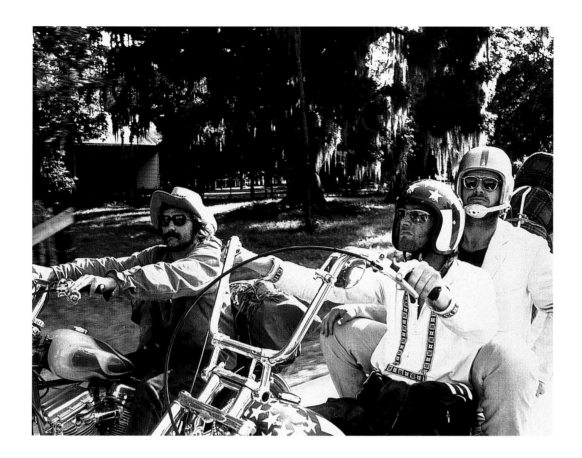

Despite a few striking appearances in a handful of films over
the next decade and a half – notably in *Tracks* (1976), *The
American Friend* (1977), and *Apocalypse Now* (1979) – Hopper
was supposedly in a bad way physically and professionally, and
his paintings and photography all but dried up during this time.
Significantly his rebirth, a process marked by his thus far greatest
performance in David Lynch's *Blue Velvet* (1986), also coincided
with his renewed interest in creating as well as collecting art,
which activities continue to the present day, albeit on a less
grandiose scale than in his youth.

Hopper has enjoyed a strong international following for his
art work over the past 15 years, coinciding with the renaissance
of his career on the big screen. In this time he has had his
photography shown at a number of solo and joint exhibitions
as well as having a retrospective exhibition of his paintings,
assemblages, and found objects alongside his photography under
the title *A Keen Eye* (2001). For all the occasional potency of his
work in other media, there is a sense that as a painter and

above Billy (Hopper), Wyatt (Fonda),
and George Hanson (Jack Nicholson)
as updated cowboys in *Easy Rider*, the
film that, for better or worse, changed
Hollywood forever.

opposite *Cemetery,* 1997. Hopper has
said, in a 1997 interview for *Artnews,*
that with this series of digitized video
stills taken from *Easy Rider*'s famous New
Orleans acid-trip sequence he is working
with "Duchamp's theory that the artist
of the future will simply point his finger
and say, 'That's art'."

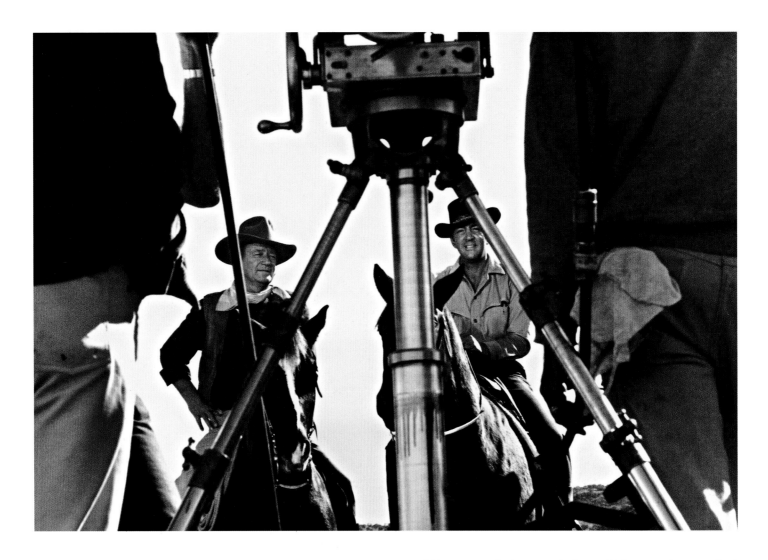

above *John Wayne and Dean Martin,* 1962. In this shot taken on the, for Hopper at least, troubled set of *The Sons of Katie Elder,* Hopper was starting to explore themes that he would tackle at length on *The Last Movie.*

overleaf *Roy Lichtenstein, Los Angeles,* 1964. The artists whom Hopper befriended and photographed in the 1950s and 1960s were so used to seeing him with his camera around his neck that they dubbed him "the tourist".

assembliste Hopper lacks a certain focus, his images often attached to other movements, most notably the Abstract Expressionism of the late 1950s. Yet he is unquestionably a gifted photographer, his finest images capturing either his friends and colleagues – Warhol, Paul Newman, Jane Fonda – or his appreciation for architectural form. An unerring ability to frame his pictures perfectly proves that he heeded Dean's early advice.

Hopper is a man whose yearning to create has led him in many directions, sadly sometimes many different directions at the same time. The interview *American Psycho* (*The Observer*, 2001) recalls that the actress Joanne Woodward once put it: "Dennis is a genius. I'm not sure of what, and I'm not sure Dennis knows of what. Certainly not acting. But he is a genius."

below *Untitled (Indian collage),* 1982. Hopper's work from this early period of his artistic and cinematic renaissance is marked by a mood of maniacal urgency.

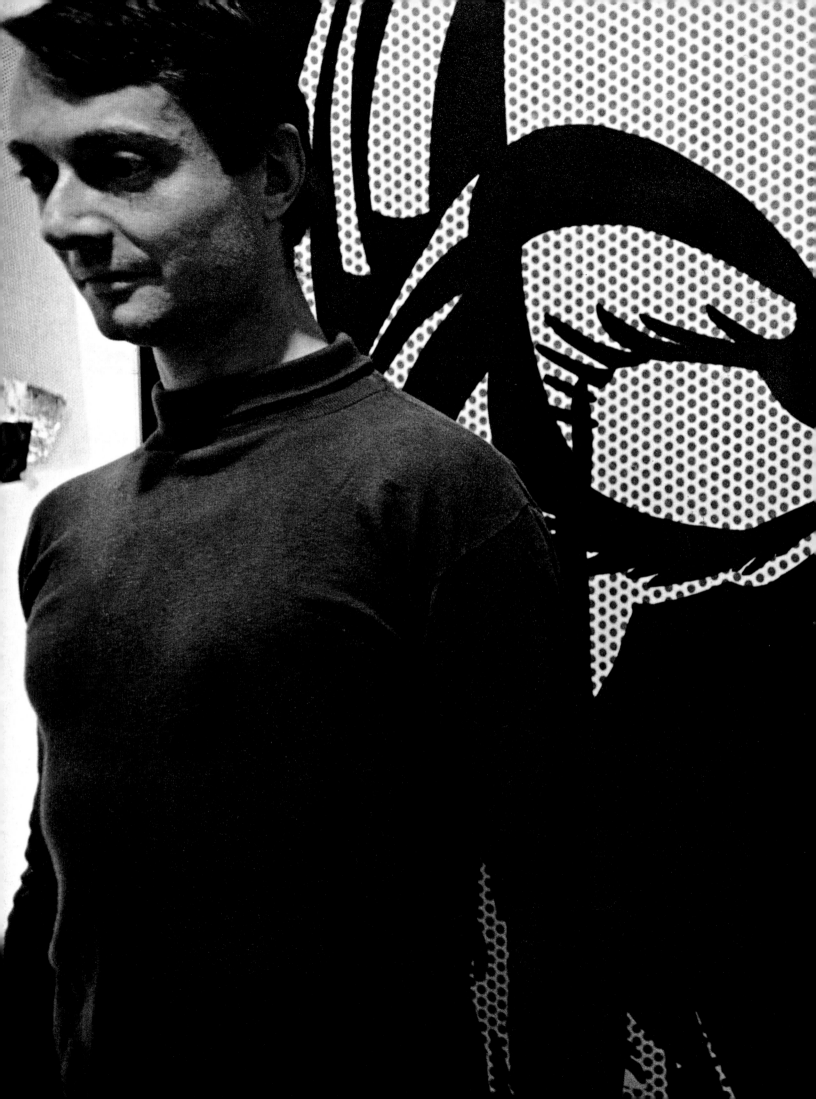

John Huston

b. Nevada, Missouri, USA, 1906
d. Middletown, Rhode Island,
USA, 1987

John Huston eventually followed, at least roughly, in his actor father Walter's footsteps, going to Hollywood and becoming a versatile writer and director for the big screen. From his astonishing debut in his mid-thirties with *The Maltese Falcon* (1941) to his swan song *The Dead* (1987), Huston was from start to finish a gifted storyteller. His films, which even his greatest fans would admit ranged wildly in quality from the distinctly ordinary to the magnificent, typically explore or at least touch on notions of masculinity. This was a central concern to Huston the man.

Before his glorious directorial debut, the film that confirmed Bogart as a tough-guy star and provided the first big-screen role for the redoubtable Sydney Greenstreet, Huston had been making a good living as a screenwriter. Notably he worked notably on Raoul Walsh's *High Sierra* (1941), another key film in Bogart's career, and Howard Hawks's *Sergeant York* (1941); later he would script Orson Welles's dark postwar thriller *The Stranger* (1946). The most important professional collaboration in Huston's

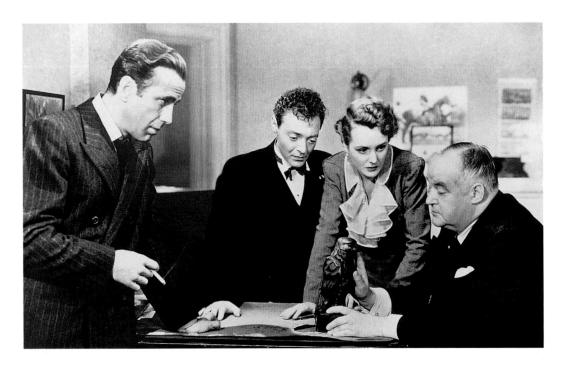

opposite *The Spirit of St Clerans,* 1960s. A vivid evocation of the hunts and the fishing trips that Huston relished during the 18 years he lived in St Clerans, his Galway country mansion, rather than of the house's other "spirit" – Daly, the ghost that was said to haunt the place.

left Sam Spade (Humphrey Bogart), Joel Cairo (Peter Lorre), Brigid O'Shaugnessy (Mary Astor), and Kasper Gutman (Sydney Greenstreet) contemplate the fake icon in Huston's astonishingly assured debut *The Maltese Falcon*.

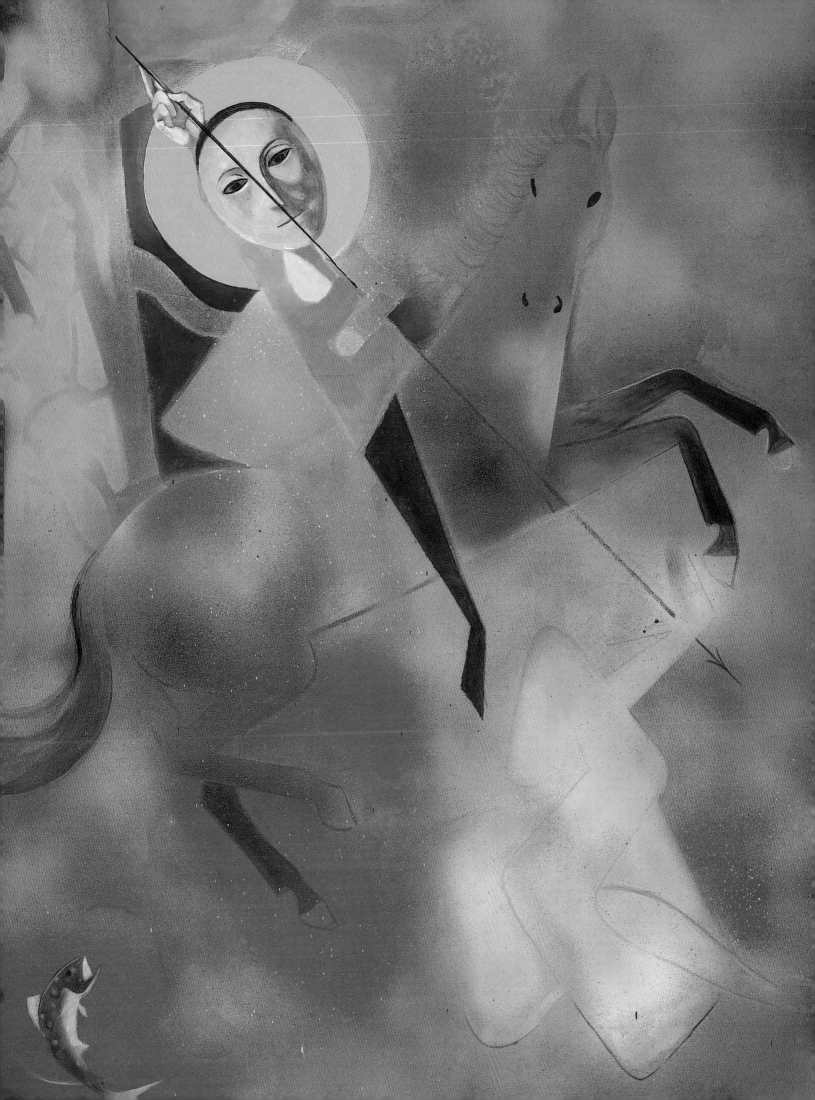

long career was with his friend and fellow macho carouser and adventurer Bogart, and together they would turn out the celebrated *The Treasure of the Sierra Madre* (1948), *Key Largo* (1948), *The African Queen* (1951), and the underrated oddity *Beat the Devil* (1953).

Although the 1960s began well with the brilliant and bleak *The Misfits* (1961), the pessimism of the film was appropriate, with its three stars (Clark Gable, Marilyn Monroe, and Montgomery Clift) all being close to death and its director set for a dismal run throughout the decade. His career was reborn with the grim boxing fable *Fat City* (1972), and remained on a reasonably even keel – the notable low point of *Escape to Victory* (1981) notwithstanding – for the remainder of Huston's life.

But things could have been very different. After a serious illness, or in Huston's opinion a minor illness wildly misdiagnosed, as a 10-year-old, the young director-to-be was all but bedridden for

several years. He emerged from his period "in the shadow of death" virtually reborn, with a determination to live an intellectually and physically full life thereafter. As a 15-year-old he was introduced to the sport of boxing, a passion he shared with his father, who would decades later co-star in *The Treasure of the Sierra Madre*. Soon afterward the young man developed an equally strong passion for painting, and as he wrote in his autobiography *An Open Book*: "Nothing has played a more important role in my life."

He was fascinated by the work of the Cubists, and the American school of Synchronism. He enrolled in the Smith School of Art in Los Angeles but was soon disillusioned with the aridity of the teaching and what he saw as the pointless, empty discipline of the life classes there. Within months he had dropped out of that school and fallen in with a group of like-minded artists in the Art Students League. He loved to paint then and would continue to paint throughout his life. One year George Gershwin would reproduce Huston's portrait of him as a Christmas card. Huston incorporated art studios into each of his homes, notably St Clerans in Galway, Ireland, a house that also contained much of his collection of art, ranging from Paul Klee paintings to his impressive hoard of Pre-Columbian art. But while still a teenager, Huston had given up on the notion of a career as an artist, believing that he would most likely starve, and turned instead to writing: his first short story was accepted for publication almost immediately, setting him on the path to artistic glory.

these pages Extracts from John Huston's sketchbook, 1956. These images, variously sweet, elegant, and naïve, but ultimately inchoate, are highly suggestive of Huston's state of mind as he prepared for *Moby Dick*, the film he had always dreamed of making; indeed he had planned to film it years earlier with his father Walter, who died in 1950, as Ahab. As Ray Bradbury, drafted in by Huston to rescue the screenplay, recalled: "He didn't know where we wanted to go. We were both children, hoping somehow to blunder through." (*The Hustons*)

Derek Jarman

b. London, England, 1942

d. London, England, 1994

Derek Jarman was born in 1942. His father, with whom he had an alternately distant and abusive relationship in his childhood (although they would become closer in later years), was a New Zealand-born squadron leader in the RAF, a frustrated, angry man who had some musical talent. His mother, to whom Jarman was close, was a gifted painter in her youth. In Tony Peake's biography he recalls of his childhood years: "Art was never mentioned in an academic context, but was a part of living in which anyone, whatever their ability or talent, could share."

After studying English and History of Art at King's College, London, where he encountered the works of gay cultural icons Allen Ginsberg, William Burroughs, Jean Genet, and Jean Cocteau, Jarman moved on to the Slade School of Art in 1963. There he refined his painting technique while exploring notions of what it was to be an artist. In one journal entry of the time, recorded in Peake's biography, he wrote: "The artist's life is one of self-revelation and destruction, he destroys his identity and is consumed by some ungovernable force, he might wish to lead a normal life but is incapable unless he destroys that which is his own existence." In this period he gradually edged into the field

left The artist as a young man: Jarman is pictured beside a self-portrait at his first exhibition, at Watford Public Library, 1959.

opposite *Drop Dead,* 1993. One of a series of large-scale, angry oil paintings created, with some help from his friends, by the dying Jarman.

right *Cool Waters,* 1965. One of several landscapes featuring *trompe l'oeil* effects and real attachments of a tap and rail that were exhibited at *The Young Contemporaries* show at the Tate Gallery, London, in 1967.

opposite *The Serpent,* 1989. At this time Jarman was doing much of his art work at his home in Dungeness, moving away from the monochrome that had dominated his work for years, and integrating found objects into the paintings.

of theatrical design. At the same time he became increasingly open in his homosexuality and moved into the social and artistic circle at the centre of which were his friends and mentors, the designer Ossie Clarke and the painter David Hockney.

Jarman's professional career began auspiciously in 1967 with his designs for Frederick Ashton's *Jazz Calendar* at London's Royal Opera House, although his second commission, to create the sets for the production of *Don Giovanni* at the Coliseum that same year, proved to be a less happy experience. Meanwhile Jarman's stark black-and-white paintings were receiving favourable notices, and he was having his work regularly selected for exhibitions, and winning prizes or honourable mentions in art competitions. In an era of national and international social upheaval, and although ostensibly apolitical himself in these early years – by

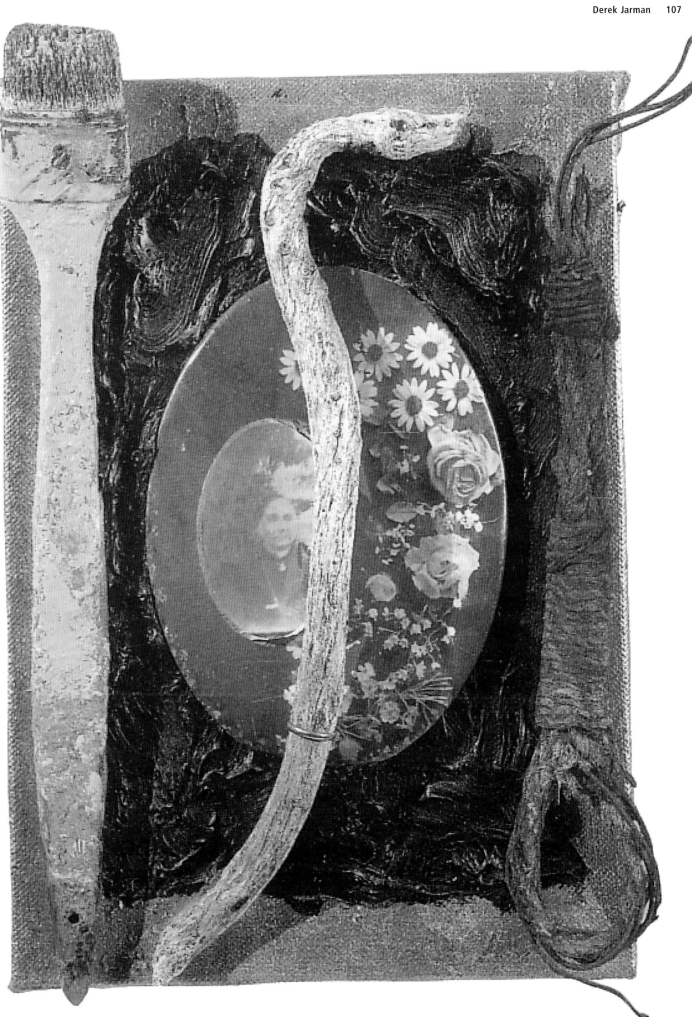

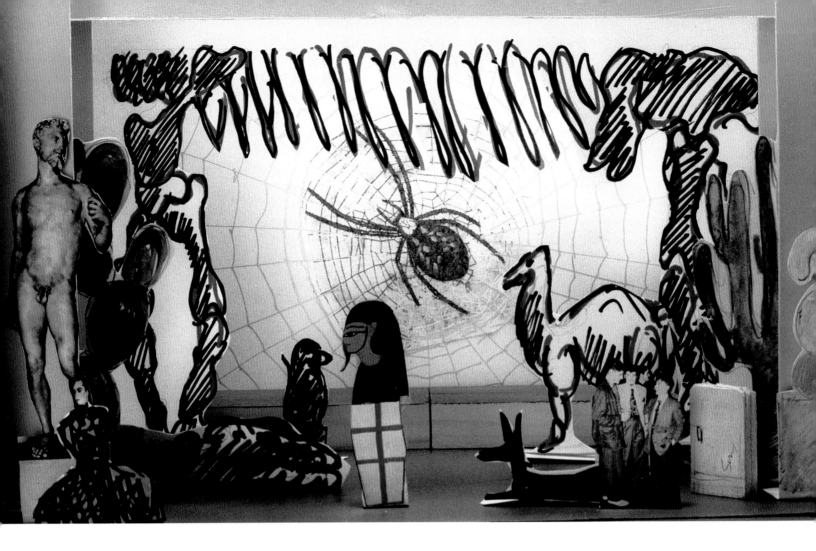

above Design for *The Rake's Progress,* 1982. One of Jarman's designs for Ken Russell's production of Stravinsky's opera *The Rake's Progress,* which was performed by the Teatro Comunale company at the Teatro della Pergola, Florence, Italy, in 1982.

the end of his life he would have become an astute activist – Jarman clearly thrived as an increasingly visible member of a group that was itself part of a wider, radical, counter-cultural, sexually liberated movement.

At the beginning of the 1970s came the commission that would launch the next chapter of Jarman's creative life. The director Ken Russell, impressed by Jarman's work for Ashton, hired him as set-designer for his film *The Devils* (1970). Jarman would continue to produce paintings throughout the 1970s and beyond – and would continue to exhibit – but much of his energy from this point on was shifted into film-making. Having completed his striking designs for *The Devils*, which, although created within the constraints of a frustratingly tight budget, collectively constitute one of his most significant achievements, Jarman immersed himself in making short Super 8 films. Many of these stood on their own, while others, including those from his childhood, would be incorporated into his later features. Increasingly wrapped up in film work, Jarman still continued with other artistic ventures, for instance collaborating with Dom Sylvester Houédard on a sculpture entitled *Grass Poem* which was inspired by one of Houédard's whimsical, druggy poems.

Jarman made his feature debut with *Sebastiane* (1976), which, boasting – uniquely – a screenplay entirely in Latin, tells the playful, homoerotic story of the last days in the life of the Christian martyr. This he followed with the angry but inchoate punk satire *Jubilee* (1978) and his intelligent, underrated version of *The Tempest* (1980).

Despite the critical success of his first three films – although they were far from unanimously well received – Jarman spent the years between 1979 and 1985 seeking funding for his next, cherished project, *Caravaggio* (1986). He spent this time fruitfully, creating more Super 8 films, directing music videos, and, having taken up painting once more in 1981, producing a number of bleakly rendered, apocalyptic landscapes. He gradually ventured into more colourful areas, with flashes of red and gold leaf adorning his nude studies, and created several elaborate installations, these featuring in a 1984 exhibition at the ICA (Institute of Contemporary Arts) in London. Jarman was also nominated for the Turner Prize (an annual award to a British artist under 50) in 1985, for which he produced a short series of gloomy paintings-cum-collages, incorporating broken glass, candles, and religious imagery, eventually losing to Gilbert and George.

above Design for *The Rake's Progress,* 1982. This commission, accepted by Jarman at a time when he was broke, and completed in haste, required him to update the story from its 18th-century setting, allowing him to vent his spleen against Britain's then prime minister, Margaret Thatcher.

right Still from *Blue,* 1993. *Blue* is Jarman's powerfully moving valedictory film in which the director, reciting his own poetry, muses on life and death while the fixed blue screen represents his own failing sight.

opposite *Dead Sexy,* 1993. One of three paintings Jarman and his helpers created on Wednesday 19 May, 1993, as he records in his journal: "*Dead Sexy* was the favourite, though I like *Arse Injected Death Syndrome.* Richard made us all a smoked salmon lunch."(*Derek Jarman,* ed. Keith Collins, Century, 2000.)

After *Caravaggio,* a relatively opulent exploration of the (according to the film at least) gay artist's life, Jarman made a virtue of his limited resources, moving on to the savage state-of-the-nation piece *The Last of England* (1987), the first of several films to be shot partly or entirely on Super 8. In his last years, in the aftermath of his diagnosis with Aids, Jarman became ever more prolific, his attitude more urgent, his work ever angrier and more ambitious, but his focus clearer. His films from this period are the elegiac *War Requiem* (1988), perhaps his most accomplished work; *The Garden* (1990), a poignant, deeply personal piece; *Edward II* (1991), a vigorous updating of Marlowe; *Wittgenstein* (1993), a short and witty biopic of the great philosopher, and his extraordinary valedictory piece *Blue* (1993). He also collaborated with the pop group The Pet Shop Boys, having previously worked with The Smiths, and created his famous garden at his home in Dungeness, Kent. In his art work – paintings and installations – he dealt directly with his own illness and the sense of outrage he felt at the shabby treatment by the media and the government of people with Aids.

Takeshi Kitano

b. Tokyo, Japan, 1947

Takeshi Kitano, a renaissance man of modern Japanese pop culture, was born in Tokyo in 1947. Like Alan Parker, Takeshi was born to a painter-decorator father, but one who had left his original trade as lacquer craftsman for financial reasons. Takeshi's childhood seems to have been a miserable one, with him and his siblings being subject to their father's violent outbursts. His father would decades later become the basis for the central character in the eponymous *Kikujiro*. His mother was compassionate but strict, encouraging the children to study hard. After school, Takeshi moved on to Meiji University, where he studied engineering.

At university he became something of a beatnik, developing a fondness for jazz and existentialism. He dropped out and took on a number of menial jobs – taxi driver, labourer – while dreaming of making it as a stage performer, specifically a comedian. He was taken on as an apprentice comic, and forged a partnership with Jiro, another young stand-up. The pair styled themselves The Two Beats (hence Takeshi's stage name, Beat Takeshi, which he still uses as an actor) and emerged gradually as a cult success with their outrageous, often obscene stage act, which in time they brought to television.

above With this painting (from *HANA-BI)* Takeshi started out expressly trying to emulate Van Gogh's *Sunflowers*, but he turned the picture into a visual joke once he realized that he couldn't quite match his model.

One in a series of serendipitous or otherwise fateful events in Takeshi's colourful career occurred in 1982, when Nagisa Oshima took a risk on the young comic and cast him against type as the brutal Hara in *Merry Christmas, Mr Lawrence*. Although he was unknown outside Japan, in his native land Takeshi's fame as a comedian affected him adversely, with the audience reputedly hooting with laughter at his every appearance on screen, whatever the violence perpetrated by his character.

But at this time, and whatever the quality of his performance, Takeshi's fame was pretty much restricted to Japan, and the nature of that fame was as a comic and television presenter – he remains to this day a popular quiz show host. This made his next sideways move equally dramatic, when he emerged as a gifted film-maker on his directorial debut with *Violent Cop* (1989).

As his film career developed, through the stylish existential thrillers *Boiling Point* (1990) and *Sonatine* (1993), and less characteristic works such as the low-key surf movie *A Scene*

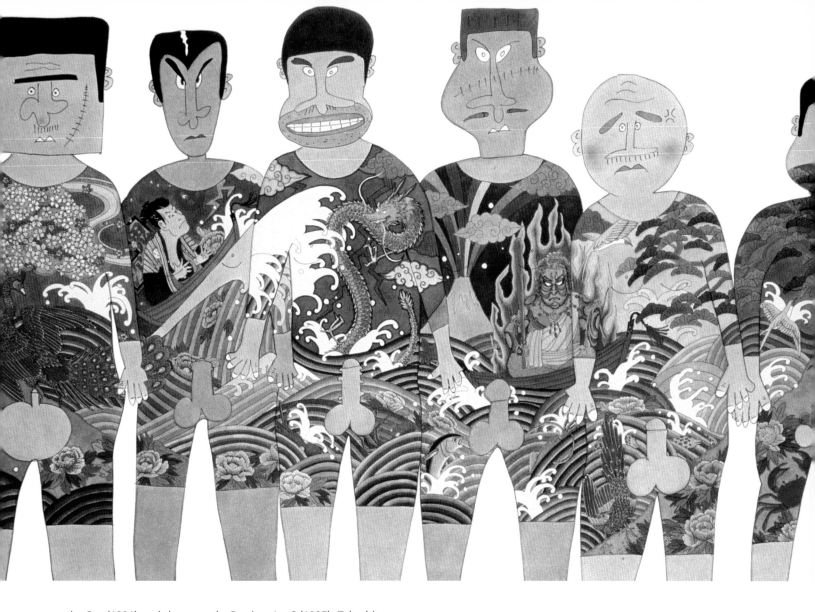

at the Sea (1991) and the comedy *Getting Any?* (1995), Takeshi somehow managed to be Japan's equivalent simultaneously of Chris Tarrant (a much-loved British comedian and game show host) and Quentin Tarantino. Significantly his films were, particularly in the first part of his big-screen career, very much less successful at home, where they continued to appear in stark contrast to his reputation as a light entertainer, albeit an oxymoronically tough light entertainer.

The next turning point in Takeshi's remarkable life, and the one that led directly to his sudden, indeed instant, flowering as a painter, came on the night of 2 August 1994. Having completed his role in the dire Keanu Reeves vehicle *Johnny Mnemonic*, Takeshi had a few drinks and went for a ride on his new motorbike. He crashed into a barrier at speed, fracturing his skull and cheekbone and knocking himself unconscious. In the aftermath of this near-fatal accident he admitted that he was not sure where he was going on his bike that night – or even whether or not it had been a suicide attempt.

above Another of the director's own paintings attributed in *HANA-BI* to the paralysed cop Horibe, this image fuses the two apparently distinct halves of Takeshi's persona – the irreverent comedian and the *auteur* of the yakuza movie.

Takeshi all but willed the accident to have life-changing implications, and recalls of its aftermath, in *"Beat" Takeshi Kitano*: "I even thought that my brain structure might have been changed and that it might make me more artistic. It even convinced me to start painting." He made a successful return to film-making the following year with *Kids Return* (1996), but his greatest triumph, the masterpiece of his career thus far, came in 1997 with *HANA-BI*, in which he took the leading role as Nishi, a retired cop who alternates between acts of casual but extreme violence and tenderness in caring for his sick wife. Takeshi had been planning this film before his accident, but his brush with death clearly informs the action and mood of the film. It is also significant that many of the paintings he created during his

convalescence are woven seamlessly into the action of *HANA-BI*, presented as the art work created by Nishi's wheelchair-bound former partner Horibe. As Takeshi remembered when speaking to J. Hoberman in the March 1998 issue of *Interview* magazine: "Strangely enough, all the paintings I had done fit into the story." Indeed there was something perfect about these dreamy images in which flowers meld with animals, dovetailing with the film's title, which consists of the Japanese word for fireworks broken down into its constituent parts: *hana* (flower), *bi* (fire).

It is typical of Takeshi's self-assurance that his inspiration in his debut art work was expressly Van Gogh. He set about trying to imitate Van Gogh's *Sunflowers*, but as he recalls it was something

of a failure. Disappointed that he was not from the outset perfectly able to recreate the most famous painting of a creative genius, he remembers in *"Beat" Takeshi Kitano*: "So I painted a sunflower on a lion's head as a gag. They were perfectly matched." What he came up with was a series of dazzlingly bright, often ironic, primitivist, cartoonish paintings: images that stand in stark contrast to the "Kitano blue" that has been identified as the trademark look of his films, especially his early films.

Even before the pictures had made it into *HANA-BI*, Takeshi's art work had appeared in the Japanese art magazine *Geijutsu Shincho*. Takeshi has continued to build on his reputation as a talented film-maker with *Kikujiro* (1999), which features his striking angel paintings, *Brother* (2000), his first film to be shot in the United States, and *Dolls* (2002). While there is a distinction made between Takeshi Kitano the genius *auteur*, and Beat Takeshi the comic and presenter, we await a fitting sobriquet for Takeshi the creator of touching, playful, vividly colourful, often death-fixated paintings.

above A happy collision of the director's art work, the theme of his film *HANA-BI*, and the wider relationship between art and the audience, with the family depicted delighting in the beautiful violence of the fireworks.

opposite Another of Takeshi's/Horibe's paintings from *HANA-BI*. The snow is made up of hundreds of copies of the Chinese pictogram for snow. The blood-red symbol at the heart of the image means suicide.

previous page The cartoon-like angel that first appeared in *HANA-BI* becomes a motif and symbol of redemption in *Kikujiro*, in which a child is repeatedly characterized as an angel, a divine healer.

Stanley Kubrick

b. New York City, USA, 1928

d. Harpenden, England, 1999

Stanley Kubrick's reputation as one of the great visionary film-makers of all time rests on a paltry-sounding output of just 13 feature films in a career that lasted nearly half a century, from *Fear and Desire*, his low-key, low-budget debut in 1953, to his final and much misunderstood masterpiece *Eyes Wide Shut*, released posthumously in 1999. But from his breakthrough film *Paths of Glory* (1957) onward there was always a strikingly distinctive quality about his films that set them, and him, apart. It had something to do with the often notorious meticulousness of his approach – it has been said that the pressure that he exerted on Shelley Duvall while making *The Shining* in 1980 led the actress to a period of semi-retirement. This was itself linked to his very particular form of intellectual inquisitiveness and a film-making talent that sought something close to the patently impossible quality of perfection in the creative process.

above In his shot of CBS television presenter Ken Murray, in New York, 1952, Kubrick's eye is drawn to the film camera itself every bit as much as it is to his human subject.

Kubrick's films are apparently wildly diverse in terms of milieu and genre, running as they do from the jet-black comedy of *Dr Strangelove* (1963) via the complex, visually crisp futurism of *2001: A Space Odyssey* (1968) to the overblown horror of *The Shining* (1980). None the less, there are certain thematic concerns and ideas running through them all.

One overriding theme links the movies to the myth of Kubrick the film-maker, crossing over between the films themselves and the conditions in which they were made: they are uniformly clinical examinations of the characters, of men and mankind *in extremis* – he repeatedly dealt explicitly with war and other human conflict – and there is a very deliberate, carefully achieved coldness in all of Kubrick's work. This sense of detachment has its roots, or at least first manifested itself, in Kubrick's early forays into the field of visual expression – in photography.

Stanley Kubrick was born in Manhattan in 1928, and grew up in a comfortable, conventional middle-class house in the Bronx, his

above The popular singer Peggy Lee, herself a native of North Dakota, photographed during a parade in Valley City, North Dakota, some time in the late 1940s.

above Frank Sinatra photographed
during a visit to WLEE Radio Station
in Richmond, Virginia, in the late 1940s.

father a well-to-do doctor. Always attracted by the notion of making movies, the young Kubrick, at best an unexceptional student, developed a fondness bordering on obsession for both chess and jazz. But it was the gift he received on his thirteenth birthday that was to set him on the path to greatness. His father gave him a Graflex camera, literally a heavyweight machine – weighing in at nearly 4 kg (nearly 9 lb) – and photography quickly became the central passion of his life. The young Kubrick and a friend, also a keen photographer, would travel around the Bronx with the camera secreted in a customized paper bag so that the future *auteur* could take candid shots of the people in his neighbourhood.

The hobby had become a profession even before Kubrick graduated from school when, while walking to Taft High one day in April 1945, he came across a news-stand poster carrying

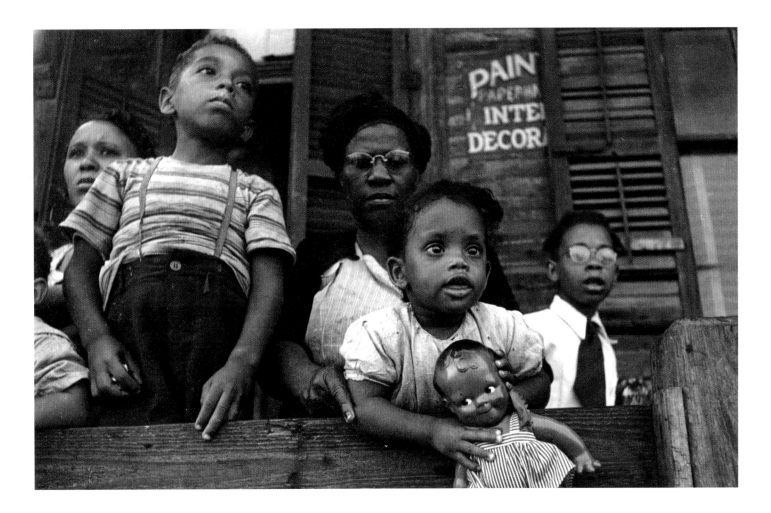

the announcement of the death of President Franklin D. Roosevelt. The story goes that Kubrick took a photograph of the stand along with the grieving vendor and, having developed the picture, rushed to the offices of *Look* magazine, whose picture editor was so impressed that she offered the prodigy $25 for the shot – an offer he accepted after first checking that no one else would pay more. If this were not evidence enough of the young man's self-assurance and chutzpah, even this early there is also a suggestion of Kubrick the nascent control-freak artist: friends recall that the shot had in fact been carefully set up, the newspaper vendor assuming his gloomy pose only on Kubrick's express instructions.

On leaving high school that same year, Kubrick was offered (having eagerly petitioned for it) the position of apprentice photographer on *Look*, and over the next five years the young

above Watching a marching band, New Orleans, 1952: the image derives a certain potency from the incongruous sight-line of the woman at its centre, who stares directly towards the camera.

man – who would remain throughout this time *Look*'s youngest staff photographer – was given a succession of increasingly prestigious commissions for the magazine. His photographs were always meticulously composed, and although sometimes playful – and one should never overlook the humour in Kubrick's movies – they were generally characterized, again as the films of the mature director would be, by a certain emotional distance between the photographer and his subject. It is no coincidence that Kubrick's declared hero as a photographer was the famous ambulance-chaser Arthur Fellig, who came to fame under the pseudonym Weegee for his often chilling photographs of New York's underbelly, most notably images of the immediate aftermath of violent crimes. Kubrick would later hire Weegee as stills photographer when he came to make *Dr Strangelove*.

During his time at *Look*, Kubrick alternated commissions from the magazine with jobs that he himself originated, the latter

right In one of his three masterly comic performances, Peter Sellers is the eponymous presidential adviser in *Dr Strangelove* (1963), a character often, though probably erroneously, said to have been based on Henry Kissinger.

including a whimsical but supposedly candid series of shots of a girl being approached by an amorous boy at a cinema, which he published under the title *A Short-Short in a Movie Balcony*. In fact, this photo story was, like the Roosevelt picture before it, carefully set up.

From the outset, however, still photography was a stepping stone for Kubrick. One of his most striking spreads for *Look*, published under the title *Prizefighter*, saw Kubrick following the middleweight boxer Walter Cartier around on the day of a big fight. The story appeared in early 1949. The following year he repeated the exercise, this time capturing Cartier's activities on a moving camera. The result, the short documentary *Day of the Fight*, marked Kubrick's retirement from professional still photography and quietly announced the start of one of the great directorial careers.

above A judge scrutinizes a desperate male competitor and his exhausted partner at a dance marathon, probably in New York, in the late 1940s.

overleaf Three smokers, department store, New York City, late 1940s. As so often in his photo-reportage work, Kubrick is at his most comfortable when carefully composing the shots himself.

Akira Kurosawa

b. Tokyo, Japan, 1910
d. Tokyo, Japan, 1998

In his youth, Akira Kurosawa, undoubtedly the key figure in popularizing Japanese cinema around the world, had dreamed of becoming an artist. His talent for drawing was encouraged by one of his key early mentors, a primary-school teacher who taught him from the age of eight to ten. Kurosawa continued to harbour these dreams and, at his father's insistence, complemented his artistic education with a course in calligraphy. On leaving high school at the age of 18, he managed to get one of his paintings, entitled *Seibutsu*, accepted for the Nika Exhibition, a prestigious annual art festival that began in 1914, but he failed to take his formal training any further. Many biographies specify Kurosawa's further education at an art school dedicated to introducing nascent Japanese artists to the Western style, and although this piece of biographical detail fits in nicely with the notion of cultural exchange between East and West that would be a feature of Kurosawa's career as a film-maker, sadly it is not true.

When asked in interviews why he had not made a career for himself as a painter, Kurosawa would routinely reply that it

above The overkill climax of *Throne of Blood*, Kurosawa's transposition of *Macbeth* to medieval Japan, with Washizu (Toshiro Mifune) turned upon by his own troops.

opposite *Village of the Windmills* from *Akira Kurosawa's Dreams*, 1990. The sketch and the sequence in the film to which it relates reveal the director's lifelong devotion to Van Gogh.

水車小屋の老人

was simply because he failed the entrance exam. He was indeed
rejected by the prestigious art school to which he applied –
again at his father's insistence – but he nevertheless remained
determined to become a professional artist. Unable to gain a
formal training, he embarked on an informal one with the true
dedication of an autodidact, visiting art galleries, and as with his
passion for the cinema, which his father had alternately tolerated
and encouraged from an early age, he was as fond of Western
artists as of traditional Japanese painters. His passion for Van
Gogh in particular would become evident in his penultimate
film, *Akira Kurosawa's Dreams* (1990), in which the elderly
director meets the artist, as played by the Kurosawa-worshipper
Martin Scorsese.

At the same time as struggling, for the most part unsuccessfully,
to establish himself in his chosen profession of artist, Kurosawa
became something of a political radical, taking up with the group
known as the Proletarian Artists' League. He would later happily
admit that his political activism was scarcely intellectually
grounded, but more the posturing of an angry and frustrated
post-adolescent. His radicalism lasted barely into his twenties,
while his career as a painter stumbled on for a few more years,
as he scraped by on a few scant commissions from popular
magazines. Yet he had a talent with a strong impressionistic slant,
as evidenced by his later preparatory sketches for his films,
notably for *Kagemusha* (1980) and *Dreams*.

The most important decision of Kurosawa's professional life was
taken when, as a 25-year-old in 1935, and having never previously

right *Mount Fuji in Red* from *Akira
Kurosawa's Dreams,* 1990. Once again the
director is paying homage to Van Gogh,
leading one critic, Stuart Klawans, in the
exhibition catalogue for *Akira Kurosawa's
Drawings* to heap praise on Kurosawa for
achieving "something that one might
have thought impossible – painting a
convincing follow-up to *The Starry Night*".

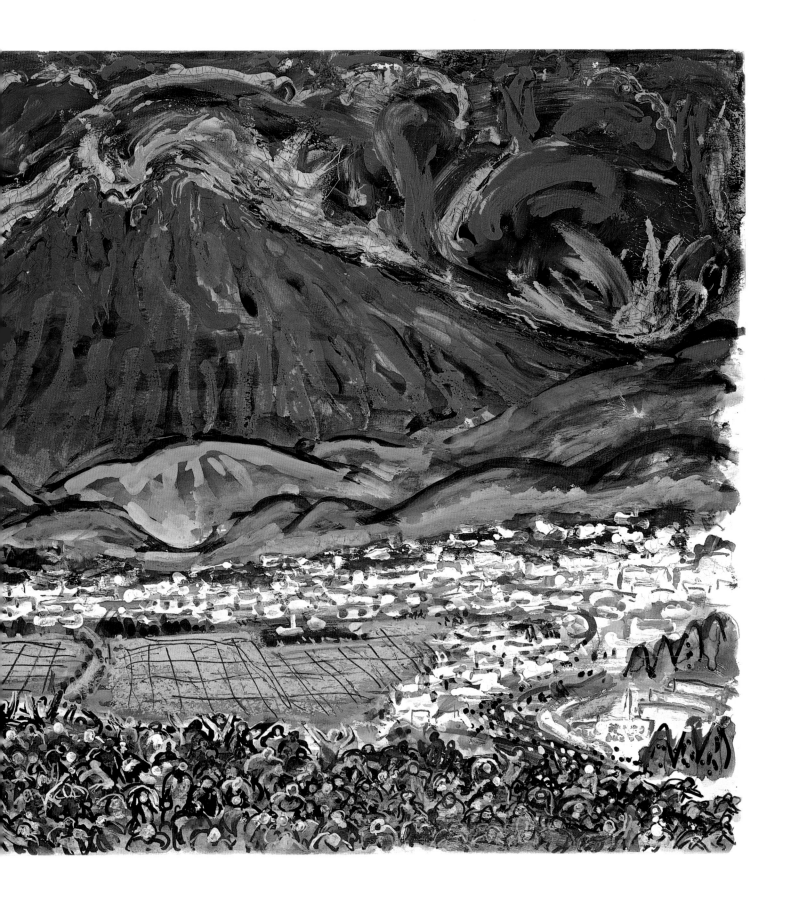

contemplated a career in films, he answered an advertisement
from Photo Chemical Laboratories seeking trainee assistant
directors. He was accepted and, taking up his post early the
following year, undertook an apprenticeship with the
established director Kajiro Yamamoto that would set him on
his path to greatness.

By the closing years of the Second World War – he was excluded
from active service having failed the medical – Kurosawa had
embarked on his career as a director, starting out in propaganda
films. By the end of the 1940s he had emerged as a film-maker
of note, had established his signature style, and, in casting
Toshiro Mifune in *Drunken Angel* (1948), had initiated the most
important collaboration of his career. In Mifune, Kurosawa had
found his ideal star, and the two would work together on a

above Design for *Kagemusha,* 1981. It
was during the preparation for *Kagemusha*
that Kurosawa once again took up his
brush, recalling in the exhibition catalogue
for *Akira Kurosawa's Drawings*: "The fear that
it would not be realized at all drove me to
record my ideas for the film on paper."

further 15 films up to *Red Beard* in 1964, *Ikiru* (1952) being
Kurosawa's only great film of this period not to feature the actor.

Kurosawa was, like his friend Satyajit Ray, a fundamentally
humanist film-maker, but he was also a great visual stylist, his
films marked by a painterly quality, and he had an unmatched
talent for staging fights and action set-pieces. His work being
marked as much by Western as by Eastern influences, it is fitting
that his films should have been reappropriated by Hollywood and
European film-makers: his samurai movies provided the source
material for Sergio Leone's *Dollars* cycle and John Sturges's *The
Magnificent Seven*, among others.

Mifune and Kurosawa claimed that their friendship and mutual
admiration remained undimmed by their professional separation

above Design for *Kagemusha,* 1981.
Of the many hundreds of sketches he
created for the films from *Kagemusha*
onward, Kurosawa recalled modestly in
Akira Kurosawa's Drawings: "To create skilful
pictures was not my intention. Rather,
these are tiny fragments of my films."

right Another eye-catching homage to
Van Gogh in a sketch for *Akira Kurosawa's
Dreams* (1991), for the sequence in which
Martin Scorsese would eventually play the
Van Gogh character.

信玄

影法師

above Design for *Kagemusha*, 1981.
The image illustrates the film's central
conceit, based on documented events,
whereby a warlord employs a double,
or *kagemusha*, as a decoy to baffle
the enemy.

in the mid-1960s, but Kurosawa's career entered a problematic
period from which he took a long time to emerge. Shortly after
the release of his first colour feature, *Dodes'Kaden* (1970),
Kurosawa attempted suicide (his beloved elder brother had killed
himself before Kurosawa's film-making career had begun).

He slowly recovered, and in his old age he had the energy for
three further, albeit flawed, masterpieces, in *Dersu Uzala* (1975),
Kagemusha, and *Ran* (1985). This last production was facilitated
financially by the intervention of George Lucas and Francis
Coppola, eminent members of the movie brat generation that
revered the work of Kurosawa (John Milius boasts of having seen
The Seven Samurai [1954] more than 50 times). Kurosawa had
also experienced particular problems in securing finance for

Kagemusha, and it was at this time, *in extremis* – indeed in
something close to despair – that, having as a young man
determined that he could not pursue simultaneous careers as
both painter and film-maker, Kurosawa finally managed to
fuse his two life-long artistic passions, resuming his career as
a draftsman, but now in the cause of his film-making. In the
prolonged periods of pre-production on each of his remaining
films he would turn out hundreds of illustrations – around 1,200
in total over a period of 18 years. One can discern something of
a joyous frenzy in these often elaborate, strikingly attractive
sketches in paint and pastel. Kurosawa's final five films were
realized with the use of detailed preparatory sketches created in
his trademark style – a style owing a clear debt to Van Gogh and
the Impressionists, but one that is also distinctively his own.

above Sketch for *Ran*, 1985. This striking
pastel is one of the images that featured
in an exhibition at the Pompidou Centre in
Paris to coincide with the release of *Ran*.

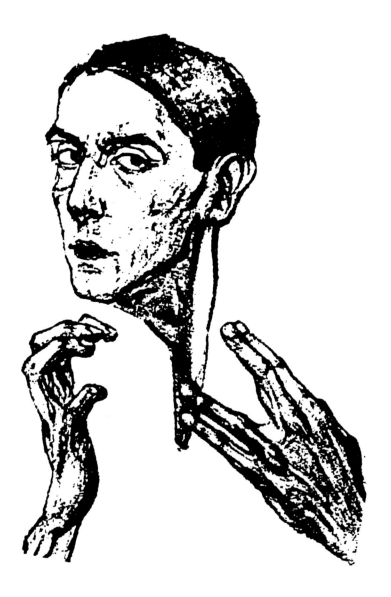

Fritz Lang

b. Vienna, Austria, 1890
d. Los Angeles, California,
USA, 1976

Fritz Lang is one of the great figures in international cinema,
a director – possibly even, in that currently unfashionable term,
an *auteur* – whose thematic concerns and narrative control
remained consistent as he moved from genre to genre, his career
divided into three distinct phases. Lang began as a screenwriter,
very soon becoming a director, in the immediate aftermath of
the First World War, attracting widespread admiration for his
early feature *Der Müde Tod* (*Destiny*, 1921), and international
acclaim for his two great masterpieces of German film, *Metropolis*
(1926) and *M* (1931). What happened next is still open to debate.

above Fritz Lang's early intense
self-portrait made in the style of his
contemporary, compatriot, and hero,
Egon Schiele (1890–1918).

opposite Lang at work in his studio.

What is clear is that Lang was courted by the movie-loving Goebbels, a great admirer of Lang's 1924 film *Die Nibelungen*. Perhaps (although not necessarily) unaware of the director's Jewish ancestry, Goebbels saw Lang as a vital figure in the Nazi propaganda machine. Whatever the precise reasons for his hasty departure, in 1934 the director fled, first to Paris, then on to Hollywood and the second phase of his career.

There, although often in conflict with what he saw as interfering producers and studio bosses, he turned out a succession of taut, intelligent genre pieces, chief among them *The Woman in the Window* (1944), *Scarlet Street* (1945), *Rancho Notorious* (1952), and *The Big Heat* (1953). Finally, disillusioned by his experiences in making the superb *Beyond a Reasonable Doubt* (1956), Lang turned his back on Hollywood for a brief valedictory period of working in India, before returning to an extended retirement in Beverly Hills, although not an uninterrupted one – see his starring role as himself in Godard's *Contempt* (1963). But Lang's first artistic love was painting.

It is hard to work out the extent of Lang's achievements as an artist, by which I mean painter, for several reasons. Little of the work from his time as a professional artist survives; and secondly Lang, like Federico Fellini and Orson Welles, was acutely aware of the importance of mystery and mythology to the reputation of an artist – here in the broader sense. In interviews he constantly reinvented and embellished his achievements, particularly those from the pre-First World War days.

Lang was born to a prosperous Viennese family in 1890. His mother, a woman of artistic pretensions, was of Jewish extraction; his Roman Catholic father was a partner in a successful building company, and not, as Lang would later boast, a famous architect. Growing up in an opulent house, surrounded by works of art – the walls were hung with oil paintings and watercolours, the house crammed with ceramics – and exposed to the artistic soirées his parents hosted, Lang resolved to become a painter.

above and right While precious little evidence remains of Lang's extensive painting undertaken in the pre-First World War years, several examples of his sculpture survive, among them this bust of Bacchus and an ornamental vase.

In his late teens, while pretending to his parents to be attending science classes, he was in fact spending much of his time at

right Maria, the perfect robot woman from *Metropolis* (1926), the film that inspired Hitler, misguidedly, to perceive the director as his spiritual ally.

various Viennese cabaret clubs, where he was employed designing posters and at times performing his own poetry. He signed up for art classes, but as Patrick McGilligan writes in *Fritz Lang: The Nature of the Beast*: "It is unclear how much study he did – even how much painting, or whether this was simply a pose." It was at this time that Lang passed off as his own, in the form of a gift to his mother, someone else's painting.

Shortly before his twenty-first birthday Lang left home, heading for Brussels, where he managed to eke out a living by selling his sketches, postcards, watercolours, and caricatures. Over the following few years he travelled widely, although exactly how widely remains a matter of dispute, around Europe and the East, studying formally and informally, collecting primitive art, surviving by selling his own art work, and engaging in a series of romances. He was based for some time in Munich, where he may have attended serious art classes, and from there moved to Paris, where he was determined to establish himself as a painter.

According to Frederick W. Ott in *The Films of Fritz Lang*: "There is strong evidence … that after a visit to Chartres, Lang made a portfolio of drawings of the great cathedral, an undertaking which suggests the influence of the architectural training in Vienna. But landscapes … remained his preferred subject in this period." It seems that only the outbreak of war prevented an exhibition of Lang's work in Paris. Shortly thereafter the nascent artist had an epiphany at a Parisian cinema: "I wanted to be a painter and it thrilled me to see a painting in motion!"

The war marked a decisive turning point in Lang's life and career. He managed to escape Paris, by his account on the last train out of the city, and on his return to Vienna signed up for military service. During the war he was wounded several times and decorated, and it was in one period of enforced inactivity, an extended stay in a military hospital, that Lang began to write screenplays for putative films. And although he still harboured some dreams of forging a career as a painter – a 1918 jaunt to St Petersburg was undertaken ostensibly as part of his studies, although its motivation was more likely romantic – he was from then on set for a career in the cinema.

above A font-like vase rich in baroque detail, betraying Lang's fascination for, indeed thwarted ambitions in, the study of architecture.

opposite Lang's architectural storyboards for *Ministry of Fear* (1944), his moody *noir* espionage thriller loosely derived from Graham Greene's 1943 novel.

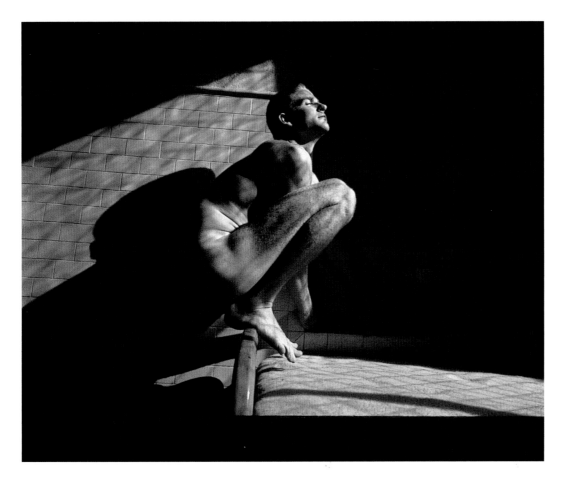

Alan Parker

b. London, England, 1944

Alan Parker was born in 1944, and grew up in Islington, North London. His mother was a dressmaker and his father did a number of jobs, among them working as a painter employed by the local council. In the *Independent on Sunday*, 1 March 2003, Parker told interviewer Matthew Sweet that he had once, when already established as an internationally successful film-maker, told some French journalists that his father was a professional painter: "They were very impressed. What sort of painting? Impressionism? Neo-realism? I told them he was way avant-garde; that he only painted in one colour. Grey."

The self-confessed "turnip head" left school with three A-levels, and after a few diversions found a job in a London advertising

above In a scene from Alan Parker's sensitive buddy picture *Birdy* (1984), the eponymous traumatized Vietnam vet (played by Matthew Modine) assumes an avian position.

opposite An apparently throwaway gag encapsulates the insecurity of the director as artist in general and of Parker in particular.

agency. By his early twenties he was a well-paid copywriter, and very quickly began to direct commercials himself. From the late 1960s to the late 1970s, by which time he had already made a mark as a feature director for television and then cinema, Parker churned out around 500 commercials, winning many awards along the way. He was at the forefront of a remarkable generation of British advertising directors – his peers included the Scott brothers, Adrian Lyne, and Hugh Hudson – who would translate their talent for story-telling, married to a distinctive visual sensibility, into massive success in Hollywood and beyond.

After early success with the outstanding television drama *The Evacuees*, Parker made his big-screen debut with *Bugsy Malone* (1976), a musical pastiche of the 1940s gangster movie with a cast of children, then promptly showed off his versatility by making the tough, Turkish-prison movie *Midnight Express* (1978). He followed up this, his breakthrough movie, with an extended sojourn in Hollywood, starting with another musical, *Fame* (1980), then skipping from genre to genre, including the musicals *Pink Floyd: The Wall* (1982), *The Commitments* (1991), and *Evita* (1996), as well the searing drama *Shoot the Moon* (1981), the historical-political drama *Mississippi Burning* (1988), the misfiring comedy

right A cartoon that hints at some creative tensions during the production of what was the third of Alan Parker's thus far five musicals.

opposite Parker vents his spleen variously at the stupidity and hypocrisy of film studios, and – one of his favourite targets – at the pseudery and intellectual élitism he considers to be at the heart of British film criticism.

The Road to Wellville (1994), and an adaptation of Frank McCourt's gritty autobiography *Angela's Ashes* (1999).

But, for all Parker's success, as his witty and characteristically entitled documentary *A Turnip Head's Guide to British Cinema* (1986) indicates, he has always displayed a distinct edge and at times a bitter resentment toward snobbery – class-based or intellectual. The sheer diversity of his work as director has led to accusations of dilettantism and this, in tandem with the uneven quality of his output and his unashamed commercialism, has created a tension between the director and certain elements of the critical establishment. This tension was exacerbated by Parker's contentious time as head of the UK Film Council, when, among other things, he championed the American model of production whereby film-making is intimately linked to distribution, a system skewed in favour of populist cinema.

Although a consistently successful moviemaker, Parker remains remarkably thin-skinned in his dealings with critics and his other

HARES IN THE GATE.

perceived enemies in the film world. This quality has found vent
in a series of cartoons he has created from the late 1970s onward
and which have been collected in volumes including *Hares in the
Gate* (1982) and *Making Movies* (1998). As a boy, Parker's talents
as an artist – he still paints and draws but insists he is not talented
at either – were encouraged by two uncles who introduced him
to photography. He has kept his other sketches to himself, but
continues to produce cartoons that are generally characterized by
an undisguised contempt towards international film critics and
the élitism and pretentiousness of art-house cinema.

Interviewed for *Take 10: Contemporary British Film Directors*
(1991) by Jonathan Hacker and David Price, Parker says: "I think
the cartoons are partly a wind-up. I tend to get a perverse
pleasure out of putting the boot into certain established film
preconceptions. But they do also allow me to articulate certain
opinions I have without resorting to a polemical essay, that I may
have trouble reasoning out anyway. One-liners are much easier,
and they cut quicker although not deeper."

"... I think that movies are made only for one, maybe two people."

Jean-Luc Godard

*"Let's face it, Jean-Luc, absolutely everyone hates your films.
If I were you, I'd think up a few snappy quotes."*

Gordon Parks

b. Fort Scott, Kansas, USA, 1912

The youngest of 15 children, Gordon Parks was born in Fort
Scott on 30 November 1912. He had a tough childhood: after
the death of his mother, he was packed off to stay with one
of his older sisters in St Paul, Minnesota, and then, thrown out
of the house by his brother-in-law, was forced to live rough. He
scraped a living as a piano-player, dishwasher, semi-professional
basketball player, and waiter, among many other jobs, before
his life was transformed in 1938 when he bought his first camera,
a Voightlander Brilliant, for $7.50. He characterized this purchase
in his autobiography *Half Past Autumn* as "a weapon I hoped to
use against a warped past and an uncertain future". His early
experiences fuelled the sense of righteous anger that infuses
many of his most powerful photographs.

Parks talked his way into jobs as a fashion photographer, albeit
an unpaid one to begin with, gaining an early break with a
commission from Marva Louis, the wife of heavyweight boxing
champ Joe Louis, before being hired by the Farm Security
Administration, a government-sponsored organization
monitoring the life conditions of those suffering at the sharp
end of the Depression. It was at the FSA that he embarked on
the socially conscious brand of reportage and portraiture with
which he would make his name.

While working there, indeed during his first visit to Washington,
DC, Parks stumbled upon the woman who would become perhaps
his most important subject: Ella Watson, a cleaner at the FSA. As
he recalls in his autobiography: "I watched her for a few moments,
then eased into conversation with her. Within 15 minutes she had

left *Self-portrait,* 1945. Gordon
Parks, by the time of this self-portrait,
just seven years after buying his first
camera, was already established as
one of America's leading photographers.

opposite *American Gothic,* 1942.
The iconic image of Farm Security
Association cleaner Ella Watson
from the photo-story with which
Parks made his name.

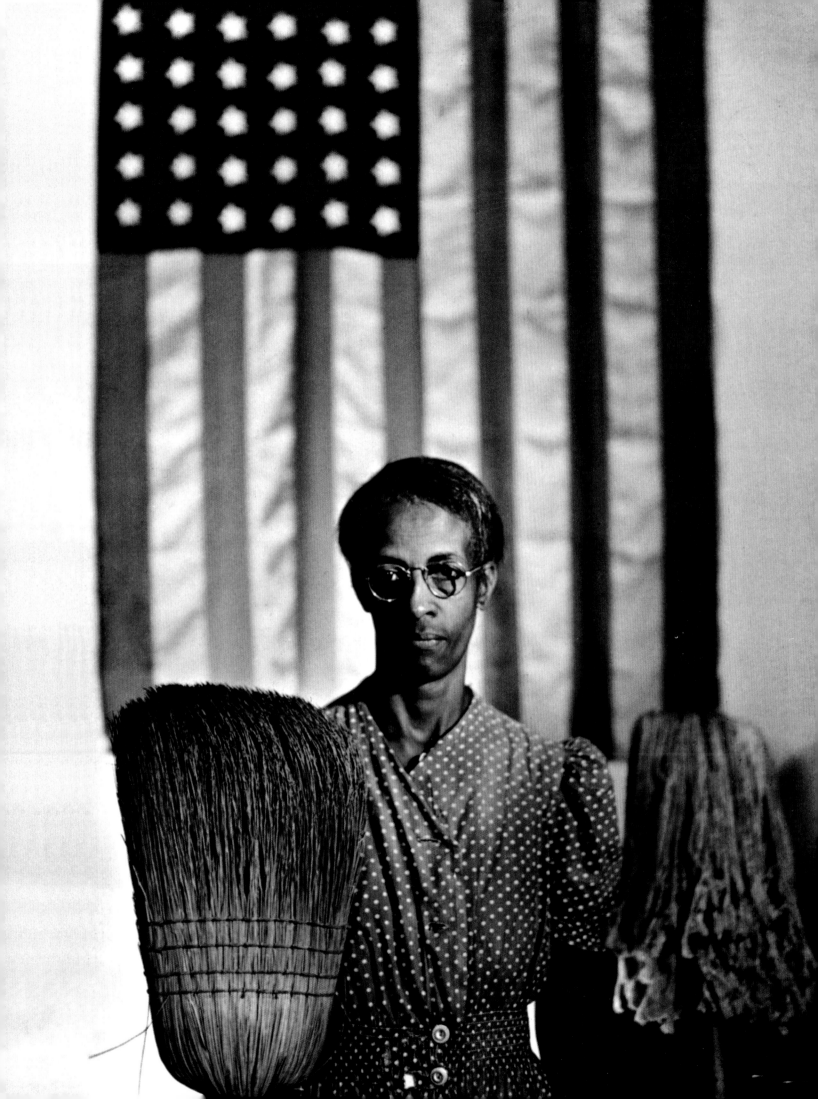

opposite *Harlem Newsboy, Washington, DC,*
1943. This quietly potent image was taken
around the time that Parks, then a war
correspondent, was refused permission to
report on the 332nd Fighter Group, the
first all-black air corps.

above Richard Roundtree as the
eponymous streetwise private eye in
Parks's second feature, the cool, violent
Shaft (1971), one of the key films of the
blaxploitation genre.

PLASTIC FOOD KEEPER

DAIRY QUEEN
Butter Pecan
SUNDAE

OOT LON

HOT DOG

Western Sauce

previous page *Drinking Fountains, Birmingham, Alabama*, 1956. As one of the great documenters of the Civil Rights Movement, Parks always eschewed violent protest, choosing from the outset to use his camera as his weapon, a tool to effect change.

right A shot from a 1959 fashion spread for *Life*. Throughout his career Parks, like his contemporary Richard Avedon, has alternated his political/social commentary work with fashion photography.

opposite The lighter side of Parks's work is shown in this cover shot for an edition of *Life* magazine.

taken me through her lifetime of bigotry and despair. 'Would you let me photograph you?' I asked. 'I don't mind,' she answered." The resulting series of images, entitled *American Gothic,* would constitute his first professional work as a photographer.

Parks quickly built up a portfolio strong enough to lend him the confidence to walk into the offices of *Life* magazine and seek out its editor without first making an appointment. He was taken on, and at once found himself working as a specialist in the diverse fields of crime and fashion, much of his work in the latter field commissioned by *Vogue* magazine. Parks would work as a photojournalist for *Life* for nearly a quarter of a century, often writing the articles that accompanied the images, and gradually increasing his range as a photographer and in other media. His photojournalism was typically political in nature – he contributed to *Life* notable stories on American gang culture, the Civil Rights

LIFE

U. S. PAT. OFF.

A NEW FORMULA EXPLODES SOME OF BASEBALL'S MYTHS

RURAL THEATER SURPRISE PACKAGES

WHALE STEALS SUMMER SHOW

20 CENTS

AUGUST 2, 1954

above *Nude,* 1975. One of Parks's many nudes using manipulated colour-processing techniques with which he experimented in the 1960s and 1970s.

opposite *Ingrid Bergman at Stromboli,* 1949. An emotionally resonant image from an intimate shoot documenting, at the couple's own request, the scandalous affair between Ingrid Bergman and Roberto Rossellini, one that left the star a Hollywood outcast for nearly a decade.

Movement, and a young Brazilian boy called Flavio. Parks would return to this last subject in order to make the documentary *Flavio* (1964). And so began his career as a film-maker, as with Stanley Kubrick, the decisive first work in motion pictures springing directly out of a photoreportage commission for a magazine.

Parks experimented with manipulated colour photographs that accompanied his own expressionistic poetry, and he also wrote fiction, notably *The Learning Tree* (1969), which contains strongly autobiographical elements, as well as three volumes of straight autobiography. He has also composed music, including sonatas, songs, and a ballet based on the life of Martin Luther King.

His career as a feature film-maker was launched with his adaptation of his own *The Learning Tree*, and took off in the early 1970s when he became one of the leading directors working within the blaxploitation genre: he directed *Shaft* (1971) and its lesser sequels as well as *Leadbelly* (1976) and several TV movies. Now, still active in his nineties, Gordon Parks is not merely one of the key figures in American photography but one of the leading figures in 20th-century African-American cultural life.

Satyajit Ray

b. Calcutta, India, 1921

d. Calcutta, India, 1992

Like his friend Akira Kurosawa in Japan, Satyajit Ray, perhaps the greatest of all humanist directors, was responsible for establishing an international interest in his national cinema in the 1950s. He was inspired equally by the approach of the Neo-realists, chiefly Vittorio de Sica's *Bicycle Thieves* (1948) and Rossellini's *Open City* (1945); the success of Kurosawa's *Rashomon* (1951); and a brief meeting with Jean Renoir during the filming of *The River* in 1949.

Ray achieved his breakthrough via the serene, wise, and astonishingly assured debut *Pather Panchali* (1955). This was the first film in what would come to be known as, alongside *Aparajito* (1956) and *The World of Apu* (1959), the *Apu Trilogy*, which would, for all the accomplishments of his later career, mark his most significant professional achievement: indeed it comprises one of the greatest works in world cinema. This is

above Ray's portraits of his friends, peers, and fellow artist/directors, (left to right) Sergei Eisenstein and Akira Kurosawa.

opposite A watercolour by Ray, dating from 1942, painted in the style of Ogata Korin (1658–1716), the Japanese master of the middle Edo period.

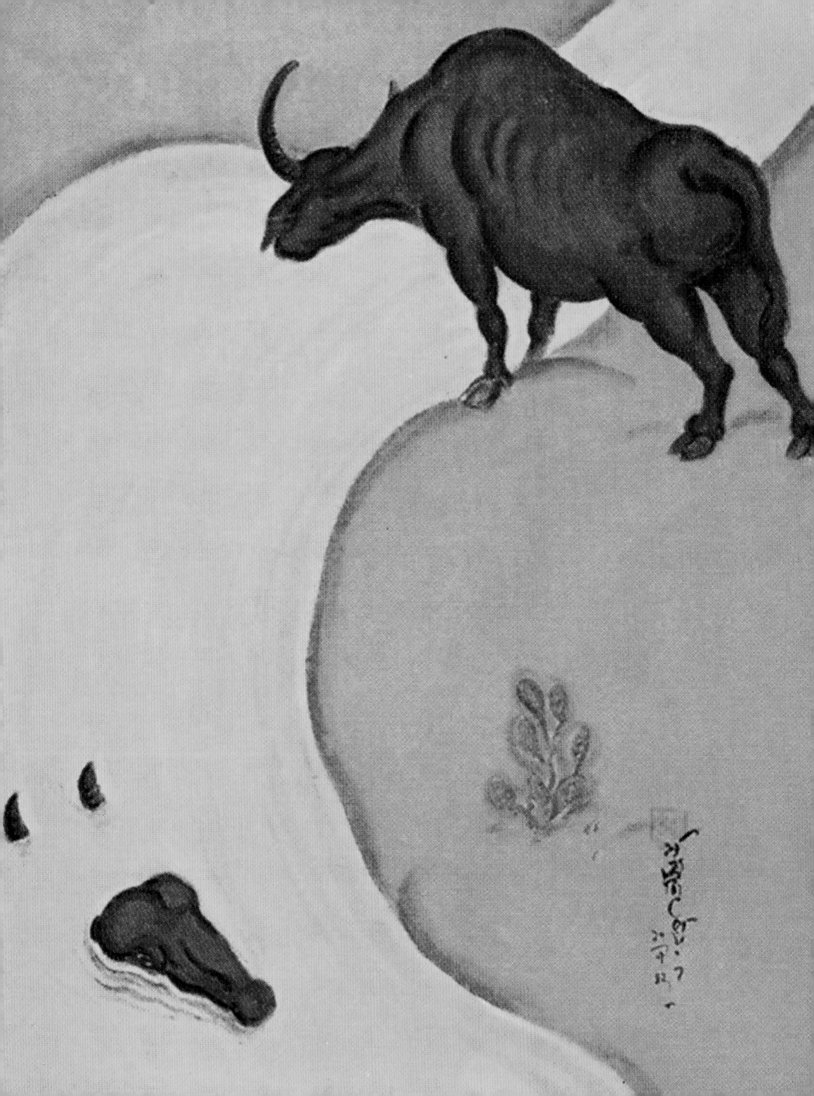

right Perhaps the most memorable sequence from all Ray's films – Apu (Subir Bannerjee) and Durga (Uma Das Gupta) rush through a field of flax to witness the passing train in *Pather Panchali* (1956), Ray's debut feature and the first of his mighty *Apu Trilogy*.

below The same scene as depicted in Ray's woodcut illustration for an abridged 1944 edition of the novel by Bibhuti Bhusan Bannerjee that gave rise to the film.

not to diminish the remaining films in his career, with such major works to his name as *Charulata* (1964), *Aranyer Din Ratri* (1969), and *Shatranj Ke Khilari* (1977).

Again like Kurosawa, Ray appeared from early childhood destined to become a professional graphic artist, and received years of training, achieving some notable success as a prolific illustrator. He was born in Calcutta in 1921 into a well-off Bengali family, one with a pedigree in various artistic pursuits that can reputedly be traced back 15 generations. In 1940 he bowed to his family's wishes and agreed to attend Shantiniketan, the university run by Rabindranath Tagore, one of the giants of Indian cultural life, a close friend of Ray's father and grandfather, and someone whose work and example would inspire Ray throughout his directorial career. Ray would adapt several of Tagore's stories for the big screen as well as producing a feature-length documentary to mark the centenary of Tagore's birth.

left Again the same sequence, this time as envisaged by Ray in his elegant wash-drawing sketches for *Pather Panchali*.

At Shantiniketan Ray, whose artistic preferences up to that time had been largely Western, was introduced to the joys of Eastern art – Japanese and Chinese as well as Indian – and with several fellow students embarked on a no-frills tour of India, enhancing his studies by scrutinizing and sketching traditional Indian sculptures, statues, and shrines. While at university he would also regularly travel to nearby villages to sketch, providing the urban and urbane Ray with an introduction to the humble life that he would explore in his first films. It would be, however, a mistake to think of Ray as purely a documentor of the poor – from *Jalsaghar* (1958) onward he would regularly explore the lives of India's middle and upper-middle classes.

Ray was profoundly affected by one teacher in particular at Shantiniketan, Binode Behari Mukherjee, and as with Tagore, he would decades later make a documentary tribute to his mentor. But sensing the need to start earning money, not least in order to care for his mother, Ray returned to Calcutta in 1942, and joined a British-owned advertising company, where he worked in a creative as well as an administrative capacity

above "In sensible households throughout India, Sunday is Paludrine Day." One of several advertisements illustrated by Ray in a 1949 campaign for the anti-malaria treatment Paludrine.

opposite The poster for *Devi* (1960) designed by Ray.

সত্যজিৎ রায় প্রোডাকসনস্-এর

মূল কাহিনী
প্রভাতকুমার মুখোপাধ্যায়

শ্রেষ্ঠাংশে
ছবি বিশ্বাস। সৌমিত্র চট্টোপাধ্যায়
শর্মিলা ঠাকুর। করুণা বন্দ্যোপাধ্যায়

সংগীত
আলি আকবর খাঁ

পরিবেশক
জনতা পিকচার্স
এ ও থিয়েটার্স
লিমিটেড

right In this sketch for *Devi* Ray depicts
the titular Doyamoyee driven mad, her
divine powers having been tested and
found wanting.

over the following decade. Throughout this period, which included a six-month sojourn in London where he furthered his cinematic education, Ray was also regularly working as a freelance illustrator, designing book jackets and posters. At the same time he worked as a film critic, in which capacity he came to meet his idol Jean Renoir. But all the while he dreamed, as he had since childhood, of breaking into movies, and it was while working on the designs for a new edition of Bibhuti Bhusan Bannerjee's novel *Pather Panchali* that Ray became consumed with the passion for a cinematic project that would see him realize his ambition, although he would come close to bankruptcy in so doing.

The troubled and protracted genesis of *Pather Panchali*, in the course of which Ray received encouragement from, among many others, John Huston, ended in triumph. The film was immediately and widely hailed as a masterpiece and Ray fêted as the master of Indian cinema, although he was in no way representative of his national cinema – indeed he was largely unimpressed by much of the output of the prolific Indian film industry.

As his fame grew – and he continued to direct films up until the late 1980s – Ray would still turn out illustrations, regularly providing the covers for the children's magazine *Sandesh* that had been launched by his father. Put simply, Satyajit Ray succeeded in converting a modest talent as a draftsman into a quiet genius for film-making.

above Ray's 1967 sketches of alien heads created for his putative project *The Alien*, whose uncredited influence on Steven Spielberg's *ET* (1982) remains a contentious issue to this day.

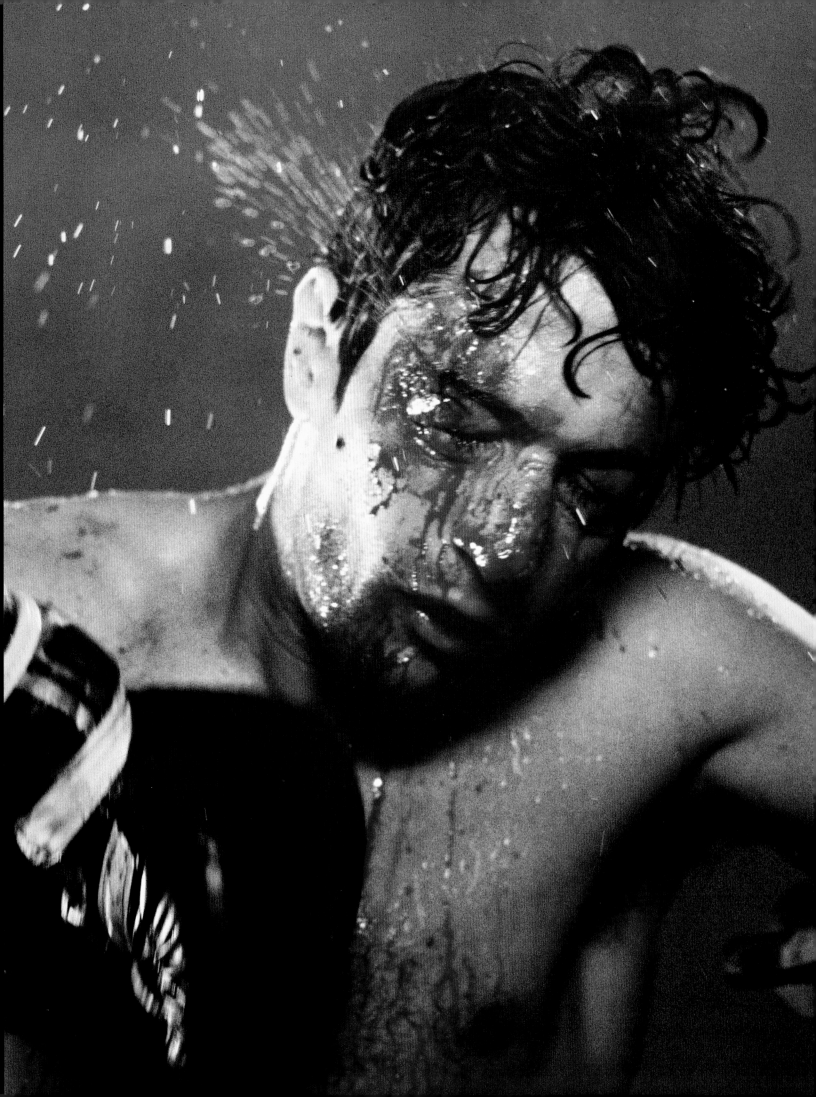

Martin Scorsese

b. New York City, USA, 1942

While never having achieved any break-out commercial success to match those of his friends and peers among the movie brat generation who swept into Hollywood in the late 1960s and early 1970s – Spielberg, Lucas, De Palma, Coppola, *et al* – Martin Scorsese is widely hailed by critics and fans as the star of his generation. Scorsese's obsession with film came about partly because of his sickliness as a child. He suffered from chronic asthma and would be taken regularly, generally by his movie-loving father, to one of the cinemas in his native Little Italy, Manhattan, where he was swept away by the escapist fantasies of costume films, historical dramas, and westerns.

His twin passions as a child and adolescent were cinema and the Church and for many years he planned to enter the priesthood, before his love of movies won out. He studied film at New York University, gaining an honours degree and then an MA. There he had access to a 16 millimetre camera, and had produced a number of short films by the time he graduated. Through the 1960s he gained experience as an editor and also made his feature debut with *Who's That Knocking on My Door?* (1968), a labour of love that starred Harvey Keitel, who would become, along with Robert De Niro, one of Scorsese's favourite actors.

Having worked as an editor on *Woodstock* (1970), Scorsese got his big break, like so many others of his generation, under Roger Corman, who assigned him to make *Boxcar Bertha* (1972), a sequel of sorts to Corman's *Bloody Mama*, an exploitation film that incidentally co-starred De Niro. The film was a modest success, but a key moment came when Scorsese screened it for his idol John Cassavetes, who praised the style but pleaded with Scorsese to go for more personal material.

Heeding that advice, Scorsese dusted off an old idea of his, a story with the working title of *Season of the Witch* that was based around the characters that had populated the nascent director's Little Italy neighbourhood in his youth. Released in

opposite Jake La Motta (Robert De Niro) takes some punishment in the ring in Scorsese's savage and glorious biopic *Raging Bull* (1980).

overleaf Scorsese's vivid and intense storyboards for the climactic scene of *Taxi Driver* (1976), his masterpiece of post-Vietnam urban paranoia.

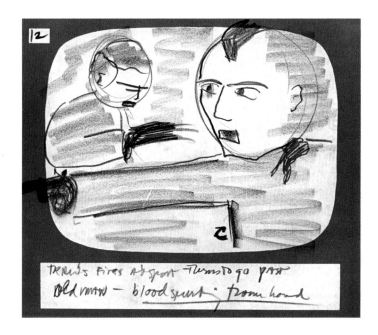

T.R reads Fires At sport Turns To go past
Old man — blood spurting from head

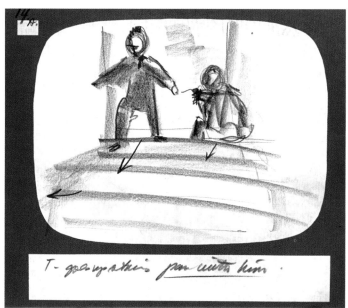

T - goes up stairs pan with him.

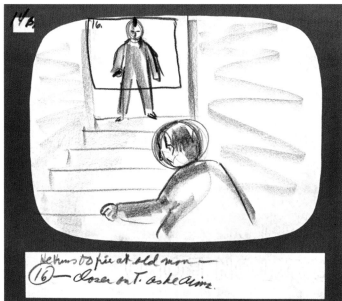

He turns to fire at old man —
(16) — closer on T. as he aims.

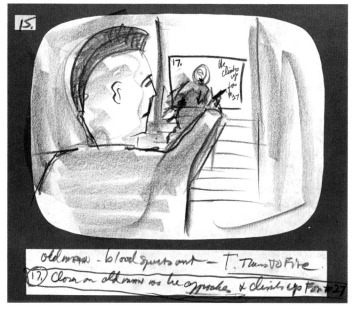

Old man - blood spurts out — T. Turns To Fire.
(17.) Close on old man as he approaches & climbs up For #27

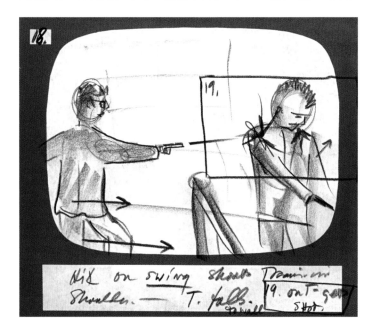

Hit on swing shoots From arm
Shoulder. — T. falls. | 19. on T - goes
shot.

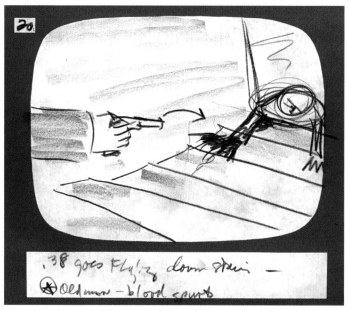

.38 goes flying down stairs —
⊛ Old man - blood spurts

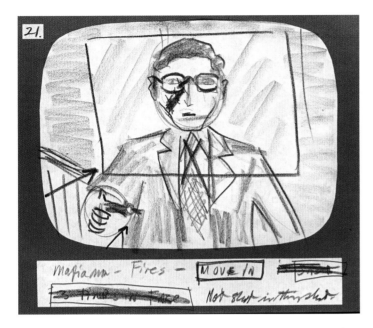

21. Mafia man — Fires — MOVE IN
Not shot in this shot

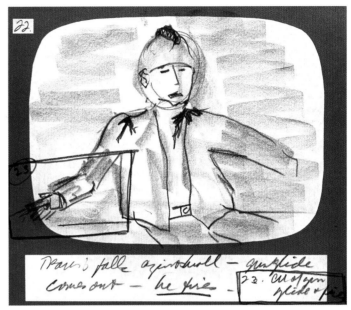

22. Travis falls against wall — gun slide
comes out — he fire — 23. Cut of gun
slide & fire

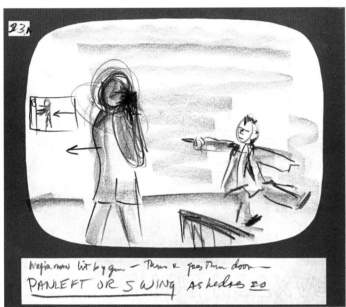

23.A Mafia man hit by gun — Throw x pass min door —
PAN LEFT OR SWING As he does so

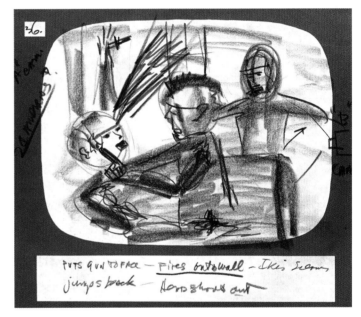

26. PUTS GUN TO FACE — Fires into wall — Ike's Scream
jumps back Hand shoots out

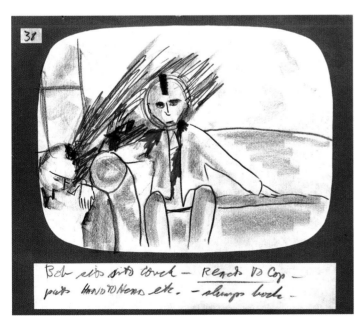

38. Bob sits into couch — Reacts To Cop —
puts HAND TO HEAD etc. — always back —

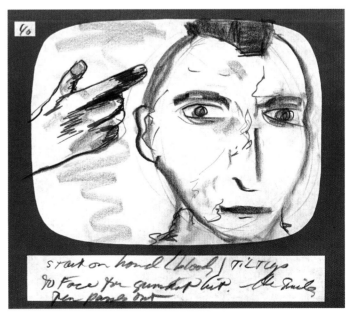

40. Start on hand (blood) TILT UP
To Face from gunshot hit. He smiles
then passes out

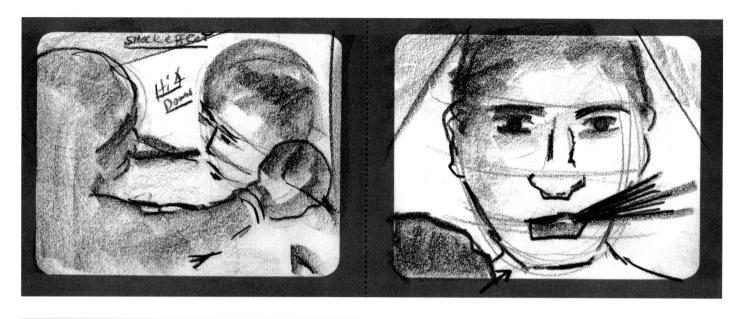

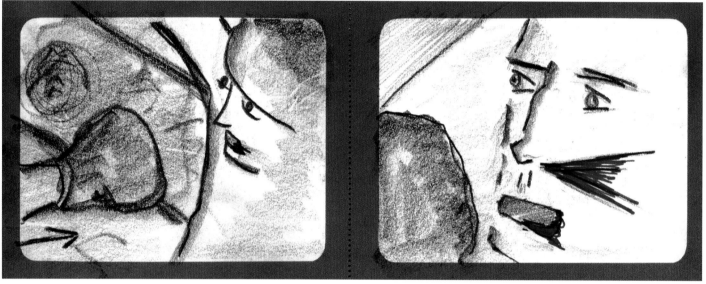

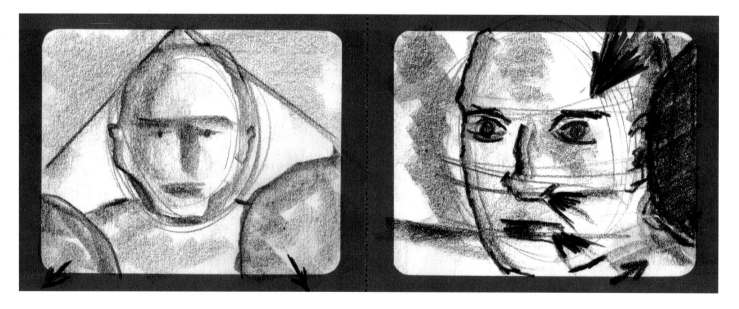

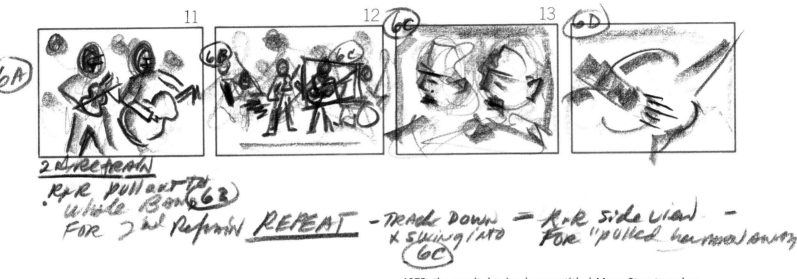

1973, the result, having been retitled *Mean Streets* and co-starring De Niro and Keitel, would make Scorsese's reputation and establish his trademark themes – men, often violent men in crisis, with religion generally in the background or foreground – and a certain directorial signature style, involving flashy, imaginative visual flourishes, long or otherwise complex takes, and a soundtrack of pervasive pop music.

While occasionally working on more mainstream material, or on scripts generated by others, including *Alice Doesn't Live Here Anymore* (1974), *After Hours* (1985), and *The Color of Money* (1986), Scorsese has generally stuck to his guns, turning out a succession of great films. These include T*axi Driver* (1976), *Raging Bull* (1980), *The King of Comedy* (1983), and *Goodfellas* (1990), which all seem to bear the personal Scorsese touch, even though many have been scripted in collaboration – Scorsese and Nick Pileggi co-wrote *Goodfellas* and *Casino* (1995) – or wholly by others, most notably Paul Schrader.

Throughout his career Scorsese has carefully storyboarded his own films. With their scratchy, urgent, primitive stylelessness, these storyboards may in themselves stretch the definition of art; indeed they may look uncomfortably like extracts from [*Taxi Driver*'s] Travis Bickle's illustrated notebooks. But they provide evidence of Scorsese's innate understanding of the medium and of his talent for framing shots and building sequences – in the examples featured here, sequences that have been etched forever into the minds of a generation of film-goers.

Josef von Sternberg

b. Vienna, Austria, 1894
d. Hollywood, California,
USA, 1969

In his exceptionally entertaining if not entirely reliable memoir *Fun in a Chinese Laundry*, Josef von Sternberg opined of the skill required of the film-maker: "It is of great importance to know how to use the camera, for it endows what it gathers with a new and radically different dimension; but it is of far greater importance to know how to use the eye." It is hard to assess how posterity will judge von Sternberg as an artist – but there is no doubt that he understood how to use the eye. He was widely fêted, especially in his golden period from the late 1920s through the 1930s, while also attracting mistrust from several collaborators and fellow professionals, and is too little known today outside film academic circles – certainly a rather more

above Von Sternberg astride a camera crane during the filming of *The Scarlet Empress* (1934), the fifth of his seven collaborations with Marlene Dietrich.

opposite Von Sternberg's greatest artistic creation was the iconic screen persona of Dietrich, first seen here in her defining role as Lola-Lola in *The Blue Angel* (*Der Blaue Engel*, 1930).

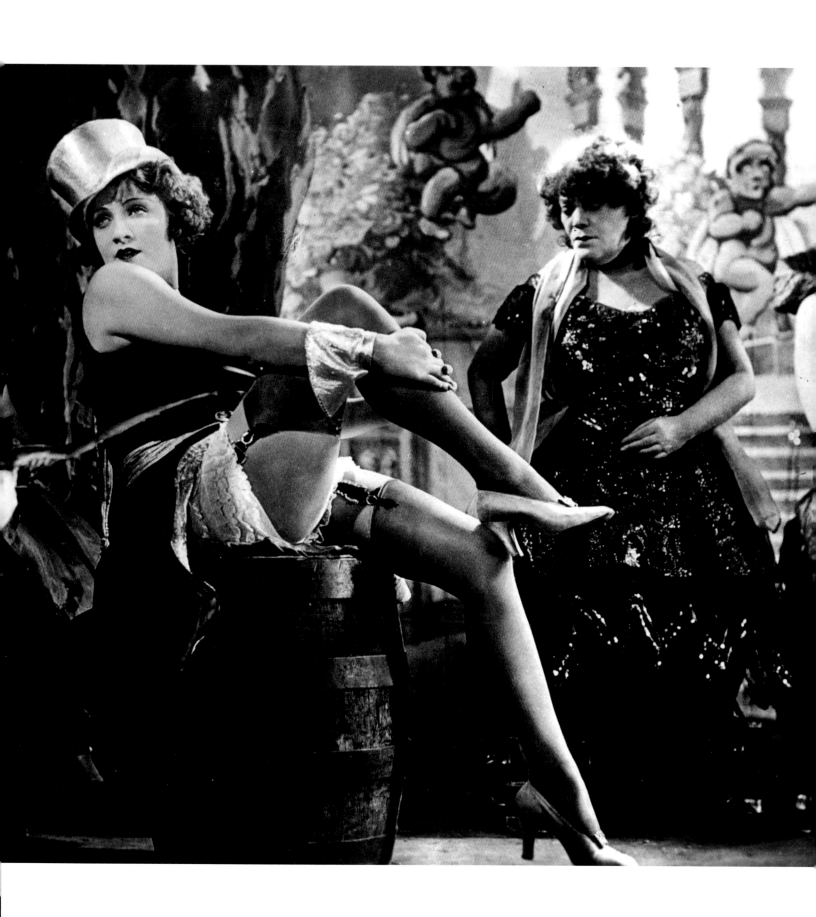

above *New York Harbor from Weehawken Cliffs,* 1953. The view from the living room of the house that von Sternberg completed in 1949 and lived in intermittently until 1957.

opposite *Fishing Skiffs in Venice,* 1939. The picture was painted during a visit to the city when von Sternberg, Marlene Dietrich, and her husband and daughter stayed with the author Karl Vollmoeller, who lived in the apartment at the Palazzo Vendramin where Richard Wagner died.

obscure figure than the cinematic icon that he created, or at least helped to fashion.

There is surely no director – a term that von Sternberg always found inadequate to capture the grandeur of his calling – whose standing was, and remains, so wrapped up with one star. He was born Josef Stern, or by some accounts Sternberg (either way, the "von" was added shortly after he started making films, allegedly without his knowledge) in Vienna in or very close to poverty. His childhood and adolescence were divided between Vienna and the unprepossessing New York City borough of Queens, where in time he earned a living working in a film laboratory. From this humble first step on the ladder, he gradually worked his way up through the industry, and eventually got his break as a director, creating *The Salvation Hunters* in 1925 with a minimal budget but an unerring instinct for narrative and more pertinently for the framing and lighting of individual shots. From the outset he understood the technique and artistry involved in lighting, especially in casting light on the face; indeeed he devotes a fascinating chapter in *Fun in a Chinese Laundry* to this subject.

Soon von Sternberg was championed and employed by Mary Pickford and then by Charlie Chaplin, although neither collaboration ended happily; he went on to confirm his talent with *Underworld* (1927) the first major Hollywood gangster film. But von Sternberg's career-making moment came when he went to Berlin in 1930 to shoot *The Blue Angel,* casting the little-known Marlene Dietrich as the temptress Lola-Lola. Over the course of seven collaborations with Dietrich, he moulded the actress, lit her with obsessive care, and created one of cinema's icons.

Von Sternberg, an autodidact with a wide knowledge of art and artists, insisted on the director's being seen as an artist and the sole author of his films. Aside from his own movies, he produced a number of striking paintings, characterized by a marked influence of Impressionist and Post-Impressionist painters, Cézanne being a particular favourite. Many were presented to friends, family, and colleagues as gifts, while others were hung on the walls of his home. Until now none of von Sternberg's paintings has been publicly exhibited or published in any form.

right *Still Life of Peppers and Wine,* 1949. The housewarming painting that von Sternberg produced for the Weehawken house.

Jan Svankmajer

b. Prague, Czechoslovakia, 1934

Jan Svankmajer was born in Prague on 4 September 1934. The seminal event in his youth came at Christmas 1944 when he was given a puppet theatre, a gift that immediately inspired the nascent artist. He went on to study at the College of Applied Arts in Prague, then in the Department of Puppetry in the city's School of Dramatic Arts. Speaking to Geoff Andrew in a 1988 *Time Out* interview, Svankmajer stated: "Surrealism exists in reality, not beside it", and in these formative years he was inspired and influenced by avant-garde and Surrealist artists and film-makers such as Picasso, Ernst, Miró, Klee, Dalí, and Buñuel, and the giants of Soviet cinema Eisenstein and Vertov. The combination of intellectual rigour and the expression of the darkest regions of the subconscious mind have characterized all Svankmajer's subsequent work, from the *outré*, dark puppet films and animations for which he has become internationally famous, to the equally strange "objects", assemblages, and paintings that he has created for and in parallel with his cinematic excursions.

After his formal training, Svankmajer went on to work with the D34 Theatre, the Semafor Theatre, and at Lanterna Magika, and served as a puppeteer on the Venice Film Festival award-winning *Johannes Doctor Faust* (directed by Emil Radok, 1958). During this time, the mid-to late 1950s, he was also establishing himself as a prolific and gifted, sometimes perverse, artist in a variety of media, from his drawings to his weird, distinctive sculpture.

He worked on numerous short films and established a reputation for these, but achieved his first real international recognition with *Alice* (1988), his wondrous version of Lewis Carroll's fairy tale. In his interview with Geoff Andrew, Svankmajer recalled the joy of finding his kindred spirit: "Carroll was a precursor of the Surrealists so mentally we're on the same side of the river (though I'm probably more anxious than he was); also we are both infantile, which in normal society is an insult." In his films he typically blends live action, puppets, and animated objects, all his work bearing testimony to his belief that these objects,

opposite The puppet of the Mad Hatter from *Alice*, Svankmajer's sinister take on the creation of his kindred spirit, the proto-surrealist Lewis Carroll.

whether mysterious or mundane, possess a strange, independent
life force of their own, which he unleashes.

Svankmajer has stated that he considers all his films and indeed
all his art work to be inherently political in nature, although only
once, with *The Death of Stalinism in Bohemia* (1990), has he
made an overtly political film. But his unconventional approach to
film-making and his serious-minded commitment to the Surrealist
movement (he has been a member of the Czech Surrealist Group
since 1970) often led him into problems with the Communist
censors, and many of his films had problems with distribution or
were banned outright. While repeatedly frustrated by his dealings
with the censors, Svankmajer would always find some outlet for
his urgent creative impulses. As well as his animation and film
design work, he would busy himself in other creative media,
creating collages and strange, sculptural, often tactile objects.

above *Insects* (from the cycle *Bilderlexicon*),
1973. One of a series of images in which
maps, architectural drawings, anatomical
sketches and the like receive the distinctive
Svankmajer touch.

opposite *La Virginité (Mutoskop)*, 1973.
Svankmajer's dark and erotically charged
version of one of the proto-cinematic
moving-picture devices.

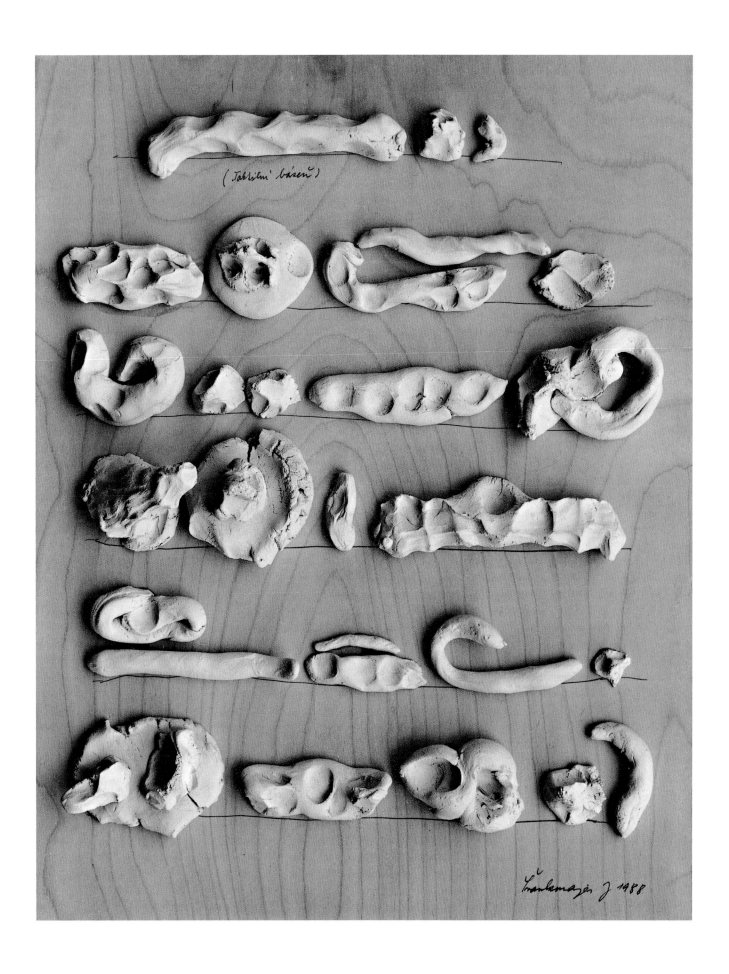

As with David Lynch, much of Svankmajer's output in films and in other media is rooted in his childhood and his dreams. He has spoken at length of how crucial these are to his creativity, and – this is central to his notion of Surrealism – the way in which artists need to have access to the vision of the world that they had in childhood, to dreams, and to other expressions of the subconscious mind. In discussing these ideas of the creative impulse and creative process Svankmajer boldly dismisses the notion of talent, insisting that the only quality separating artists from non-artists is the former's ability to dredge the innermost workings of their minds while the latter's access to this rich resource is blocked.

"From as early as my school days I was criticized for a certain morbidity, sickness, negativism, and pessimism," Svankmajer said in the book *Dark Alchemy*. Aside from his extra-cinematic projects he has worked in different media within his films, employing diverse techniques, from the eerie puppet-work of *Alice* to the plasticine animation of *Dimensions of Dialogue* (1982), a darkly

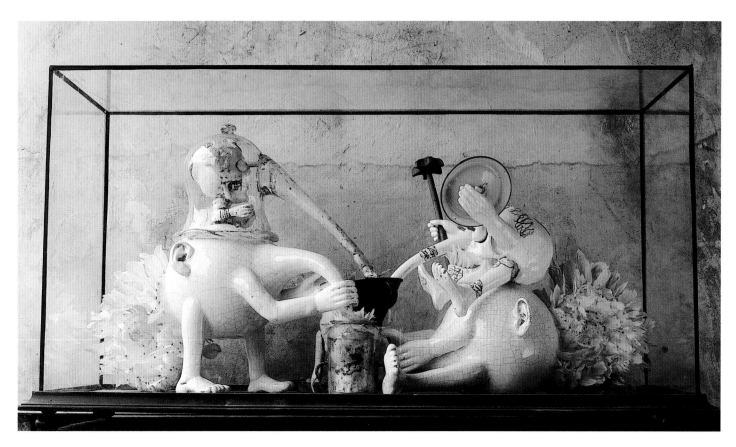

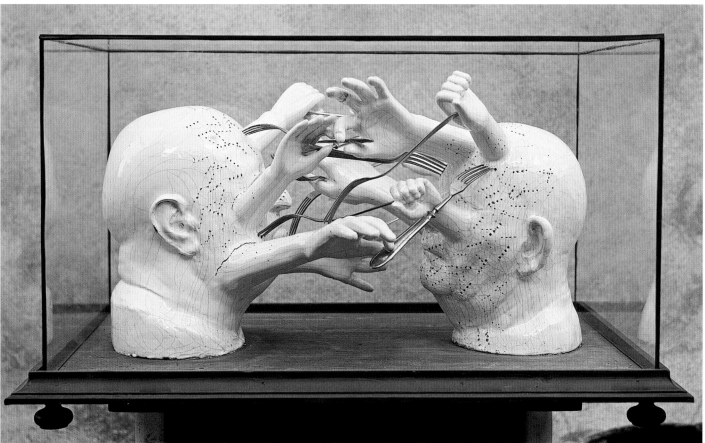

above *A Supermale* (from the cycle *Eros and Thanatos*), 1987. This is one of a number of collages that the artist created, alongside a series of "animated frottages", in 1987.

opposite *The Natural History Cabinet,* 1972. This series of wildly fused creatures betrays Svankmajer's avowed debt to his no less eccentric predecessor, the artist Giuseppe Arcimboldo (1527–93).

comical and influential trilogy that was denied a release at the time, indeed was used by the Czechoslovakian authorities as an object lesson in what was politically unacceptable. Through his work in film and other media, Svankmajer has created his own, distinctive artistic universe, as recognizably his own as those of Lynch or Tim Burton. But the latter pair have had the luxury of creating their art with relative freedom of expression and often, in the case of their movie projects, with generous budgets. Considering the pressures and restrictions under which Svankmajer has been forced to work, it is astonishing both how prolific he has been and the way in which he has managed to persevere on his singular track with, for all the horrors and erotomaniac perversity of his work, such clarity of purpose and lack of moral or intellectual compromise. In an interview with Wendy Jackson entitled *The Surrealist Conspirator* it is cited that his compatriot and fellow film-maker Milos Forman summed him up thus: "Disney plus Buñuel equals Svankmajer", yet this, though rather neat, seems altogether too limited a judgment.

Wim Wenders

b. Düsseldorf, Germany, 1945

Wim Wenders was one of the leading lights, along with Werner Herzog and Rainer Werner Fassbinder, of the New German Cinema generation of directors that emerged in the late 1960s and early 1970s. Born in Düsseldorf in 1945, Wenders flirted with medicine and philosophy before studying film at the Film and Television Academy in Munich. But as he said in an interview with Taja Gut, reproduced in *Wim Wenders: On Film, Essays and Conversations:* "I always wanted to be a painter. [While dabbling in other pursuits in early adulthood] what I was actually doing was painting."

above *Joshua and John (behind), Odessa, Texas,* 1983. A rare splash of wry humour in the context of Wenders's starkly beautiful panoramic cityscapes and desertscapes, with this shot of the buses of the Calgary Baptist Church in Odessa, Texas.

opposite Wenders and camera. He began his photographic career working with a Russian 35mm camera and moved on to a Japanese Art Panorama.

right *Dust Road in Western Australia,* 1988.
In his own comment on this picture,
Wenders recalls that this road leads to
a house complete with an overgrown
garden and a tennis court with trees
poking through the clay.

Wenders continued to pursue his ambition to live the life of a
painter by moving to Paris in the mid-1960s. There the bitter
winter cold drove him from his unheated garret to the cheapest
warm environment available, which happened to be a cinema. It
was here that his obsessive love of movies began, and more
particularly of American movies.

Wenders abandoned the idea of becoming a professional painter,
although he had been an accomplished artist adept at sensitive
watercolours and more avant-garde montages, and turned his
attention to the cinema, first as critic and then as director. His
cinematic vision was born out of his love of American films, and
he merged his particular Germanic sensibility with elements of
American cinematic iconography. He collaborated with Dennis
Hopper and Nicholas Ray in *The American Friend* (1977) and
with Ray again in the elegiac documentary *Lightning Over Water
(Nick's Movie*, 1980), and repeatedly worked within the very
American genre of the road movie.

It was inevitable that Wenders would some day work in the
United States, although his first experience there, *Hammett*
(1982), was not a happy one. The film, a long-cherished project
of Francis Coppola, was initially intended for British director Nic
Roeg but was handed over to Wenders when Coppola and others

at his studio American Zoetrope were impressed by the director's
work in *The American Friend*. *Hammett* ultimately suffered from
the lack of a coherent script, and the general sense of confusion
at Zoetrope, but Wenders's next film marked a high point in his
directorial career. With the beautifully crafted, spare *Paris, Texas*
(1984), he was able to express his love of Americana, of American
space and isolation, of people journeying toward some new,
meaningful realization. The film also proved to be a watershed
in Wenders's career. He followed it up with the dreamy, mystical,
poetic, and political *Wings of Desire* (1987), which became an
international art-house hit. It also marked a new, for some critics
not altogether welcome, direction for Wenders's films, which
would become increasingly vague, at times digressive musings
on various themes.

From the early 1980s Wenders had taken up his camera and
proved himself to be an inspired photographer. In the early 1990s
he worked on a series of striking, impressionistic, electronically
manipulated images, which he titled "electronic paintings". But
his most arresting images, and arguably his most artistically
accomplished work in the days since *Wings of Desire*, have been
conventional wide-angle images, particularly those vistas of
American landscapes that are bereft of people but which
generally feature some remnant of human occupation. The fact

that signs of one kind or another almost invariably feature in these images led Wenders to call the 1986 exhibition that gathered them together *Written on the West*. When exhibited, these striking photographs are shown on a large scale, individual prints measuring up to 178 x 447mm (7 x 17½in).

Wenders's new artistic direction in fact began in 1983 while the director was looking for potential locations for *Paris, Texas*. He chose to record the images with an old panoramic camera, a decision partly inspired by a reaction against what he saw as the insidious influence of technological advances on photography whereby photographs could no longer be relied on to reflect reality. He would confront the theme of the unreliability of the manipulated photograph head-on in his series of electronic

paintings in the early 1990s. As Peter-Klaus Schuster writes in his introduction to the catalogue of Wenders's photographic exhibition *Pictures from the Surface of the Earth* (2001): "In light of such arbitrariness, the maker of images regains his dignity, among other things, by dint of consciously returning to the outdated technique of photography."

On a simple level, the photographs when gathered together serve as a kind of visual diary of Wenders's life over the past two decades, an elegant scrapbook/travelogue recording where he has been and what he has seen, from the American West to the Australian outback, from the Golan Heights in Israel to the streets of Havana in which he filmed his poignant and joyous celebration of Cuban music, *Buena Vista Social Club* (1999).

above *Two Cars and a Woman Waiting, Houston, Texas, 1983.*

opposite *"Entrance", Houston, Texas, 1983.* Wenders presents a car park (opposite) as a starkly beautiful piece of Guggenheim Museum-like architecture, and the view from it (above) as a distorted cinema screen.

PARIS, TEXAS

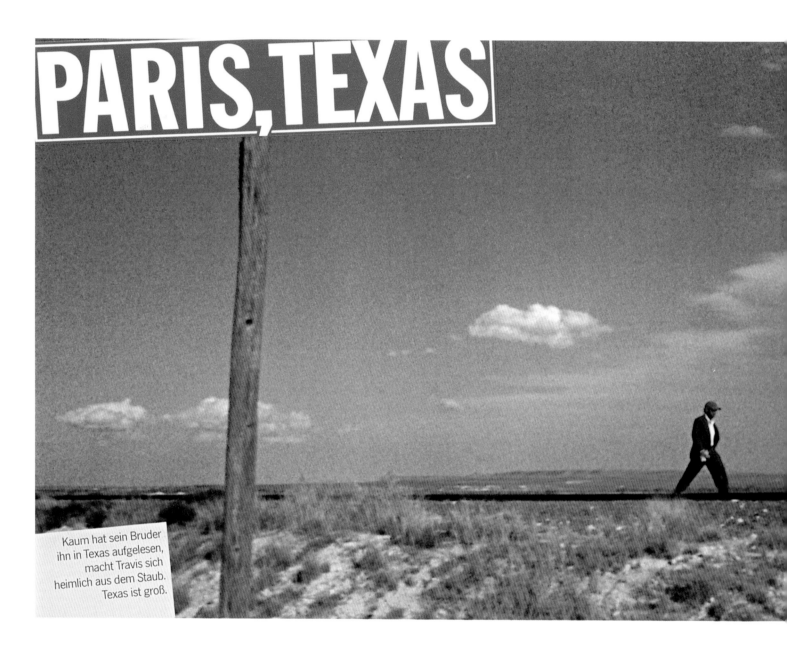

Kaum hat sein Bruder ihn in Texas aufgelesen, macht Travis sich heimlich aus dem Staub. Texas ist groß.

above Travis (Harry Dean Stanton) wanders across the Texan desert in *Paris, Texas*, Wenders's extended love letter to the great American landscape.

For all his diatribes against the swamping effect of Hollywood movies, Wenders, a long-time Los Angeles resident, remains a lover of America, an artist who has reacted against the physical and emotional claustrophobia he felt in his native Germany and has been formed by American literature, films, art, and photography. Since his prime as a film-maker, his most compelling artistic achievements have been these majestic, often panoramic images. His photographs, while bearing his own distinctive visual sensibility, are also marked by the influence of two of his great artistic idols, Walker Evans and Edward Hopper. Evans provided the visual inspiration for *Kings of the Road* in 1975; in the catalogue for *Pictures from the Surface of the Earth* Wenders recalls: "it was often the case that we stopped on the road to film a scene because a section of the countryside or an architectural motif reminded us of one of his photos". The other influence is Hopper – to whose paintings Wenders has paid conscious and loving tribute in his photographs.

top *The Black Car, Havana,* 1999.

above *Boy at Bat, Havana,* 1999.
These panoramic cityscapes were taken while Wenders was in Cuba making *Buena Vista Social Club*.

Filmography

**Non-comprehensive list of films
by the featured directors**

Jean-Jacques Beineix
Mortel transfert (Mortal Transfer) 2001
Otaku 1994
IP5: L'île aux pachydermes (IP5: The Island
of Pachyderms) 1992
Roselyne et les lions (Roselyne and the
Lions) 1989
37°2 le matin (Betty Blue) 1986
La Lune dans le caniveau (The Moon in
the Gutter) 1983
Diva 1981

Charlie Chaplin
A Countess from Hong Kong 1967
A King in New York 1957
Limelight 1952
Monsieur Verdoux 1947
The Great Dictator 1940
Modern Times 1936
City Lights 1931
The Circus 1928
The Gold Rush 1925
A Woman of Paris 1923
Pay Day 1922
The Idle Class 1921
The Kid 1921
A Day's Pleasure 1919
Sunnyside 1919
Shoulder Arms 1918
The Bond 1918
Triple Trouble 1918
A Dog's Life 1918
Chase Me Charlie 1918
The Rink 1916
Behind the Screen 1916
The Pawnshop 1916
One A.M. 1916
The Vagabond 1916
The Fireman 1916
The Floorwalker 1916
Burlesque on Carmen 1916
Police 1916
Burlesque on Carmen 1915
A Night in the Show 1915
Shanghaied 1915
The Bank 1915
A Woman 1915
Work 1915
By the Sea 1915
The Tramp 1915
A Jitney Elopement 1915
In the Park 1915
The Champion 1915
A Night Out 1915
His New Job 1915
A Busy Day 1914

Caught in the Rain 1914
The Face on the Bar Room Floor 1914
Gentlemen of Nerve 1914
Her Friend the Bandit 1914
His Musical Career 1914
His New Profession 1914
Mabel's Strange Predicament 1914
The Property Man 1914
Recreation 1914
Those Love Pangs 1914
Twenty Minutes of Love 1914
His Prehistoric Past 1914
Getting Acquainted 1914
Dough and Dynamite 1914
His Trysting Place 1914
The New Janitor 1914
The Rounders 1914
The Masquerader 1914
Laughing Gas 1914
Mabel's Married Life 1914

Jean Cocteau
Le Testament d'Orphée (The Testament
of Orpheus) 1960
Orphée (Orpheus) 1949
Les Parents terribles (The Storm Within)
1948
L'Aigle à deux têtes (The Eagle with Two
Heads) 1948
La Belle et la bête (Beauty and the Beast)
1946
Le Sang d'un poète (The Blood of a Poet)
1930

Sergei Eisenstein
Ivan Groznyj II: Boyarsky zagovor (Ivan the
Terrible, Part Two) 1958
Ivan Groznyj I (Ivan the Terrible, Part One)
1945
Aleksandr Nevsky 1938
Bezhin lug (Bezhin Meadow) 1937
Que viva Mexico! (unfinished) 1932
Staroye i novoye (Old and New) 1930
Oktyabr (October) 1927
Bronenosets Potyomkin (The Battleship
Potemkin) 1925
Stachka (Strike) 1925
Dnevnik Glumova (Glumov's Diary) 1923

Federico Fellini
La Voce della luna (The Voice of the
Moon) 1990
Intervista 1987
Ginger e Fred (Ginger and Fred) 1986
E la nave va (And the Ship Sails On) 1983
La Città delle donne (City of Women)
1980
Prova d'orchestra (Orchestra
Rehearsal) 1978

Il Casanova di Federico Fellini (Fellini's
Casanova) 1976
Amarcord 1973
Fellini's Roma 1972
Satyricon 1969
Giulietta degli spiriti (Juliet of the Spirits)
1965
8½ 1963
La Dolce Vita 1960
Le Notti di Cabiria (Nights of Cabiria)
1957
Il Bidone (The Swindle) 1955
La Strada (The Road) 1954
I Vitelloni (Spivs) 1953
Lo Sceicco bianco (The White Sheik) 1952
Luci del varietà (Lights of Variety) 1950

Mike Figgis
Cold Creek Manor 2003
The Battle of Orgreave 2001
Hotel 2001
Timecode 2000
Miss Julie 1999
The Loss of Sexual Innocence 1999
Flamenco Women 1997
One Night Stand 1997
Leaving Las Vegas 1995
The Browning Version 1994
Mr Jones 1993
Liebestraum 1991
Internal Affairs 1990
Stormy Monday 1988

Terry Gilliam
Good Omens (in production 2004)
The Brothers Grimm 2004
Fear and Loathing in Las Vegas 1998
Twelve Monkeys 1995
The Fisher King 1991
The Adventures of Baron Munchausen
1988
Brazil 1985
The Crimson Permanent Assurance 1983
Time Bandits 1981
Jabberwocky 1977
Monty Python and the Holy Grail 1975

**Peter Greenaway
(features, shorts, and documentaries)**
The Tulse Luper Suitcases, Episode 3:
Antwerp 2003
The Tulse Luper Suitcases: The Moab
Story 2003
Cinema16 2003
The Man in the Bath 2001
The Death of a Composer: Rosa, a Horse
Drama 1999
Eight and a Half Women 1999
The Bridge 1997

The Pillow Book 1996
Lumière et compagnie (Lumière and
Company) 1995
Stairs 1 Geneva 1995
The Baby of Macon 1993
Rosa 1992
Prospero's Books 1991
Hubert Bals Handshake 1989
The Cook, the Thief, His Wife & Her Lover
1989
Fear of Drowning 1988
Drowning by Numbers 1988
The Belly of an Architect 1987
Inside Rooms: 26 Bathrooms, London &
Oxfordshire, 1985 1985
A Zed and Two Noughts 1985
Making a Splash 1984
The Coastline 1983
Four American Composers 1983
The Draughtsman's Contract 1982
Terence Conran 1981
Country Diary 1980
The Falls 1980
Lacock Village 1980
Leeds Castle 1979
Women Artists 1979
Zandra Rhodes 1979
1–100 1978
Cut Above the Rest 1978
Eddie Kid 1978
A Walk Through H: The Reincarnation
of an Ornithologist 1978
Dear Phone 1977
Goole by Numbers 1976
Vertical Features Remake 1976
Water 1975
Water Wrackets 1975
Windows 1975
H Is for House 1973
Erosion 1971
Intervals 1969
5 Postcards From Capital Cities 1967
Revolution 1967
Train 1966
Tree 1966
Death of Sentiment 1962

Alfred Hitchcock
Family Plot 1976
Frenzy 1972
Topaz 1969
Torn Curtain 1966
Marnie 1964
The Birds 1963
Psycho 1960
North by Northwest 1959
Vertigo 1958
The Wrong Man 1956
The Man Who Knew Too Much 1956

The Trouble with Harry 1955
To Catch a Thief 1955
Rear Window 1954
Dial M for Murder 1954
I Confess 1953
Strangers on a Train 1951
Stage Fright 1950
Under Capricorn 1949
Rope 1948
The Paradine Case 1947
Notorious 1946
Spellbound 1945
Aventure malgache (Madagascar
 Landing) 1944
Bon Voyage 1944
Lifeboat 1944
Shadow of a Doubt 1943
Saboteur 1942
Suspicion 1941
Mr & Mrs Smith 1941
Foreign Correspondent 1940
Rebecca 1940
Jamaica Inn 1939
The Lady Vanishes 1938
Young and Innocent 1937
Sabotage 1936
Secret Agent 1936
The 39 Steps 1935
The Man Who Knew Too Much 1934
Waltzes from Vienna 1933
Number Seventeen 1932
Rich and Strange 1932
The Skin Game 1931
An Elastic Affair 1930
Juno and the Paycock 1930
Mary 1930
Murder! 1930
Sound Test for Blackmail 1929
The Manxman 1929
Blackmail 1929
Champagne 1928
The Farmer's Wife 1928
Easy Virtue 1928
Downhill 1927
The Ring 1927
The Lodger 1927
The Mountain Eagle 1926
The Pleasure Garden 1925

Dennis Hopper
Chasers 1994
Catchfire 1990 (and Alan Smithee)
The Hot Spot 1990
Colors 1988
Out of the Blue 1980
The Last Movie 1971
Easy Rider 1969

John Huston
The Dead 1987
Prizzi's Honor 1985
Under the Volcano 1984
Annie 1982
Escape to Victory 1981
Phobia 1980
Wise Blood 1979
Independence 1976

The Man Who Would Be King 1975
The Mackintosh Man 1973
The Life and Times of Judge Roy Bean
 1972
Fat City 1972
The Kremlin Letter 1970
A Walk with Love and Death 1969
Sinful Davey 1969
Reflections in a Golden Eye 1967
Casino Royale 1967
The Bible 1966
The Night of the Iguana 1964
The List of Adrian Messenger 1963
Freud 1962
The Misfits 1961
The Unforgiven 1960
The Roots of Heaven 1958
The Barbarian and the Geisha 1958
Heaven Knows, Mr Allison 1957
Moby Dick 1956
Beat the Devil 1953
Moulin Rouge 1952
The African Queen 1951
The Red Badge of Courage 1951
The Asphalt Jungle 1950
We Were Strangers 1949
Key Largo 1948
The Treasure of the Sierra Madre 1948
Let There Be Light 1946
Across the Pacific 1942
In This Our Life 1942
The Maltese Falcon 1941

**Derek Jarman
(features and shorts)**
Glitterbug 1994
The Next Life 1993
Blue 1993
Wittgenstein 1993
Edward II 1991
The Garden 1990
War Requiem 1989
L'Ispirazione 1988
The Last of England 1988
Caravaggio 1986
The Angelic Conversation 1985
Imagining October 1984
B2 Tape 1983
Pirate Tape 1983
Waiting for Waiting for Godot 1983
Ken's First Film 1982
Pontormo and Punks at Santa Croce 1982
Jordan's Wedding 1981
Sloane Square: A Room of One's Own
 1981
T.G.: Psychic Rally in Heaven 1981
In the Shadow of the Sun 1980
The Tempest 1979
The Pantheon 1978
Every Woman for Herself and All for Art
 1977
Jordan's Dance 1977
Jubilee 1977
Art and the Pose 1976
Gerald's Film 1976
Sea of Storms 1976
Sebastiane 1976

Picnic at Ray's 1975
Sebastiane Wrap 1975
The Devils at the Elgin 1974
Duggie Fields 1974
Fire Island 1974
Ula's Fete 1974
Art of Mirrors 1973
Stolen Apples for Karen Blixen 1973
Sulphur 1973
Tarot 1973
A Walk on Møn 1973
Andrew Logan Kisses the Glitterati 1972
Garden of Luxor 1972
Miss Gaby 1972
A Journey to Avebury 1971
Studio Bankside 1970

Takeshi Kitano
Zatoichi 2003
Dolls 2002
Brother 2000
Kikujiro no natsu 1999
HANA-BI (Fireworks) 1997
Kidzu ritan (Kids Return) 1996
Minnâ-yatteruka! (Getting Any?) 1995
Sonatine 1993
Ano natsu, ichiban shizukana umi (A
 Scene at the Sea) 1991
3-4x jugatsu (Boiling Point) 1990
Sono otoko, kyobo ni tsuki (Violent Cop)
 1989

**Stanley Kubrick
(features and documentaries)**
Eyes Wide Shut 1999
Full Metal Jacket 1987
The Shining 1980
Barry Lyndon 1975
A Clockwork Orange 1971
2001: A Space Odyssey 1968
Dr Strangelove or: How I Learned to Stop
 Worrying and Love the Bomb 1964
Lolita 1962
Spartacus 1960
Paths of Glory 1957
The Killing 1956
Killer's Kiss 1955
The Seafarers 1953
Fear and Desire 1953
Flying Padre 1951
Day of the Fight 1951

Akira Kurosawa
Madadayo (Not Yet) 1993
Hachi gatsu no kyôshikyôku (Rhapsody
 in August) 1991
Yume (Akira Kurosawa's Dreams) 1990
Ran 1985
Kagemusha (The Double) 1980
Dersu Uzala 1975
Dodes'ka-den (Clickety-Clack) 1970
Akahige (Red Beard) 1965
Tengoku to jigoku (Heaven and Hell) 1963
Tsubaki Sanjûrô 1962
Yojimbo (The Bodyguard) 1961
Warui yatsu hodo yoku nemuru (The Bad
 Sleep Well) 1960

Kakushi toride no san akunin (The
 Hidden Fortress) 1958
Donzoko (The Lower Depths) 1957
Kumonosu jô (Throne of Blood) 1957
Ikimono no kiroku (I Live In Fear: Record
 of a Living Being) 1955
Shichinin no samurai (Seven Samurai)
 1954
Ikiru (Living) 1952
Hakuchi (The Idiot) 1951
Rashomon (In the Woods) 1950
Shubun (Scandal) 1950
Nora inu (Stray Dog) 1949
Shizukanaru ketto (The Quiet Duel) 1949
Yoidore tenshi (Drunken Angel) 1948
Subarashiki nichiyobi (One Wonderful
 Sunday) 1947
Waga seishun ni kuinashi (No Regrets for
 My Youth) 1946
Asu o tsukuru hitobito (Those Who Make
 Tomorrow) 1946
Tora no o wo fumu otokotachi (The Men
 Who Tread On the Tiger's Tail) 1945
Zoku Sugata Sanshiro (Judo Saga II) 1945
Ichiban utsukushiku (The Most Beautiful)
 1944
Sugata Sanshiro (Judo Saga) 1943

Fritz Lang
Die Tausend Augen des Dr Mabuse (The
 Thousand Eyes of Dr Mabuse) 1960
Journey to the Lost City 1959
Das Indische Grabmal (The Indian Tomb)
 1959
Der Tiger von Eschnapur (Tiger of Bengal)
 1959
Beyond a Reasonable Doubt 1956
While the City Sleeps 1956
Moonfleet 1955
Human Desire 1954
The Big Heat 1953
The Blue Gardenia 1953
Clash by Night 1952
Rancho Notorious 1952
American Guerrilla in the Philippines 1950
House by the River 1950
Secret Beyond the Door 1948
Cloak and Dagger 1946
Scarlet Street 1945
The Woman in the Window 1945
Ministry of Fear 1944
Hangmen Also Die 1943
Man Hunt 1941
Western Union 1941
The Return of Frank James 1940
You and Me 1938
You Only Live Once 1937
Fury 1936
Liliom 1934
Das Testament des Dr Mabuse (The
 Testament of Dr Mabuse) 1933
M 1931
Frau im Mond (Woman in the Moon)
 1929
Spione (Spies) 1928
Metropolis 1927
Die Nibelungen: Kriemhilds Rache (Die

Nibelungen: Kriemhild's Revenge) 1924
Die Nibelungen: Siegfrieds Tod (Siegfried's
 Death) 1924
Dr Mabuse, der Spieler (Dr Mabuse: The
 Gambler) 1922
Vier um die Frau (Four Around a Woman)
 1921
Der Müde Tod (Destiny) 1921
Das Wandernde Bild (The Moving Image)
 1920
Die Spinnen, 2. Teil: Das Brillantenschiff
 (The Spiders, Part 2: The Diamond
 Ship) 1920
Die Pest in Florenz (The Plague in
 Florence) 1919
Harakiri (Madame Butterfly) 1919
Die Spinnen, 1. Teil: Der Goldene See
 (The Spiders, Part 1: The Golden
 Lake) 1919
Der Herr der Liebe (Master of Love) 1919
Halbblut (The Half-Caste) 1919

Alan Parker
(features and shorts)
The Life of David Gale 2003
Angela's Ashes 1999
Evita 1996
The Road to Wellville 1994
The Commitments 1991
Come See the Paradise 1990
Mississippi Burning 1988
Angel Heart 1987
Birdy 1984
Pink Floyd: The Wall 1982
Shoot the Moon 1982
Fame 1980
Midnight Express 1978
Bugsy Malone 1976
Footsteps 1974
Our Cissy 1974

Gordon Parks
(features and documentary)
Leadbelly 1976
The Super Cops 1974
Shaft's Big Score! 1972
Shaft 1971
The Learning Tree 1969
The World of Piri Thomas 1968
Flavio 1964

Satyajit Ray
Agantuk (The Stranger) 1991
Shakha Proshakha (The Branches of the
 Tree) 1990
Ganashatru (An Enemy of the People)
 1989
Sukumar Ray 1987
Ghare-Baire (The Home and the World)
 1984
Joi Baba Felunath (The Elephant God)
 1978
Shatranj Ke Khiladi (The Chess Players)
 1977
Bala 1976
Jana Aranya (The Middleman) 1976
Sonar Kella (The Golden Fortress) 1974

Ashani Sanket (Distant Thunder) 1973
The Inner Eye 1972
Pratidwandi 1972
Seemabaddha (Company Limited) 1971
Sikkim 1971
Aranyer Din Ratri (Days and Nights in the
 Forest) 1970
Goopy Gyne Bagha Byne (The Adventures
 of Goopy and Bagha) 1968
Chiriyakhana (The Zoo) 1967
Nayak (The Hero) 1966
Kapurush (The Coward) 1965
Mahapurush (The Saint) 1965
Charulata (The Lonely Wife) 1964
Mahanagar (The Big City) 1963
Abhijaan (The Expedition) 1962
Kanchenjungha 1962
Rabindranath Tagore 1961
Teen Kanya (Three Daughters) 1961
Devi (The Goddess) 1960
Apur Sansar (The World of Apu) 1959
Jalsaghar (The Music Room) 1958
Parash Pathar (The Philosopher's Stone)
 1958
Aparajito (The Unvanquished) 1957
Pather Panchali (Song of the Road) 1955

Martin Scorsese
(features, documentaries, and shorts)
The Aviator 2004
Gangs of New York 2002
Bringing Out the Dead 1999
Il mio viaggio in Italia (My Voyage to Italy)
 1999
Kundun 1997
Casino 1995
The Age of Innocence 1993
Cape Fear 1991
Made in Milan 1990
Goodfellas 1990
New York Stories 1989
The Last Temptation of Christ 1988
The Color of Money 1986
After Hours 1985
The King of Comedy 1983
Raging Bull 1980
American Boy: A Profile of: Steven Prince
 1978
The Last Waltz 1978
New York, New York 1977
Taxi Driver 1976
Alice Doesn't Live Here Anymore 1974
Italianamerican 1974
Mean Streets 1973
Boxcar Bertha 1972
Street Scenes 1970
Who's That Knocking at My Door? 1969
The Big Shave 1967
It's Not Just You, Murray! 1964
What's a Nice Girl Like You Doing in a
 Place Like This? 1963
Vesuvius VI 1959

Josef von Sternberg
Jet Pilot 1957
Anatahan 1954
Macao 1952

The Town 1944
The Shanghai Gesture 1941
Sergeant Madden 1939
I, Claudius (unfinished) 1937
The King Steps Out 1936
The Fashion Side of Hollywood 1935
Crime and Punishment 1935
The Devil Is a Woman 1935
The Scarlet Empress 1934
Blonde Venus 1932
Shanghai Express 1932
An American Tragedy 1931
Dishonored 1931
Morocco 1930
Der Blaue Engel (The Blue Angel) 1930
Thunderbolt 1929
The Case of Lena Smith 1929
The Docks of New York 1928
The Dragnet 1928
The Last Command 1928
Underworld 1927
A Woman of the Sea 1926
Exquisite Sinner 1926
The Salvation Hunters 1925

Jan Svankmajer
(features and shorts)
Otesánek (Greedy Guts) 2000
Spiklenci slasti (Conspirators of Pleasure)
 1996
Faust 1994
Jídlo (Food) 1992
The Death of Stalinism in Bohemia 1990
Animated Self-Portraits 1989
Flora 1989
Meat Love 1989
Tma/Svetlo/Tma (Darkness/Light/Darkness)
 1989
Another Kind of Love 1988
Muzné hry (The Male Game) 1988
Neco z Alenky (Alice) 1988
Do pivnice (Down to the Cellar) 1983
Kyvadlo, jáma a nadeje (The Pit, the
 Pendulum and Hope) 1983
Moznosti dialogu (Dimensions of
 Dialogue) 1982
Zánik domu Usheru (The Fall of the House
 of Usher) 1981
Otrantský zámek (Castle of Otranto)
 1977
Leonarduv denik (Leonardo's Diary) 1972
Zvahlav aneb Saticky Slameného Huberta
 (Jabberwocky) 1971
Don Sanche (Don Juan) 1970
Kostnice (The Ossuary) 1970
Tichý týden v dome (A Quiet Week in
 the House) 1969
Byt (The Flat) 1968
Picknick mit Weissmann (Picnic with
 Weissmann) 1968
Zahrada (The Garden) 1968
Historia Naturae, Suita 1967
Et Cetera 1966
Rakvickarna (The Coffin House) 1966
Hra s kameny (A Game with Stones) 1965
Johann Sebastian Bach: Fantasia G-moll
 1965

Poslední trik pana Schwarcewalldea a
 pana Edgara (The Last Trick) 1964

Wim Wenders
(features, documentaries, and shorts)
Don't Come Knockin' (in production
 2004)
Land of Plenty 2004
The Soul of a Man 2003
Viel passiert – Der BAP-Film (Ode to
 Cologne: A Rock 'n' Roll Film) 2002
The Million Dollar Hotel 2000
Buena Vista Social Club 1999
Willie Nelson at the Teatro 1998
The End of Violence 1997
Lumière et compagnie (Lumière and
 Company) 1995
Die Gebrüder Skladanowsky (Brothers
 Skladanowsky) 1995
Al di là delle nuvole (Beyond the Clouds)
 1995
Lisbon Story 1994
In weiter Ferne, so nah! (Faraway, So
 Close!) 1993
Arisha, der Bär und der steinerne Ring
 (Arisha, the Bear and the Stone Ring)
 1992
Bis ans Ende der Welt (Until the End of
 the World) 1991
Aufzeichnungen zu Kleidern und Städten
 (A Notebook on Clothes and Cities)
 1989
Der Himmel über Berlin (Wings of Desire)
 1987
Tokyo-Ga 1985
Docu Drama 1984
Paris, Texas 1984
Der Stand der Dinge (The State of Things)
 1982
Hammett 1982
Lightning Over Water 1980
Der Amerikanische Freund (The American
 Friend) 1977
Im Lauf der Zeit (Kings of the Road) 1976
Falsche Bewegung (False Movement)
 1975
Alice in den Städten (Alice in the Cities)
 1974
Der Scharlachrote Buchstabe (The Scarlet
 Letter) 1972
Die Angst des Tormanns beim Elfmeter
 (The Goalkeeper's Fear of the Penalty
 Kick) 1972
Summer in the City 1970
Alabama: 2000 Light Years From Home
 1969
Silver City 1969
Klappenfilm 1968
Victor I. 1968
Same Player Shoots Again 1968
Schauplätze 1967

Books

Bedazzi, Giannalberto, *Cartoons: One Hundred Years of Cinema Animation*, John Libbey, London, 1994

Beylie, Claude and Pinturault, Jacques, *Les Maîtres du Cinéma Français*, Bordas, France, 1990

Drawing into Film: Directors Drawings (exhibition catalogue), The Pace Gallery, NY, 1993

Ferguson, Russell et al (ed.), *Hall of Mirrors: Art and Film Since 1945*, The Museum of Contemporary Art, Los Angeles/The Monacelli Press, 1996

Hacker, Jonathan and Price, David, *Take 10: Contemporary British Film Directors*, Clarendon Press, Oxford, 1991

Hughes, David, *The Complete Lynch*, Virgin Publishing, UK, 2001

Katz, Ephraim, *The Macmillan International Film Encyclopaedia*, Macmillan, London, 1996

Lynch, David, *Images*, Hyperion, NY, 1994

Lyon, Christopher (ed.), *The International Directory of Films and Filmmakers: Directors*, Papermac, London, 1987

Roud, Richard (ed.), *Cinema: A Critical Dictionary*, Secker and Warburg, London, 1980

Russell, Ken, *A British Picture: An Autobiography*, Heinemann, London, 1989

Thomson, David, *The New Biographical Dictionary of Film*, Little Brown, London, 2002

Beineix, Jean-Jacques, *Miroirs Brisés/Shiver Mirrors* (exhibition catalogue), Tokyo, 1996

Chaplin, Charlie, *My Autobiography*, Bodley Head, London, 1964

Chaplin: 100 Years, 100 Images, 100 Documents (exhibition catalogue), Le Giornate del Cinema Muto, Italy, 1989

Geduld, Harry M., *Chapliniana: A Commentary on Charlie Chaplin's 81 Movies, Volume I: The Keystone Films*, Indiana University Press, 1987

Haining, Peter, *The Legend of Charlie Chaplin*, W.H. Allen, London, 1982

Huff, Theodore, *Charlie Chaplin*, Cassell, London, 1952

Lynn, Kenneth S., *Charlie Chaplin and His Times*, Aurum, London, 1998

Minney, R.J., *Chaplin, the Immortal Tramp*, George Newnes, UK, 1954

Mitry, Jean, *Tout Chaplin*, Cinema Club, France, 1972

Robinson, David (updated edition), *Chaplin: His Life and Art*, Penguin, UK, 2001

Chanel, Pierre, *Album Cocteau*, Henri Veyrier-Tchou, 1975

Cocteau, Jean, *The Art of Cinema*, Marion Boyars Publishers, London, 1992

Cocteau, Jean, *Portraits d'amis et autoportraits*, Mentha, France, 1991

Cocteau, Jean and Howard, Richard, *Past Tense: The Cocteau Diaries vol. 2*, Methuen, London, 1990

Peters, Arthur King, *Jean Cocteau and His World*, Thames and Hudson, London, 1987

Steegmuller, Francis, *Cocteau: A Biography*, Macmillan, London, 1970

Various authors, *Jean Cocteau and the French Scene*, Abbeville Press, NY, 1984

Weisweiller, Carole, *Les Murs de Jean Cocteau, commentaire de Jean Cocteau, photographies de Suzanne Held*, Hermé, France, 1998

Barna, Yon, *Eisenstein: The Growth of a Cinematic Genius*, Little Brown, London, 1966/1973

Eisenstein, Sergei, *The Film Sense*, Faber and Faber, London, 1986

Eisenstein, Sergei, *Immoral Memories – An Autobiography*, Peter Owen, London, 1983

Van, Nancy and Baer, Norman, *Theatre in Revolution: Russian Avant-Garde Stage Design 1913–1935*, Thames and Hudson, London, 1992

Chandler, Charlotte, *I, Fellini*, Random House, NY, 1995/Bloomsbury, London, 1997

Costantini, Costanzo (ed.), *Conversations with Fellini*, A Harvest Original, Harcourt Brace, USA, 1995

Fellini, Federico (translated by Graham Fawcett), *Cinecittà*, Studio Vista, Great Britain, 1989

Raffaele, Monti, *Bottega Fellini: La Città delle donne: progetto, lavorazione, film*, De Luca, Italy, 1981

Turnabuoni, Lietta (ed.), *Federico Fellini*, Rizzoli, NY, 1995

Figgis Mike, *In the Dark*, Booth-Clibborn Editions, London, 2003

Figgis, Mike (ed.), *Projections 10*, Faber and Faber, London, 1999

Christie, Ian (ed.), *Gilliam on Gilliam*, Faber and Faber, London, 1999

Gilliam, Terry and Cowell, Lucinda, *Animations of Mortality*, Eyre Methuen, London, 1978

McCabe, Bob, *Dark Knights and Holy Fools*, Orion, London, 1999

Python, Monty, *The Brand New Monty Python Papperbok*, Methuen, London, 1976

Thompson, John O. (ed.), *Monty Python: Complete and Utter Theory of the Grotesque*, British Film Institute, London, 1982

Greenaway, Peter, *Flying over water/Volar damunt l'aigua*, Merrell Holberton, London, 1997

Greenaway, Peter, *100 Allegories to Represent the World*, Merrell Holberton, London 1998

Steinmetz, Leon and Greenaway, Peter, *The World of Peter Greenaway*, Journey Editions/Charles E. Tuttle, USA, 1995

Auiler, Dan, *Hitchcock's Notebooks*, Bloomsbury, London, 1999

Auiler, Dan, *Vertigo – The Making of a Hitchcock Classic*, St Martin's Press, NY, 1998

Barr, Charles, *English Hitchcock*, Cameron Books, Scotland, 1999

Gottlieb, Sidney (ed.), *Hitchcock on Hitchcock*, Faber and Faber, London, 1995

Paini, D. and Cogeval, G.(ed.), *Hitchcock and Art: Fatal Coincidences*, Montreal Museum of Fine Arts/Mazzotta, 2001

Spoto, Donald, *The Dark Side of Genius: The Life of Alfred Hitchcock*, Muller, London, 1988

Taylor, John Russell, *Hitch*, Faber and Faber, London, 1978

Truffaut, François, *Hitchcock*, Paladin, London, 1986

Wood, Robin, *Hitchcock's Films Revisited*, Faber and Faber, London, 1989

Dennis Hopper: A Keen Eye, NAI Publishers, Amsterdam, 2001

Hopper, Marin (ed.), *Dennis Hopper: 1712 North Crescent Heights: Photographs 1962–1968*, Greybull Press, USA, 2001

Grobel, Lawrence, *The Hustons*, Bloomsbury, London, 1990

Huston, John, *An Open Book*, Alfred A. Knopf Inc., USA, 1980/Macmillan, London, 1981

Kaminsky, Stuart, *John Huston – Maker of Magic*, Houghton Mifflin, USA, 1978

Pratley, Gerald, *The Cinema of John Huston*, Tantivy, London, 1977

Jarman, Derek, *Dancing Ledge*, Allen, Shaun (ed.), Quartet Books, UK, 1984

Jarman, Derek, *Derek Jarman's Garden*, with photographs by Howard Sooley, Thames and Hudson, London, 1995

Jarman, Derek and Christie, Michael, *Derek Jarman – At Your Own Risk: A Saint's Testament*, Hutchinson, London, 1992

Lippard, Chris (ed.), *By Angels Driven: The Films of Derek Jarman*, Flicks Books, UK, 1996

O'Pray, Michael, *Derek Jarman: Dreams of England*, British Film Institute, London, 1996

Peake, Tony, *Derek Jarman*, Little Brown, London, 1999

Jacobs, Brian (ed.), *'Beat' Takeshi Kitano*, Tadao Press, 1999

Baxter, John, *Stanley Kubrick: A Biography*, HarperCollins, London, 1997

Crone, Rainer and Schaesberg, Petrus Graf, *Stanley Kubrick: Still Moving Pictures, Fotografien 1945–1950*, Schnell and Steiner, Munich, 1999

Kubrick, Christiane, *Stanley Kubrick: A Life in Pictures*, Little Brown, London, 2002

LoBrutto, Vincent, *Stanley Kubrick*, Faber and Faber, London, 1998

Akira Kurosawa Drawings (exhibition catalogue), ISE Cultural Foundation, Tokyo, 1994

Galbraith IV, Stuart, *The Emperor and the Wolf: The Lives and Films of Akira Kurosawa and Toshiro Mifune*, Faber and Faber, London, 2002

Kurosawa Akira, *Something Like an Autobiography*, Vintage, USA, 1983

Aurich, Rolf, Jacobsen, Wolfgang and Schnauber, Cornelius (ed.), *Fritz Lang, His Life and Work, Photographs and Documents*, in collaboration with Nicole Brunnhuber and Gabriele Jatho, Jovis, Berlin, 2001

Eisner, Lotte H., David Robinson (ed.), *Fritz Lang*, Oxford University Press, NY, 1977

Elsaesser, Thomas, *Metropolis (bfi Film Classics, 54)*, British Film Institute, London, 2000

Jenkins, Stephen (ed.), *Fritz Lang: the Image and the Look*, British Film Institute, London, 1981

McGilligan, Patrick, *Fritz Lang: the Nature of the Beast*, Faber and Faber, London, 1997

Minden, Michael and Bachmann, Holger (ed.), *Fritz Lang's Metropolis: Cinematic Visions of Technology and Fear*, Camden House, USA, 2000

Ott, Frederick, *The Films of Fritz Lang*, Citadel Press, USA, 1979

Schönemann, Heide, *Fritz Lang: Filmbilder, Vorbilder (Filmmuseum Potsdam)*, Edition Hentrich, 1992

Making Movies: Cartoons by Alan Parker, British Film Institute, London, 1998

Parker, Alan, *Hares in the Gate*, Pavilion Books, London, 1983

Parker, Alan, *Puddles in the Lane*, André Deutsch, London, 1977

Parker, Alan, *Un Cartoon de*, Alan Parker Film Company, UK, 1982

Gordon Parks: A Poet and His Camera, André Deutsch, London, 1969

Parks, Gordon, *Half Past Autumn: A Retrospective*, Bulfinch/Little, Brown, NY, 1997

Das, Santi (ed.), *Satyajit Ray: An Intimate Master*, Allied Publishing of India, 1998

Robinson, Andrew, *Satyajit Ray: the Inner Eye*, André Deutsch, London, 1989

Seton, Marie, *Portrait of a Director – Satyajit Ray*, Dobson, London, 1971

Kelly, Mary Pat, *Martin Scorsese – A Journey*, Secker and Warburg, London, 1992

Kelly, Mary Pat, *Martin Scorsese: The First Decade*, Redgrave Publishing Company, Pleasantville, NY, 1980

Thompson, David and Christie Ian (ed.), *Scorsese on Scorsese*, Faber and Faber, London, 1996 edition

Higham, Charles, *Marlene – The Life of Marlene Dietrich*, Mayflower Books, London, 1978

von Sternberg, Josef, *Fun in a Chinese Laundry*, Macmillan, NY, 1965

Walker, Alexander, *Dietrich*, Thames and Hudson, London, 1984

Hames, Peter (ed.), *Dark Alchemy: The Films of Jan Svankmajer*, Flick Books, UK, 1995

Magincová, Dagmar (ed.), *Anima animus animation: EvaSvankmajerJan*, Slovart Publishing, Prague, 1997

Graf, Alexander, *The Cinema of Wim Wenders*, Wallflower Press, UK, 2002

Pictures from the Surface of the Earth: Photographs by Wim Wenders, Schirmer Art Books, London, 2001

Wenders, Wim, *Emotion Pictures – Reflections on the Cinema*, Faber and Faber, London, 1989

Wenders, Wim, *Wim Wenders: On Film*, Faber and Faber, London, 2001

Articles and essays

Two or Three Things We Know About Beineix, David Russell, *Sight & Sound*, Winter 1989/90, Vol. 59 No. 1

Will Hodgkinson on Mike Figgis, in *The Guardian*, 30 January 2004, www.guardian.co.uk

Liz Hoggard interview with Mike Figgis in *The Observer*, 26 October 2003

Kim Janssen interview with Mike Figgis in *Camden New Journal*, www.camdennewjournal.co.uk/archive

Joshua Klein interview with Mike Figgis in the a.v.club, www.theavclub.com

Spencer H. Abbott interview with Peter Greenaway, 6 June 1997, http://users.skynet.be/chrisrenson-makemovies/Greenaw3.htm#abbott

Spellbound, in *Sight & Sound*, April 1996 (the Spellbound exhibition at the Hayward Gallery, London, featuring Gilliam and Greenaway among others)

Peter Clothier on Dennis Hopper, *Art News*, September 1997

American Psycho, Lynn Barber interviews Dennis Hopper, *The Observer* (UK), 14 January 2001

Edouard Laurot interview with John Huston, *Film Culture*, vol. 2 no. 8, 1956

John Huston: The Eleventh Annual American Film Institute Life Achievement Award, 3 March 1983

Devils at the Opera, Tate International Arts and Culture, March/April 2003 (Derek Jarman)

Look magazine, June 26, 1945 (Kubrick)

Being Politic Is Difficult for Me, interview with Alan Parker by Xan Brooks in *The Guardian*, 7 March 2003

Martin Scorsese profile by David Thompson, *Independent on Sunday*, 17 November 2002

A Faust Buck, Geoff Andrew in Conversation with Jan Svankmajer, *Time Out*, September 1994

Malice in Wonderland, Geoff Andrew in conversation with Jan Svankmajer, *Time Out*, October 1988

The Surrealist Conspirator: An Interview with Jan Svankmajer, Wendy Jackson, *Animation World Magazine*, Issue 2.3, June 1997, www.awn.com

Wendy Hall interview with Jan Svankmajer, *Animato*, July 1997

Svankmajer on Alice, in *Afterimage* (UK), no. 13, 1987

Latin America Part II, special photojournalism report in *Life*, 16 June 1961

Web sites

www.filmbug.com
www.imdb.com (general film resource)
www.absolutad.com (Hitchcock)
www.eyestorm.com (Hopper)
www.pythononline.com (Gilliam)
www.petergreenaway.net
www.life.com (Parks)
www.illumin.co.uk/svank (Svankmajer)
www.wim-wenders.com

Exhibitions, archives, and collections

Archive at Academy of Motion Picture Arts and Sciences, Margaret Herrick Library, Beverly Hills, LA

bfi Special Materials, Berkhampstead, UK

Miroirs Brisés/Shiver Mirrors, Jean-Jacques Beineix, Tokyo, 1996

Chaplin: 100 Years, 100 Images, 100 Documents, Le Giornate del Cinema Muto, Pordenone, Italy, 1989

Collection of the American Film Institute, Library of Congress, Washington, DC

The Director's Eye, Museum of Modern Art, Oxford, 1996

Drawing into Film, Pace Gallery (now Pace Wildenstein Gallery), New York City

Fellini!, Guggenheim Museum, New York, 2003/2004

In the Dark (Mike Figgis), Proud Camden, London, 2003

Vincent Gallo Retrospective: 1977–2002, Hara Museum of Contemporary Art, Tokyo, 2002

Flying over water/Volar damunt l'aigua by Peter Greenaway, Fundació Joan Miró, Barcelona, 1997

Hitchcock and Art: Fatal Coincidences, Montreal Museum of Fine Arts, 2000/2001 (and Centre Georges Pompidou, Paris, 2001)

A System of Moments (Dennis Hopper), Mak Exhibition Hall, Vienna, 2001

Dennis Hopper: A Keen Eye, Stedelijk Museum, Amsterdam, 2001

Akira Kurosawa Drawings, ISE Cultural Foundation, Tokyo, 1994

Fritz Lang: Filmbilder, Vorbilder, Filmmuseum Potsdam, 1992

Half Past Autumn: a Retrospective (Gordon Parks), Corcoran Gallery of Art, Washington, DC (and national tour), 1997

Satyajit Ray Film and Study Collection (RayFASC), University of California Santa Cruz (UCSC), soon to be online

Spellbound: Art and Film, curated by Ian Christie and Philip Dodd, Hayward Gallery, London, 1996

The Collection of the Lily Library, Indiana University, Bloomington, Indiana (Orson Welles)

Pictures from the Surface of the Earth (Wim Wenders photography), Hamburger Bahnhof – Museum für Gegenwart, Berlin, 2001 and subsequent world tour

Index

Page numbers in *italics*
refer to illustrations

A

Abstract Expressionism 96
Adventures of Goopy and Bagha
 (Ray, 1968) *7*
advertising 16, 20, 84, *89*, 146,
 164, 167
The African Queen (Huston, 1951) 102
After Hours (Scorsese, 1985) 173
Akira Kurosawa's Dreams (Kurosawa,
 1990) *129*, 130, *131*, *134–5*
Alexander Nevsky (Eisenstein, 1938)
 38, 40
Alice Doesn't Live Here Any More
 (Scorsese, 1974) 173
Alice (Svankmajer, 1988) *182*, 183, *188*
Allen, Woody 82
The American Friend (Wenders, 1977)
 95, 194, 195
An Open Book (Huston) 103
Angela's Ashes (Parker, 1999) 148
animation
 Gilliam 66, *67*, 70
 Svankmajer 183, 185, 188, 190
Animations of Mortality (Gilliam) *63*
Aparajito (Ray, 1956) 160
Apocalypse Now (Coppola, 1979) 95
Apur Sansar (Ray, 1959) 160
Arcimboldo, Giuseppe 190
art collecting 90, 95, 103
art training 6–7
 formal 73, 103, 105, 128, 162,
 164, 183
 informal 84, 143
assemblages
 Greenaway 81
 Hopper *92*, 94, 95–6
 Svankmajer 183
avant-garde 183, 194

B

Bacon, Francis 20
Barclay, Humphrey 66
Barton, Ralph *23*
Basquiat, Jean-Michel 90
The Battleship Potemkin (Eisenstein,
 1925) 39–40
Beat the Devil (Huston, 1953) 102
Beineix, Jean-Jacques 12–21
Bergman, Ingmar 73
Berman, Wallace 94
Berri, Claude 12
Besson, Luc 12
Betty Blue (Beineix, 1985) *12*, 16

Beyond a Reasonable Doubt (Lang,
 1956) 140
Bicycle Thieves (de Sica, 1948) 160
The Big Heat (Lang, 1953) 140
Bigelow, Kathryn 11
Birdy (Parker, 1984) *145*
Blake, Peter 94
The Blue Angel (von Sternberg, 1930)
 177, 178
Blue (Jarman, 1993) 110
Blue Velvet (Lynch, 1986) 95
Bogart, Humphrey 100, 102
Boiling Point (Kitano, 1990) 114
Boxcar Bertha (Scorsese, 1972) 169
Brazil (Gilliam, 1985) *62*, *68–9*, 70
Bresson, Robert 11
Brother (Kitano, 2000) 119
The Browning Version (Figgis, 1994) 52
Buena Vista Social Club (Wenders, 1999)
 197, 199
Bugsy Malone (Parker, 1976) 146
Buñuel, Luis 183
Burroughs, William 105
Burton, Tim 9, 190

C

Caravaggio (Jarman, 1986) 109, 110
Carax, Léo 12
caricatures
 Chaplin *23*
 Eisenstein *37*
 Fellini 11, 44, 46
Carroll, Lewis 183
cartoons
 Eisenstein 39
 Fellini 44, 46
 Gilliam *66*, 70
 Parker *144*, *146*, *147*, 148–9
Casino (Scorsese, 1995) 173
Cassavetes, John 169
ceramics 10, 35
Chaplin, Charlie 6, 8, 22–5
Charulata (Ray, 1964) 162
The Chess Players (Ray, 1977) 162
City Lights (Chaplin, 1931) 22
Clarke, Ossie 106
Cleese, John 66
Clément, René 12
Cocteau, Jean 7, 8, 25, 26–35, 105
Cold Creek Manor (Figgis, 2003) 56
collages
 Greenaway *74*
 Hopper *97*
 Jarman 109
 Svankmajer 185, *190*
The Colour of Money (Scorsese,
 1986) 173

comic strips (Fellini) 44, 46
The Commitments (Parker, 1991)
 146
Connor, Bruce 94
Contempt (Godard, 1963) 140
*The Cook, the Thief, His Wife and Her
 Lover* (Greenaway, 1989) *73*, 81
Coppola, Francis Ford 95, 194–5
Corman, Roger 94, 169
Crumb, Robert 66
Cubism *34*, 103

D

Dalí, Salvador 183
Dark Knights and Holy Fools (McCabe)
 70
The Day the Clown Cried (Lewis,1972)
 12, 14
Days and Nights in the Forest (Ray,
 1969) 162
De Niro, Robert *168*, 169, 173
De Palma, Brian 88
de Sica, Vittorio 160
de Toth, André 10
The Dead (Huston, 1987) 100
Dean, James 11, 90
The Death of Stalinism in Bohemia
 (Svankmajer, 1990) 185
Der Müde Tod (Lang, 1921) 139
Dersu Uzala (Kurosawa, 1975) 136
The Devils (Russell, 1970) 108
Die Nibelungen (Lang, 1924) 140
Dietrich, Marlene 176, *177*, 178
The Director's Eye exhibition (various,
 1996) 9, 10
Diva (Beineix, 1980) 14
Do Not Adjust Your Set TV show
 (1960s) 62
Dodes'Kaden (Kurosawa, 1970) 136
Dolls (Kitano, 2002) 119
doodles (Eisenstein) 37, 40
Dr Strangelove (Kubrick, 1963) 121, 124
The Draughtsman's Contract
 (Greenaway, 1982) 74, 78
Drawing into Film exhibition (various,
 1993) 9, 10
drawings
 Cocteau *28*, *30–1*, 32, *35*
 Fellini 44
 Figgis *52*
 Hitchcock *86–7*
 Huston *102*, *103*
 Kurosawa 128
 Lang 143
 Ray *160*
 Svankmajer *9*, 183, *185*, *186*
 see also sketches

Drowning by Numbers (Greenaway,
 1988) 81

E

Easy Rider (Hopper, 1969) 94
Edward II (Jarman, 1991) 110
8½ (Fellini, 1963) 44, 49
Eisenstein, Sergei *10*, 11, 36–43,
 160, 183
Ernst, Max 183
Escape to Victory (Huston, 1981) 102
The Evacuees (Parker) 146
Evans, Walker 199
Evita (Parker, 1996) 146
Expressionism 82, 96
Eyes Wide Shut (Kubrick, 1999) 120

F

The Face on the Bar-Room Floor
 (Chaplin, 1914) *24*
The Falls (Greenaway, 1980) 74
Fame (Parker, 1980) 146
Family Plot (Hitchcock, 1976) 82
Fassbinder, Rainer Werner 192
Fat City (Huston, 1972) 102
Fear and Desire (Kubrick, 1953) 120
Fellig, Arthur 124
Fellini, Federico 8, 10, 11, 44–9, 140
Figgis, Mike 50–61
The Films of Fritz Lang (Ott) 143
Flavio (Parks, 1964) 158
Fonda, Peter *90*, 94
Ford, John 10
Forman, Milos 190
frescoes (Cocteau) 35
Fritz Lang: The Nature of the Beast
 (McGilligan) 143
From Hell to Texas (Hathaway, 1958)
 90, 94
Fun in a Chinese Laundry (von
 Sternberg) 176, 178

G

Gallo, Vincent 9
The Garden (Jarman, 1990) 110
The General Line (Eisenstein, 1929)
 39–40
Genet, Jean 105
German Expressionism 82
Gershwin, George 103
Getting Any? (Kitano, 1995) 115
Gilliam, Terry 62–71
Ginsberg, Allen 105
Godard, Jean-Luc 11, 73, 140
The Goddess (Ray, 1960) *165*, *166*

The Gold Rush (Chaplin, 1925) 22, 25
Goodfellas (Scorsese, 1990) 173
Gordon, Douglas 89
The Great Dictator (Chaplin, 1940) 22
Greenaway, Peter 6, 7, 8, 72–81
Greenstreet, Sydney 100

H
Hammett (Wenders, 1982) 194–5
HANA-BI (Kitano, 1997) *115*, 118, *119*
Hannah and the Companions of Boom
 (Greenaway) 78
Hares in the Gate (Parker) 149
Hathaway, Henry 90, 94, 96
Hawks, Howard 100
Herzog, Werner 192
High Sierra (Walsh, 1941) 100
Hitchcock, Alfred 8, 11, 82–9
Hitchcock by Truffaut (Truffaut) 85
Hockney, David 94, 106
Hopper, Dennis 7, 90–9, 194
Hopper, Edward 10, 199
Hotel (Figgis, 2001) 56
Houédard, Dom Sylvester 108
The House (Figgis, 1984) 51
Hudson, Hugh 146
Huston, John 9, 100–3

I
I, Fellini (Chandler) 44, 46, 49
Ikiru (Kurosawa, 1952) 133
illustrations
 Cocteau *30–1, 32, 34*, 35
 Fellini 44, 49
 Gilliam *63*, 66
 Ray *162, 164*
Immoral Memories (Eisenstein) 38
Impressionism 178
installations 11, 110
 Greenaway *76–7*
Internal Affairs (Figgis, 1990) 51–2
Intervista (Fellini, 1987) 48
IP5 (Beineix, 1992) 20
Ivan the Terrible (Eisenstein, 1942/1946)
 39, 40, *41*

J
Jabberwocky (Gilliam, 1977) 70
Jarman, Derek 7, 8, 104–11
Johannes Doctor Faust (Radok, 1958)
 183
Jones, Terry 70
Jubilee (Jarman, 1978) 109

K
Kagemusha (Kurosawa, 1980) 130,
 132, 133, 136–7
A Keen Eye exhibition (Hopper, 2001)
 95
Keitel, Harvey 169, 173
Key Largo (Huston, 1948) 102
Kid Auto Races at Venice (Chaplin,
 1914) 22

Kids Return (Kitano, 1996) 118
Kienholz, Ed 94
Kikujiro (Kitano, 1999) *112*, 113,
 116–17, 119
The King of Comedy (Scorsese, 1983) 173
Kings of the Road (Wenders, 1975) 199
Kitano, Takeshi 8, 112–19
Klee, Paul 84, 103, 183
Kubrick, Stanley 7, 8, 120–7
Kundun (Scorsese, 1997) *174–5*
Kurosawa, Akira 7, 8, 11, 128–37, *160*
Kurtzman, Harvey 66

L
La Belle et la Bête (Cocteau, 1946) 29
La Dolce Vita (Fellini, 1960) 44, *46, 47*
The Road (Fellini, 1954) 46
Lang, Fritz 11, 39, 138–43
The Last Movie (Hopper, 1971) *90*, 94
The Last of England (Jarman, 1987) 110
The Last Waltz (Scorsese, 1978) *173*
Last Year at Marienbad (Resnais, 1961)
 73
Le Notti di Cariria (Fellini, 1957) *49*
Le Sang d'un Poète (Cocteau, 1931)
 29, 32
Le Testament d'Orphée (Cocteau, 1959)
 32
Leadbelly (Parks, 1976) 158
The Learning Tree (Parks, 1969) 158
Leaving Las Vegas (Figgis, 1995) *51*,
 52, 56
Lewis, Jerry 12, 14
Lichtenstein, Roy 94, *98–9*
Liebestraum (Figgis, 1991) 52
Lightning Over Water/Nick's Movie
 (Wenders, 1980) 194
literature 8, 29, 32, 158
The White Sheik (Fellini, 1952) 46
Locked-in Syndrome (Beineix) 20
The Lodger (Hitchcock, 1926) 88
The Loss of Sexual Innocence (Figgis,
 1999) 56
Lynch, David 9, 95, 188, 190
Lyne, Adrian 146

M
M (Lang, 1931) 139
Making Movies (Parker) 149
The Maltese Falcon (Huston, 1941) 100
maps (Greenaway) *72*, 78
Marais, Jean 29, *33*
Marshall, Herbert 37
Mean Streets (Scorsese, 1973) 169, 173
Merry Christmas, Mr Lawrence (Oshima,
 1982) 114
Metropolis (Lang, 1926) 139, *141*
Mexican Drawings (Eisenstein) 40
Midnight Express (Parker, 1978) 146
Mifune, Toshiro *128*, 132–3, 136
Ministry of Fear (Lang, 1944) *142*
Miró, Joán 20, 183
Miroirs Brisés exhibition (Beineix, 1996)
 20
The Misfits (Huston, 1961) 102

Mississippi Burning (Parker, 1988)
 146
Moby Dick (Huston, 1956) 103
Modern Times (Chaplin, 1936) 22
Monty Python and the Holy Grail
 (Gilliam/Jones, 1975) 70
Monty Python TV shows (1969-74)
 62, *67*, 70, *71*
The Moon in the Gutter (Beineix, 1983)
 14, 16
Mortel Transfert (Beineix, 2001) 20
Mr Jones (Figgis, 1993) 52
murals (Cocteau) *29*, 35
The Music Room (Ray, 1958) 164

N
neo-realism 46, 160
Nijinsky, Vaslav 27, *32*
North by Northwest (Hitchcock, 1959)
 84, 88
Notorious (Hitchcock, 1946) 88

O
"objects" (Svankmajer) 183, *184,
 187, 189, 191*
October (Eisenstein, 1927) 39–40
Oldenburg, Claes 94
One Night Stand (Figgis, 1997) 56
O'Neill, Oona 22
Orphée (Cocteau, 1949) 29, *33*
Oshima, Nagisha 114

P
paintings
 Beineix *13, 15, 16, 17, 18–19*, 20, *21*
 Cocteau *29*, 35
 Figgis *57*
 Greenaway *75*, 78–9, *81*
 Hopper *91*, 94, 95–6
 Huston *5, 101*
 Jarman *104*, 105, 106, *107*, 109,
 110, *111*
 Kitano *112, 114, 115, 116–17*,
 118–19
 Kurosawa *119*, 128, 130, *131,
 134–5*
 Lang 140, 143
 Ray *161*
 von Sternberg 178, *179, 180–1*
Paisà (Rossellini, 1946) 46
Paris, Texas (Wenders, 1984) 195, *198*,
 199
Parker, Alan 6, *9*, 144–9
Parks, Gordon 7, *9*, 150–9
Pather Panchali (Ray, 1955) 160, *162,
 163*, 167
Paths of Glory (Kubrick, 1957) 120
photo-montages
 Figgis *50*
 Greenaway *80*
photography
 Figgis 51, *53, 54–5*, 56, 59
 Hopper 11, 90, *93*, 95, 96, *98–9*
 Kubrick *120*, 121, 122–5

Parks 150, *151, 152, 154–5*, 156,
 157, 158, *159*
Wenders *10*, 11, *192, 193, 194*,
 195–7, 199
Picasso, Pablo 25, 27, 35, 183
Pictures from the Surface of the Earth
 exhibition (Wenders, 2001) 2,
 10, 197
Pink Floyd: The Wall (Parker, 1982) 146
The Pleasure Garden (Hitchcock, 1925)
 88
portraits
 Chaplin *23*
 Figgis 59, *60–1*
 Hopper *93*, 96, *98–9*
 Parks *159*
 Ray *160*
 of Wenders *2*
 see also self-portraits
Post-Impressionism 178
posters
 Chaplin *22*
 Cocteau 27
 Ray *165*, 167
Prospero's Books (Greenaway, 1991)
 79
Psycho (Hitchcock, 1960) *83*, 88
puppets *182*, 183

Q
Que Viva Mexico! (Eisenstein, 1975) 40, *43*

R
Radiguet, Raymond 27
Radok, Emil 183
Raging Bull (Scorsese, 1980) *168, 172*,
 173
Ran (Kurosawa, 1985) 136, *137*
Rancho Notorious (Lang, 1952) 140
Rashomon (Kurosawa, 1951) 160
Ray, Nicholas 194
Ray, Satyajit 7, 8, 133, 160–7
Rear Window (Hitchcock, 1954) 88
Red Beard (Kurosawa, 1964) 133
Renoir, Jean 10, 160, 167
Resnais, Alan 73
The Road to Wellville (Parker, 1994)
 146, 148
Robinson, David 22
Roma, città aperta (Rossellini, 1945)
 46, 160
Roselyne and the Lions (Beineix, 1989)
 20
Rossellini, Roberto 46, 160
Rowlandson, Thomas 84
Russell, Ken 108

S
Saboteur (Hitchcock, 1942) *84–5*
The Salvation Hunters (von Sternberg,
 1925) 178
The Scarlet Empress (von Sternberg,
 1934) *176*
Scarlet Street (Lang, 1945) 140

A Scene at the Sea (Kitano, 1991)
 114–15
Schnabel, Julian 90
Scorsese, Martin *6,* 7, 8, 130, 134,
 168–75
Scott, Ridley 16
Scott brothers 146
sculpture 10
 Cocteau 35
 Lang *138, 140, 143*
 Svankmajer 183, 185, *189, 191*
Sebastiane (Jarman, 1976) 109
self-portraits
 Chaplin 22, 25
 Cocteau *26,* 32
 Eisenstein *37*
 Hitchcock *89*
 Jarman *105*
 Lang *139*
 Parks *150*
Sergeant York (Hawks, 1941) 100
The Seven Samurai (Kurosawa, 1954)
 136
The Seventh Seal (Bergman, 1957) 73
Shaft (Parks, 1971) *153,* 158
The Shining (Kubrick, 1980) 120, 121
Shoot the Moon (Parker, 1981) 146
Sickert, Walter 84
sketches
 Eisenstein *10,* 11, *36,* 37–8, *39, 41,*
 42, 43
 Fellini 10, *11,* 46, *47, 48, 49*
 Figgis *56, 58, 59*
 Greenaway 78, 81
 Hitchcock 10, 82, *84–5,* 89
 Kurosawa *132, 133, 136,* 137
 Parker 149
 Ray *7, 163, 166,* 167, *167*
 see also drawings
Sonatine (Kitano, 1993) *113,* 114
The Sons of Katie Elder (Hathaway,
 1965) 94, 96
Spellbound exhibition (various, 1996)
 64, *76–7*
stills (as art) *64–5, 94, 110*
Stormy Monday (Figgis, 1988) 51
storyboards
 Eisenstein *38*
 Gilliam *68–9,* 70–1
 Hitchcock 82, *84,* 89
 Lang *141*
 Scorsese *6, 170–2,* 173, *174–5*
The Stranger (Welles, 1946) 100
Strangers on a Train (Hitchcock, 1951)
 88
Strike (Eisenstein, 1924) 39–40
Surrealism 32, 183, 185, 188
Svankmajer, Jan 8–9, 182–91
Synchronism 103

T
tactile art (Svankmajer) 185, *187*
Takeshi *see* Kitano, Takeshi
Taxi Driver (Scorsese, 1976) *170–1,* 173
The Tempest (Jarman, 1980) 109
theatrical design 105, 106, *108, 109*

The 39 Steps (Hitchcock, 1935) 10, 82,
 86–7, 88
Throne of Blood (Kurosawa, 1957) *128*
Timecode (Figgis, 2000) 56
Touch and Imagination (Svankmajer,
 1983) 188
Tracks (Jaglom, 1976) 95
The Treasure of the Sierra Madre
 (Huston, 1948) 102
True Grit (Hathaway, 1969) 94
Tulse Luper Suitcases: The Moab Story
 (Greenaway, 2003) 74
A Turnip Head's Guide to British Cinema
 (Parker, 1986) 148
Twelve Monkeys (Gilliam, 1996) *64–5*
24 Hour Psycho (Gordon, 1993) 89
2001: A Space Odyssey (Kubrick, 1968)
 121

U
Underworld (von Sternberg, 1927)
 178

V
Van Gogh, Vincent 11, 118–19, 128,
 130, 134, 137
Vertical Features Remake (Greenaway,
 1978) 74
Vertigo (Hitchcock, 1958) 88
Vertov, Dziga 183
Violent Cop (Kitano, 1989) 114
von Sternberg, Josef 176–81

W
A Walk through H (Greenaway, 1978)
 74, 78
Walsh, Raoul 100
War Requiem (Jarman, 1988) 110
Warhol, Andy 90, 94
We Have Ways of Making You Laugh
 TV show 66, 70
Welles, Orson 9, 100, 140
Wenders, Donata 2
Wenders, Wim *2,* 7, *10,* 192–9
Who's That Knocking on My Door?
 (Scorsese, 1968) 169
Wim Wenders on Film (Gut) 192
Wings of Desire (Wenders, 1987) 195,
 199
Wittgenstein (Jarman, 1993) 110
The Woman in the Window (Lang, 1944)
 140
woodcuts (Ray) *162*
Woodward, Joanne 96
Written on the West exhibition
 (Wenders, 1986) 196

Y
Yamamoto, Kajiro 132

Z
Zidi, Claude 12